D0844117

Ute von Reibnitz

Scenario
Techniques

McGraw-Hill Book Company GmbH

Hamburg · New York · St. Louis · San Francisco · Auckland
Bogotá · Guatemala · Lisbon · London · Madrid · Milan
Mexico · Montreal · New Delhi · Panama · Paris · San Juan
São Paulo · Singapore · Sydney · Tokyo · Toronto

Title of the original version:
Szenarien – Optionen für die Zukunft
© 1987 by McGraw-Hill Book Company GmbH, Hamburg
Translated from German by Peter A. W. Rosenthal and Philippa Hammond

CIP-Titelaufnahme der Deutschen Bibliothek

Reibnitz, Ute von:
Scenario techniques / Ute von Reibnitz. [Transl. from German
into English by Peter A. W. Rosenthal]. – Hamburg ; New
York [u. a.] : McGraw-Hill, 1988
 Dt. Ausg. u.d.T.: Reibnitz, Ute von: Szenarien – Optionen für die
 Zukunft
 ISBN 3-89028-220-2

Set, printed and bound by Clausen & Bosse, Leck
Cover design by Grafik Design Studio, Hamburg

Printed in Germany
ISBN 3-89028-220-2

Contents

Those who pretend to know the future lie, even if they accidentally speak truth.

(Arabian Proverb)

1
Scenario Techniques – Origins

The earliest traces of a method for viewing or knowing the future are to be found in the writings of Seneca: "It is more important to know whither events turn than to know where they come from." The philosophy of scenario concepts and scenario techniques has already been in existence for more than 2000 years. Seneca's various writings reveal how he was intensely occupied by the thought: How is the future going to develop? Here, then, the beginnings of scenario techniques become recognizable – without, however, any method being formulated.

Military History

The earliest outlines of possible scenarios (or what could be interpreted as such) are contained in writings by Moltke and Clausewitz. Moltke and Clausewitz were primarily concerned with military survival and their aim of vanquishing the enemy. To this end, various methods and means were described and put into practice. Modern strategic planning encompasses very marked references to Moltke and Clausewitz, as they first formulated the principles of real strategic planning, e. g.

– attack your enemy where he is weakest,
– build on your own strength and
– always keep in mind the long-term objective of battle or campaign.

It is interesting in this context to compare strategy and tactics. Strategy referred to whatever long-term plans for overcoming their enemies had been developed by commanders-in-chief before any particular battle or campaign; tactics referred to whatever, during the course of an actual battle, lower-ranking commanders or generals were permitted to put into effect within their own commands in order to successfully conclude that battle.

This distinction between strategy and tactics may be very easily transferred

to business enterprises and organizations. Strategies are orientated towards medium and long term or permanent company goals (in military terms: victorious campaign) and must be developed by the high command (top management). Tactics involve reacting flexibly and in the short term to any new situation, which reaction then also contributes towards achieving company goals and is implemented by middle and lower management (short-term actions within a wider campaign). Tactics must on no account whatsoever contradict the overall goal of a business enterprise or campaign.

This approach, which for many years or, rather, several centuries had not been sufficiently appreciated, was suddenly revived in the context of US strategic planning. Within the scope of a US government program, Herman Kahn, who in the early fifties was the first person to talk about scenarios, developed military strategic studies for Rand Corporation. Similar to a theatre production where stage set and scenery create a backdrop, the accent here was on creating a background for certain scenes and setting up a framework for possible future activities by showing future environment situations. The military planners' task consisted of operating as well as possible within these set conditions and of coming through even in adverse circumstances.

The first scenarios were principally set up for political and military purposes. Predominantly, they were of the visionary type; it remained unclear how these visions of the future were worked out, how they had been arrived at, and how they were to develop from present conditions. The military strategic purpose of those scenarios was to train the military in handling unaccustomed environment situations and to get them to show the best possible reactions in such situations to ensure victory for their country.

Economic History

Models of military strategic planning entered the business environment only in the early seventies, when there had been attempts to set up scenarios that were not just mere intellectual sand-table exercises but which showed a definite reference to actual planning as well as to having been set up systematically. Two groupings may be distinguished here: One group was of a clearly quantitative orientation, the other more of a qualitative orientation. The first, quantitatively oriented, group counted among its representatives the Club of Rome, which hit the headlines with its studies "The Limits to Growth" (Meadows 1972) and "Mankind at the Turning Point" (Pestel 1974). The principal exponent of the second, more qualitatively orientated, school of thought was the Shell Group that, initially from an unease towards quantitatively orientated planning methods, attempted by trial-and-error approaches to include quali-

tative aspects in their planning. Further institutes that, within the scope of qualitative planning, showed a development towards implementing scenario techniques were the Datar Institute (Office for Regional Planning and Development in France) and the Battelle Institute in Frankfurt, Germany. The first scenarios that were worked out systematically and in a form readily understood were set up in voluminous studies by public commission in the mid-seventies (e. g. in areas like regional planning, research planning, industrial planning for the chemical industries, and road planning).

The situation during the seventies (the uncertain outlook for the future and the increasing importance of qualitative aspects against the background of the setbacks suffered by quantitative planning) gave rise to the development of the first scenarios used in industry. First users were those branches of industry that had been hit hardest by the oil crisis: oil companies and car manufacturers. They developed systematic approaches for turning scenario techniques into a basis for planning on which they could build to work out plans for their products and systems and that were orientated towards the future and secure in the long term.

During the second half of the seventies and, in particular, during the eighties, scenario techniques achieved wider recognition in Europe and the United States as for many branches of industry the business environment situation became more and more difficult and existing planning methods could not develop a sound enough basis for strategic business planning.

Parallel to the uncertainties in the business environment, strategic planning developed as an important instrument for business planning. Strategic planning, which on the basis of given internal and external preconditions for a certain enterprise works out promising alternatives for the future, is principally based on scenario techniques; the main approach of these techniques consists of linking external and internal developments pointing towards the future, on which basis alternative strategies for the future are then developed. The widespread use of strategic planning in many business enterprises made them particularly receptive to scenario techniques.

2

How the Scenario Approach Compares to other Planning and Forecasting Methods

Definition of a Scenario Approach

A scenario approach involves developing future environment situations (scenarios) and describing the path from any given present situation to these future situations.

To this end, several methods may be used:

- The method of global scenarios
- The method of company specific scenarios

Global scenarios are set up for definite subjects of general interest to several branches of industry or higher level departments. As they do not have a definite starting point, these global scenarios must be developed on the basis of global data that have been abstracted to a very considerable extent. The advantage of such scenarios is that they provide relevant situational data for a certain well-defined branch of industry. Their disadvantage is, however, that these developments are not geared to any company specific situation; thus, a company working with these global scenarios needs to develop an additional company specific approach (linking global statements with company specific requirements).

Company specific scenarios are, as it were, "tailor-made" to the requirements of a company, irrespective of what branch of industry this company may be in. Here, there is a definite, company specific, starting situation (internal analyses of goals, strategies, and strengths/weaknesses) that is taken as the basis from which company relevant influence factors are determined and, at a later stage, projected into the future. This type of company specific approach has the advantage of all environment data referring indirectly or directly to the company

involved; scenarios, therefore, do not embrace any other data, which may be of little or no relevance to the company concerned. It will thus be possible to develop customized company specific scenarios and derive strategies that take due account of the actual company situation as well as to develop company specific compatible strategies that look into the future, showing successes among differing environment scenarios.

Comparing Scenario Techniques to other Planning Methods

Comparison with Conventional Forecasting

Conventional forecasting centres on analyzing an existing 'status quo' situation and, by means of some formula, asks how this current situation might be projected into the future. Using this approach, many forms of classical forecasting do not take into account influences by external company environments; thus, they merely extrapolate an existing internal situation. Forecasts of this type may only be applied to certain limited areas within any company (e.g. market share / market volume development for some product, acceptance development for a certain product). However, forecasts of this type throw up problems if the product concerned ceases to be accepted in a number of environment situations, or if changes in legislation or substitution products significantly alter the product environment. Conclusion: Classical forecasts are only of relevance to well-defined and limited subjects, and should be backed up by other approaches such, for example, as those involving scenarios.

Comparing the Scenario Approach to Portfolio Analysis

In its approach, portfolio analysis centres to a very large extent on considering market attraction and market growth. To this end, a number of widely differing factors are determined on the X/Y coordinate system and duly entered. The portfolio approach serves as an excellent tool for showing the present situation of a company, with its various strategic business units, in relation to that company's competitors. However, the limits of the portfolio approach lie in forward predictions. Taking a present situation as its starting point, and without knowing how business environments will develop in the future and what the alternatives are, it is almost impossible with this type of approach to set up a 'target' portfolio.

In many companies it is common practice to set up a target portfolio on the

basis of an existing 'as it is' portfolio; however, this kind of target portfolio essentially represents "wishful thinking". The approach simply places strategic business units that are not too well positioned and which "could do better in future" into the positive part of any portfolio (into 'star position'), without anyone actually knowing how it would get there and what strategies could be used to achieve that 'star position'.

Hence my recommendation: Portfolio analysis is an excellent tool for defining an existing 'present' situation, even in relation to competitors (steps 1 and 2 of the scenario approach); however, starting from a pure portfolio basis, it is not as well suited to set up projections into the future. On the other hand, it has proved very useful indeed to set up a target portfolio on the basis of scenario developments and the relevant master strategy derived from those scenarios (see the section on 'Developing Strategies').

Comparing Scenario Methods to Simulation Models

Simulation models enable researchers to calculate and depict systematically all conceivable future developments. Their main area of application are statistical analyses and government supported research programs, where there is an emphasis on a diversity of differing results.

However, all simulation models are subject to one major problem: today, no individual planner is humanly able to grasp comprehensively the diversity of conceivable future situations (scenarios and other models) and so to 'digest' them properly, let alone come to decisions on that basis.

Within a certain context, simulation models are of value and should be used (See the chapter on 'Computer-Aided Methods within the Scenario Procedure'). However, one should not expect too much from simulation models, which, in theory, are able to depict all conceivable futures; for, in the last analysis, everything turns on the individual planner being able to work with them as well as to come to decisions based on them.

Many users of simulation models, therefore, apply additional decision criteria (such as consistency, stability, diversity, probability) to obtain a reduced selection of sub-optimum simulations. Only with a reduced selection of simulation results is it possible to draw definite conclusions and work out plans.

Let us plan what is difficult whilst it is still easy, let us do great things whilst they are still small. Everything difficult on this earth originates from what is easy, everything great originates from what is small.

(Laotse)

3

Reorientation in Planning Approaches

A New Business Environment

In the days when economic growth was continuous, planners in both private industry and the public sector were well served by forecasts based on historical data. As long as economic development generally was marked by high rates of growth, and business environments behaved after a continuous and mostly "calculable" fashion, these extrapolations of current trends provided a reliable basis for planning. Occasional crises remained limited to certain industrial sectors and, as such, could be absorbed and handled by the economic network as a whole.

It was only when the 1973 oil crisis struck that, for the first time, Western economic structures were disrupted to a significant extent and with far-reaching consequences for almost all branches of industry. This event and its consequences may serve to illustrate some very general planning errors that were still being made until quite recently. The list includes:

- Firm faith in forecasting methods that are based on historical data and assume unbroken economic growth as well as continuous and uninterrupted economic development.

- Inadequate observation and assimilation of developments taking place on the political, social and economic levels, as well as of newly arising crisis points.

- Inadequate observation of developing societal trends and processes likely to shape public opinion, which first find expression in acceptance problems (particularly in the form of local interest groups, citizen's initiatives and associations) and later are reflected in new laws and decrees as well as effects on planning (this aspect is especially well illustrated by the many court cases which have arisen in connection with the planning and construction of nuclear power stations). The uncertainties in this area – as well as in the consumer

goods and service markets – result from the spread in modern society of various differing value systems and philosophies, which are accepted by large parts of the population. Whilst a majority of people still adhere to the industrial view of life (dominated by an orientation towards high achievement), there is already a large group actively practising and promoting a postindustrial way of life (so-called 'alternative' ways of life).

– When new competitors appear in the marketplace, they are not recognized early enough; therefore, effective counter-measures come late or not at all. (Japanese penetration of Western markets is a case in point. If this development had been effectively observed and analyzed, from the day Japan first entered Western markets with optical equipment, the German and US motor industries would not have had to stand by in bewilderment as Japanese market shares seemingly just grew and grew, but could have prepared timely and effective counter-strategies.)

This analysis shows that business planning must take into account a host of uncertainties in business environments, a fact which was vividly borne out by events during the 1970s. External factors, which may no longer be ignored in future, include e. g.:

– The increasing significance of political and societal developments.
– Legislative measures and intervention in the economy (product liability, conservation requirements etc).
– Ever decreasing product life cycles in the marketplace, and simultaneously increasing development periods and costs.
– Unstable demand patterns in an economy that has stopped being calculable and features some saturated markets.

These influences stemming from business environments have caused a shift of emphasis in planning. The new type of forward-looking planning should, therefore,

– be based on alternative developments and variations, and no longer on linear forecasts.
– endeavour to recognize any threats and risks, as well as opportunities, at an early stage.
– include in its planning process and assimilate any company relevant external information from the political, societal, and economic arenas.
– treat forecasts as a means of orientation only, and give up unrealistic expectations regarding their precision and certainty of fulfilment.

If, in any long-term business planning, these points are taken into account, there is a much improved chance for the company concerned to cope with changes in its dynamically developing business environment; and it will stand a better chance of overcoming any external or internal disruptive events.

A Need for New Approaches to Planning

As business enterprises find themselves in increasingly difficult situations regarding their external business environments, today (even more so in the future) all companies need to take on board and apply new approaches to planning. What is implied by new approaches to planning? These involve considering, at the same time that quantitative influences are taken into account, any qualitative factors in business environments; these, too, may significantly influence the company concerned.

Experience shows that companies are somewhat reluctant to include qualitative factors in their planning, as these are normally very hard to quantify. However, the scenario approach enables qualitative and quantitative influences to be processed on an equal footing and in exactly the same way, allowing this reluctance to be dispelled and companies to take into account all significant external influences of a qualitative nature.

New planning approaches for the future, therefore, involve:

- Recognizing: how will business environments develop?
- What alternatives are there?
- How should companies adapt to these various alternatives? If possible, a master strategy should be developed that promises to be successful in the context of differing future developments.

To give an example for the significance of qualitative aspects, the following case is quoted:

A company, predominantly engaged in space technology and arms production, had a vacancy for a qualified employee in its own research and development section. The vacancy was advertised in several national business journals; the text, however, did not name the company concerned, which received approximately 400 applications in response to its advertisement. The company then selected all applications that promised to be of most interest, sent a letter to the applicants concerned and told them what company they had sent their application to. In response to that letter approximately 40% of applicants withdrew their application, saying that they did not wish to be employed by a company engaged in arms production.

This example shows very clearly of what paramount significance qualitative factors, like a change in value systems, may be to a company, even to a company that is not directly engaged in the consumer goods sector but active in a completely different sector, i. e. arms production.

A further case in point for the significance of qualitative aspects is that certain products, made of substances (chemical industry) no longer sanctioned by society at large, will increasingly be subject to acceptance difficulties in their markets; they will only be able to re-establish themselves after some reorientation has taken place.

Thus it may be safely concluded from these examples that, in order to work out strategies for their future, companies must increasingly tackle the issues raised by external developments and in particular by qualitative societal changes. Naturally enough, the most effective strategies are those that build on future trends (e. g. nature, health food, health, high-tech trends).

Whoever does not know how to take care of the future in the present will depend on the uncertainties of that very future.

(Seneca)

4

The Scenario Approach: A Description

The Scenario Model

What does a Company's Information Requirement look like?

If we look at the information a company needs, certain hierarchical information levels become apparent (see Figure 1).

The central planning department or strategic planning staff rely initially on internal company information available from the various departments. The information coming from different fields is not usually presented in the form in which it is needed for the various planning tasks, and there is frequently an excess of information with a vast amount of detail from which the information relevant to planning must be filtered out.

For planning purposes, market information is also required. This information can mostly be supplied by the company divisions that have direct or indirect connections with these markets, data on the raw materials market being obtainable for example from the production and materials handling divisions. The marketing division is normally very well informed on the sales and export markets for the various company products, while the personnel department knows about the status and development of the regional labour market. For planning purposes, this information from a company's immediate environment also has to be put into a suitable form, filtered, and weighted according to its significance for the company.

In short or medium term planning for periods not greater than two to five years it is normally sufficient to work with existing company data plus market analyses conducted by tried and tested methods. But where the planning horizon is more than five years ahead it is no longer adequate only to consider those markets with which the company is directly and indirectly associated; the areas beyond, in the outer ring of the diagram, must now also be included in

the planning process. Many planners have found that the behaviour of their customers or competitors is largely determined by factors unrelated to the market, such as legislation, social attitudes, general economic conditions, world trade or new technological developments, and for this reason the information in the outer ring, with its strong influence both on the behaviour of competitors and customers and on internal business policy, has to be included. This is the point at which things normally start to get difficult for planners, because most companies have little or no information on legislation, infrastructure, world trade, and the technological developments of customers and substitution competitors. There exists however a great deal of statistical and forecasting information on subjects related to the outer environment, for example, global studies by Prognos, INSEAD, SRI, EIU, Infratest, Battelle Institut, Inside R & D, World Future Society, American Management Association, and Harward. These studies contain a wide range of information in the form of well-researched figures, usually presented in the form of forecasts, simulation models or input/output models. This material has to be converted

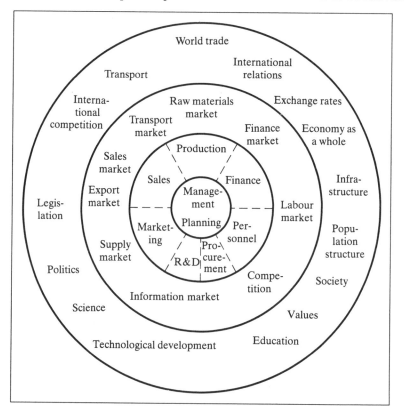

Figure 1: A company's environmental system

to a form that suits a company's specific needs, because not all the statistics will be relevant to a particular company, or other factors must be worked out that are not included in the studies, yet have a powerful influence on the company concerned.

To find a way through the confusing multiplicity of available information (usually there is too much information rather than too little), the scenario technique offers a method of filtering this information with specific reference to a company, working out future projections and deriving from these tailored company strategies.

The Scenario Conceptual Model

Scenarios can be illustrated by a concept known as the scenario funnel.

Taking the present situation, in whatever year it lies, as the starting point, one can say that a company is affected by a number of fixed factors such as markets, competitive structure, infrastructure, laws, standards, contracts, and the economic situation. These factors have a specific structure that can be comprehended and the effects of which can be taken into account and used tactically at any given moment. When these factors are projected into the near future – a period of two to three years – in most cases they change to some extent but not very significantly. But if an attempt is made to project this external environmental situation further into the future, a point is very quickly reached where one no longer knows exactly how the factors will develop and what effects their alternative developments will have on the company. The further one tries to define future development on the basis of present knowledge, the greater is the uncertainty and the greater is the number of alternatives and possible combinations. This gives rise to the idea of a funnel opening out into the future, the funnel being a symbol of complexity and uncertainty.

If a section is now drawn through the funnel at any point in the future, for example, the mid nineties, the year 2000 or beyond, then all conceivable theoretically possible future situations (scenarios) will lie somewhere on this section. At this point many planners draw back in dismay, thinking it necessary to work out and develop systematically what may be thousands of future situations and take them into account in planning.

Planners have two typical responses: either they give up because of the uncertainties and stick with trusted extrapolations that offer a kind of pseudocertainty despite their known shortcomings, or they grasp the nettle of future uncertainty and work out alternative paths into the future for all developments that have uncertainties from the perspective of the present.

The pioneer of scenario development, Shell United Kingdom, recognised very early – at the beginning of the seventies – that for corporate planning purposes it is quite enough to generate two scenarios, but that these scenarios must fulfil the following criteria: on the one hand, each should have in itself the maximum possible harmony, consistency and freedom from contradiction, and, on the other hand, the two scenarios should be as different as possible from each other. If computer aided methods are used, it is also possible to carry out stability testing of the scenarios, so as to reduce the number of scenarios that come into question and to choose scenarios with a high degree of system stability (see also the chapter on computer-aided methods for scenario techniques).

If these two scenarios are worked out by a systematic process – the scenario method – a master strategy suitable for both these very different future situations can be developed. The scenario method also provides for abruptly occurring disruptive events to be taken into account. The effects of such disruptive events are systematically analysed and preventive measures and responses (avoiding action and crisis plans) are worked out for them, the preventive measures then being integrated into the master strategy for its greater security.

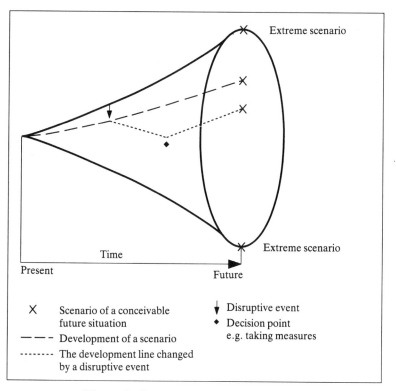

Figure 2: Conceptual model of scenarios

The Eight Steps of the Scenario Process

> *Threefold is the march of time: Hesitantly is the future drawn nearer,*
> *Quick as an arrow has the present flown, Eternally still stands the past.*
> (Schiller)

Step 1: Task Analysis

> *Even a journey of 1000 miles begins with one step.*
> (Japanese proverb)

The aim of this step is to analyse the present situation of a company or strategic business unit. This should be handled differently depending on whether the company has a uniform or mixed business structure. Medium-sized and small companies with a uniform market normally focus on the company as a whole, while for companies that are widely diversified and have different product/market combinations it is more sensible to carry out strategic business unit or division scenarios.

For this purpose the company's existing corporate identity, goals and strategies are assembled and their importance assessed. Next, the strengths and weaknesses of the company or strategic business unit are analysed. On the basis of this - corporate identity, goals, strategies, strengths and weaknesses – it is easy to see what problems the company has and which of these must be solved in the short, medium and long term. The problems are then formulated into questions that all begin: How can we ...? The way the questions are formulated should not indicate any possible solutions; at the moment the aim is to recognise and define the company's main problem areas for the future. The questions listed here could theoretically be answered now with the aid of problem solving techniques – but answering them at this stage would give too heavy a bias to past events and empirical knowledge, whereas the purpose of a scenario process is to bring future perspectives and alternative thinking into the answers to these questions so that the strategy can in fact develop in a forward-looking way.

For this reason, the questions are simply listed at this stage and are not answered until step 6 when the consequences for the company are worked out.

Some examples of such questions are:

How can we

1. find new fields of application for existing products?
2. exploit the changing values of society for product innovation?
3. profit/learn from the technological developments of our customers?
4. integrate our customers into innovation processes?
5. learn from newcomers to our sector?
6. convert confrontation in the market to cooperation?
7. find new methods of communication with our customers?
8. profit from economic developments in our customer countries?

The next important thing is to define the scenario time horizon. The horizon depends on how long a company needs, for example, to develop innovations and bring them onto the market or to implement long-term investment plans. It is clear that generally applicable horizons do not exist; rather, they can vary considerably depending on the sector and the company; for example, the chemical and pharmaceutical industries operate with horizons of 15 to 20 years – they have very long research and development horizons – while in other sectors a horizon of about ten years is sufficient. As a rule of thumb, the horizon for a scenario is the period of time a company needs to develop an innovation or develop new business activities, plus an additional buffer period of roughly five to seven years.

Companies that already use portfolio analysis methods can very well use actual portfolio analyses to estimate the present company situation in relation to competitors.

The analysis of company strengths and weaknesses can be carried out both intuitively, by grouping strengths and weaknesses after a certain preparatory period, and systematically with the aid of check lists. In these check lists the present and future situation of all divisions of a company or functional divisions of a strategic business unit are assessed, and as a result of this the problem areas to which the master strategy must pay special attention in steps 6 and 8 will inevitably become clear.

Before tackling a scenario project it is advisable in any case to catalogue a number of questions that could describe the company in its present status. These questions should be given to the scenario team about four to six weeks before the start of the first scenario workshop.

A general note here is that scenarios can be worked out in different forms. The most usual forms at present are a so-called mini scenario project (i. e. two three-day scenario workshops) or a scenario project (four two- to three-day scenario workshops). The procedure is the same in both cases but has to be compressed somewhat for the mini scenario project.

Example of a Check List:

**General, non company or sector specific check list
for company or organisation analysis**

	Present			Future		
	1	2	3	1	2	3
1. General company situation						
1.1 Turnover Definition						
1.2 Profit Definition						
1.3 Costs Definition						
2 Management and organisation						
2.1 Quality of planning Definition						
2.2 Quality of management Definition						
2.3 Organisational structure Definition						
2.4 Flexibility of the organisation Definition						
2.5 Capacity for innovation Definition						
2.6 Creativity Definition						
2.7 Assertive capacity Definition						

Assessment key
1 = Poor
2 = Satisfactory
3 = Good
Future = Period of about fiver years
(only taking into account measures already introduced)

	Present			Future		
	1	2	3	1	2	3
3 Marketing						
3.1 Marketing know-how Definition						
3.2 Market performance						
Breadth of product range Definition						
Depth of product range Definition						
Quality Definition						
Market penetration Definition						
3.3 Marketing costs Definition						
3.4 Prices Definition						
3.5 Image Definition						
3.6 Renown Definition						
4 Production						
4.1 Production capacities Definition						
4.2 Production technology Definition						
4.3 Investment flexibility Definition						
4.4 Production and raw material costs Definition						

	Present			Future		
	1	2	3	1	2	3
5 Procurement						
5.1 Procurement know-how Definition						
5.2 Procurement performance Definition						
6 Research and development						
6.1 R&D performance Definition						
6.2 R&D know-how Definition						
6.3 Patent and trademark rights Definition						
6.4 Licences from others Definition						
6.5 R&D costs Definition						
7 Personnel						
7.1 Quality of staff including availability Definition						
7.2 Staff costs Definition						
8 Finances						
8.1 Available capital Definition						
8.2 Equity Definition						
8.3 Borrowed capital Definition						
8.4 Capital turnover Definition						

To conclude step 1, the original formulation of the task is checked once again to verify that it is correct in the light of the actual status analysis, and, if necessary, it is reformulated.

Step 2: Influence Analysis

> *Yet it is a general human weakness to let oneself be swayed overmuch by hope and set overmuch in fear of uncertain and unknown things.*
>
> (Gaius Julius Caesar)

The aim of this step is to define the external areas of influence that affect a company or strategic business unit, to ascertain and assess the external influencing factors within these areas of influence, and to work out the interrelationships between the areas of influence.

Typical areas of influence that occur in nearly all sectors are sales market or customers, procurement market, competition, legislation, technology, economy and society. But a detailed analysis shows very quickly that it is impossible to work with headings such as the ones listed above. Areas such as technology or sales markets may be very different for a bank, a chemical firm, a trading company or an electronics company, and so within each area of influence the influencing factors relevant to the particular company must be ascertained and their significance for the company assessed. This assessment is made by working out a relative ranking. After defining all the influencing factors and their relative order of rank, the interrelationships between the areas of influence can be ascertained. By this we mean the extent to which each area, characterised by its most important influencing factors, influences all the other areas, and to find this every area is compared with every other. This network analysis, normally produced with the aid of a network matrix, results in an active total which expresses for each area the extent to which it influences all the other areas, and a passive total which says how much each area is influenced by others (Figure 3: network matrix).

How can a System be analysed?

To analyse a system, first all the system elements must be identified, analysed by structure and function, and delimited one from another. Once the individual system elements have been analysed – there must be no overlapping in respect of function or structure between the system elements – a network or interrelationship matrix can be used to determine the influence that each sys-

tem element has on the others. The network matrix (see Figure 3) is evaluated as follows: from left to right one finds the extent to which each system element affects all the other system elements. The degrees of influence are normally weighted as follows:

0 = no influence
1 = weak influence
2 = medium influence

Adding the total for each element across the row gives the so-called active total (the total extent to which one element affects all the other system elements). Adding the columns gives the so-called passive total for each system element (the extent to which each element is influenced by all the other elements).

When determining the degree of influence it is also important to establish the type of influence that element A has on element B, etc., and to note the justification for the degree of influence on a separate sheet so that the system analysis can later be verified.

The importance of a system element within such a system is expressed by the ratio of the active and passive totals.

System elements	A	B	C	D	E	F	G	H	Active total
A	X	2	2	2	2	1	2	1	12
B	1	X	1	1	0	0	0	0	3
C	0	2	X	2	2	1	2	1	10
D	0	2	2	X	2	1	1	0	8
E	1	2	1	1	X	0	0	0	5
F	0	1	0	0	1	X	0	1	3
G	1	1	1	0	0	0	X	0	3
H	0	0	1	1	0	1	0	X	3
Passive total	3	10	8	7	7	4	5	3	47:8 = 5,9

Figure 3: Network matrix

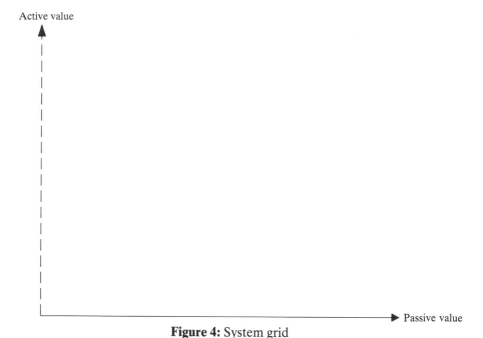

Figure 4: System grid

For greater clarity, the figures from the network matrix can then be transferred to a so-called system grid (see Figure 4 and Figure 5).

Figure 5 shows that dividing a system grid by the active and passive axes produces four fields.

Field I contains the active system elements. System elements located in this field are characterised by very high activity (these elements have a relatively strong influence on all the others in the system) and relatively low passivity (elements in this field are relatively little influenced by all the other elements).

Field II contains the so-called ambivalent elements. Elements located in this field are characterised by relatively high activity and relatively high passivity; in many cases activity and passivity are virtually balanced. Elements in this field influence the system as strongly as they are influenced by the system.

Field III contains the so called buffering or lesser ambivalent system elements. Elements in this field have relatively little influence on the system and are relatively little influenced by it (low activity and passivity).

Field IV contains the passive system elements. These are very strongly influenced by all system elements (high passivity) and have relatively little influence on the system (low activity).

System elements A-H can now be placed in a hierarchical order according to the importance of each field:

Rank 1	A	Rank 5	B
Rank 2	C	Rank 6	H
Rank 3	D	Rank 7	F
Rank 4	E	Rank 8	G

What Basic Rules can be derived from a System Analysis based on the System Grid and the Network Matrix?

Once a system has been analysed, the next task is not simply to ascertain the particular system dynamics but to make use of them for concrete activities, strategies, etc.

To obtain the maximum reinforcement or synergy effect in a system, the behaviour and types of influence of the elements in the active area must be used in such a way that they are in line with company goals and strategies. In some cases this may mean a company asking itself how it can influence certain

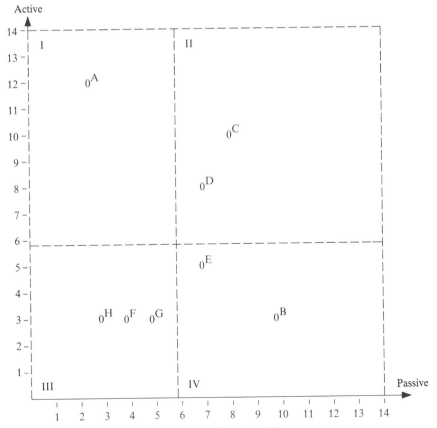

Figure 5: System grid

elements in the active area in such a way that these in turn influence other elements in the ambivalent and passive areas towards company objectives so as to cause a snowball effect or chain reaction.

The first rule of system dynamics is, therefore, to exert leverage in the system at those points where the greatest reinforcement effect can be achieved. These are normally active elements, or in some cases ambivalent elements with a clear active balance.

The second rule of system dynamics is, if possible, not to exert direct influence on passive or buffering elements, because they have relatively little influence in the system.

As an example of this, many analyses of the environmental systems of specific companies have shown that global system elements or areas of influence have a determining – in other words active or ambivalent – character, while system elements or areas of influence directly associated with the company itself, such as sales markets, competition, procurement markets, are more likely to assume a passive position.

This fact shows the importance of global developments and the behaviour of global system elements for the way an overall system functions. What does this mean in concrete terms for a company? Most company analyses have shown that a firm can itself only actively influence global system elements such as technology, the economy and society to a small extent. In most cases, there is no chance to influence economy and society. What this means in concrete terms for a company is that existing developments in these areas, including their effects on other areas, must be analysed very carefully, not only quantitatively but above all qualitatively, to find how the behaviour of the system elements in relation to each other can be exploited for the implementation of company strategies.

As an example of this, for a company that has recognised technology as a system element of central importance in the system, the following question arises: How can technological developments be exploited in different ways, for example both to rationalise and improve internal company organisation, and also to develop innovations which can be used to achieve a powerful influence on sales markets and competition – in other words, a competitive advantage?

It is only by purposefully exploiting the most active factor – technology – that an effective strategy for sales market and competition can be achieved, namely, to gain a competitive advantage by means of innovation. Naturally, accompanying marketing and competition strategies must be developed and implemented, but the central point is still the technology and the innovation.

So when dealing with networked systems, first the structure of the system and its interrelationships must be analysed and one must then concentrate on the elements with the greatest leverage or reinforcement action within the

system to achieve the maximum effect. It is also advisable to work out and test a mixture of measures for controlling and reinforcing the overall utilization of the system. This means that at the same time as activating the most dynamic element in the system, accompanying measures must be introduced, as in the marketing activities example, as an important source of support for the leverage.

The question now arises: when is it advisable to implement such a system analysis and controlled system exploitation? The procedure can be used in all cases where the system being dealt with is complex and not at first transparent. Such a system may be the overall structure of a company, the environmental structure of a company, a system of R&D strategies, a system of marketing activities, or a decision situation in a company (in this case the criteria for the company decision should be analysed and dealt with as system elements, so that the criteria can be more effectively weighted and thus a more effective decision chosen).

What Typical Errors occur when dealing with Networked Systems?

Error no. 1:

From fear of the complexity and lack of transparency of a system there is a tendency to reduce it to its most visible problem, to analyse the problem as such and deal with it in isolation, and thus to cause undesired changes in the system.

Error no. 2:

When the structure and the internal and external characteristics of a system have been analysed in all their complexity, specific strategies relating to the system objectives are defined that exploit the most active elements in the system. The strategies adopted are implemented and a rapid system response or an initial indication of success is now expected from the strategies introduced. But it has become apparent that many systems need a relatively long time to adjust to the changed situation and to respond in accordance with the new system dynamics. An error often made here results from impatience in the face of the slow system response; attempts are made to introduce further activities and strategies that then cause the system to overreact without this having been intended. At the same time, overreacting means that the system will not respond in the way originally expected, but alternative effects are produced that can hinder or even nullify the original intention of the strategies implemented.

To take a simple example of this, a person learning to drive will tend to oversteer the car system by correcting too far to the left or right on a straight stretch of road. An experienced driver knows that on a straight stretch practically no steering actions are required.

Error no. 3:

The strategies described above do not bring success in the time expected, and traditional methods of isolating problems and dealing with parts of problems – methods that can severely disturb the system – are reverted to out of disappointment.

What are the Characteristics of Successful Systems?

The ability to exploit and build on internal synergy effects, within the company: for example, the use of staff expertise not only in line and staff functions, but also in interdepartmental planning and project teams, or the use of existing information about customer complaints not just in the service department but also as an impetus for possible product improvements and innovations.

Seeing and using external interference as an opportunity for further development rather than as a threat: for example, government conditions and restrictions relating to environmental protection can be used as an opportunity to develop new ecologically and economically improved production methods.

Sensitivity, and resulting from this, a high degree of flexibility in the face of internal and external influences and changes: for example, using stagnating or declining turnover in a product group or a market segment as an opportunity to reassess the range, or diversify.

Maintaining system equilibrium through diversity and decentralisation: for example, maintaining different company functions with different sales and procurement markets rather than a pure production or marketing organisation depending on a few suppliers and customers. If important customers decline or fail, "monoculture" companies are faced with a crisis that threatens their very existence. Decentralisation provides the possibility of rapidly ironing out hiccups at the point where they occur. Diversification stabilises the overall company system and secures its existence if turnover collapses in individual parts.

Maintaining feedback processes in the system, rather than treating problem areas in isolation: for example, combining different products or product groups into product/market areas such as health, communications or energy. Within these areas feedback processes develop that may then lead to product replacement or reassessment of the range. The area is maintained as a system, while within the system elements – the products – adaptations can be made to market needs that in turn stabilise the system as a whole.

Clear objectives for an overall system rather than detailed programs for separate divisions: for example, defining strategic goals for the company as a whole and then allowing the functional divisions to work out strategies for achieving these goals, with the possibility of decentralised correction if hiccups occur. Within the divisions, only the forward development guidelines should be linked back with overall strategic planning.

The advantage of this is that the divisions have greater opportunities for responsibility and control, leading to increased motivation and entrepreneurial attitudes on the part of those involved. Company management can worry about overall goals and strategies and does not have to immerse itself in questions of detail that can in any case be solved more effectively by the divisions.

The Net Result

Consistent application to company practice of the basic rules of system analysis and system dynamics can contribute to company survival both now and in the future. Ecological systems that have not been manipulated by massive human intervention have known since time immemorial how to survive and develop by applying these rules. For example, the goal of ensuring the species through a high degree of sensitivity and flexibility in adapting to changed environmental conditions.

Step 3: Projections

> *A path is made by being trodden.*
>
> (Chuang Tzu)

The aim of this step is to ascertain, on the basis of the influencing factors determined in step 2, descriptors that describe the present and future status of each factor. It is important for the descriptors to be formulated neutrally, since otherwise there is a risk that the development of a descriptor will only continue in a given direction. Some examples of this are to use attitude to new technologies as a descriptor rather than rejection or acceptance of new technologies, or market development rather than market growth.

Attempts to project acceptance of new technologies into the future, for example, would inevitably result in projections being worked out in terms of greater or less acceptance, and if market growth were projected, future projections would be worked out in terms of greater or less market growth. The

question whether acceptance could turn to rejection or whether market growth could turn to stagnation or decline would simply not be asked.

Experiments with different groups of participants have shown that if descriptors are formulated neutrally, it is easier to think about different future developments. Using this method, one often arrives at a point where it is not clear exactly how certain factors will develop in future, and within the scenario team there will be different opinions that can all be equally well justified. In this case it is important to show factors in their alternative developments such as in growth or decline, liberalisation or tightening up of legislation, acceptance or rejection of certain technologies or products. Such descriptors containing different future developments are known as alternative descriptors. As well as this, there are descriptors that can be determined relatively clearly from the point of view of the present; these are treated as so-called clear descriptors, i. e. their development draws a relatively clear line into the future with a certain latitude for fluctuation. For both types of descriptor, both clear and alternative, reasoned justifications must be used for their assumed future development, and it is advisable to use forecast data from various sources for this.

Step 4: Grouping Alternatives

> *An archer should not hit the mark now and then, but miss now and then.*
>
> (Seneca)

The aim of this step is to check the various alternative developments identified in step 3 against each other for consistency, compatibility and logic. This can be done in two ways. The various alternatives can be compared with each other in discussion and complete self-consistent clusters identified intuitively. For more complex problems with more than 12 to 15 descriptors, it is advisable to carry out a detailed analysis using a consistency matrix (Figure 6).

In a detailed consistency analysis resulting in a consistency matrix, the group should ask the following questions:

1. Are the two alternatives of a descriptor that apply in one field directly correlated? If not, this means a weighting of 0 = neutral, no direct relationship. If there is a relationship between two alternatives, the next questions are:

2. Is this relationship consistent and free of contradiction or does it contradict itself?
 If the relationship is consistent, this means a positive weighting.

Consistency matrix	1		2		3		4		5		6		7		8		9		10		11	
	a	b	a	b	a	b	a	b	a	b	a	b	a	b	a	b	a	b	a	b	a	b
1) New technologies a) Success	×																					
b) Flop																						
2) GNP a) Growth	2	0		×																		
b) Decline	0	1																				
3) Structural change a) Success	2	−1	2	−1		×																
b) Flop	−1	2	0	2																		
4) Unemployment rate a) Higher	0	1	1	0	2	0		×														
b) Lower	1	0	0	2	1	1																
5) Social attitudes to technology a) Acceptance	2	0	0	1	0	2	−1	1		×												
b) Rejection	−1	1	−1	1	−1	2	1	0														
6) Legislation a) Liberal	1	0	0	0	0	0	0	0	0	0	×											
b) Stricter	0	1	0	1	0	0	0	0	0	0												
7) a)														×								
b)																						
8) a)															×							
b)																						
9) a)																	×					
b)																						

Figure 6: Consistency matrix

3. Is this relationship consistent and free of contradiction with or without reinforcement?

 If it is consistent without reinforcement, the value $+1$ is assigned; if it is consistent with mutual reinforcement the value $+2$ is used.

 If a relationship is inconsistent, the question is:

4. Is it partly or absolutely inconsistent/contradictory? For partial inconsistency a value of -1 is assigned; for absolute inconsistency -2.

Selected Scenarios (example):

Difference value	:	10

Consistency: 40
- New technologies : success
- New materials : success
- GNP : rising
- Structural change : success
- Unemployment rate : low
- Attitudes to technology : acceptance
- Values : work
- Taxation : liberal
- General legislation : liberal
- Competitive pressure : status quo

Consistency: 34
- New technologies : flop
- New materials : flop
- GNP : falling
- Structural change : flop
- Unemployment rate : high
- Attitude to technology : rejection
- Values : leisure
- Taxation : stricter
- General legislation : stricter
- Competitive pressure : increased

It must be borne in mind here that it is relatively easy to ascertain future synergy effects ($+2$ weightings) from the present standpoint, but relatively difficult to decide now what future correlations can be ruled out absolutely. In practice, therefore, weightings of -1 are assigned more frequently than -2.

After the consistency matrix has been completed with the aid of a form and detailed justifications, the consistency analysis data is processed by a computer program with the following functions:

1. Calculation of all theoretically possible scenario clusters.

2. Selection of scenarios with the maximum possible consistency.

3. Selection of those scenarios from the most consistent ones that have internal stability.
 Internal stability means that, when subject to disruptions, these scenarios do not improve in the direction of greater consistency. Scenario instability means that, when subject to disruptive events, the scenarios change in the direction of greater consistency. The purpose of a stability analysis, normally carried out with the aid of a scenario computer program, is to ascertain which scenarios have high stability and hence in most cases have long-term validity.
 The purpose of this type of planning is to generate scenarios with maximum possible stability so that scenarios with long term validity are used in planning, and one avoids concentrating on scenarios that could only illuminate a momentary future situation (unstable scenarios).

4. Selection of two scenarios that are consistent, stable, and also very different from each other.
 In practice, of, for example, about 1000 calculated scenarios, there are usually only about 30 that have a very good consistency value. Of these 30 scenarios about 15 are usually relatively stable. If these 15 scenarios are then selected according to the difference criterion, there often remain only very few scenario pairs that optimally meet the criteria of consistency, stability and difference, and in many cases there are only two scenarios that optimally meet these criteria.

This method of analysis supports the claim made by Shell in the seventies that two scenarios are sufficient.

At this point a so-called sensitivity analysis can also be carried out, in which new scenarios are generated by changing each descriptor in the chosen scenarios. This clearly shows how the descriptors from the global environmental areas can influence or even topple the overall scenario structures. In most cases, a scenario is changed only slightly by changing the descriptors that originate from passive and buffering fields of influence. This likewise confirms the significance of the system dynamics from step 2 (network analysis). Sensitivity

analysis and its results are very important for the environmental monitoring that comes later (for further information on scenario computer programs, see the chapter on computer-aided methods in scenario techniques).

Step 5: Scenario Interpretation

> *Judge no man, and hold nothing to be impossible, for there is no man who does not have his future, and there is no thing that is not given its hour.*
>
> (Talmud)

The aim of this step is to organise and interpret the environment scenarios on the basis of the consistency analysis carried out in step 4, the result of which was two internally consistent, stable but very different scenarios, using the clear descriptors ascertained in step 3, and taking into account the results of the network analysis.

Computer-aided methods enable the clear descriptors to be assessed in relation to the alternative descriptors and their compatibility. Whether the clear descriptors are evaluated by computer program, or whether they are added manually, interpreted qualitatively and adapted to the structural alternative descriptors, depends on the amount a company wants to spend on such a scenario operation.

The difficulty of scenario interpretation stems from the fact that scenarios do not develop statically into the future, but have certain dynamic properties of their own; it may be, for example, that a specific scenario constellation causes certain reactions such as activity on the part of legislators, some competitors or customers or social groups, that can then lead to new developments in the particular scenario. These changes must be taken into account and processed in the scenario interpretation. On the other hand this dynamic way of looking at things leads to greater plausibility and increases the willingness of planners to identify with the scenarios.

This step results in two contrasting but in themselves logically consistent and plausible scenarios or pictures of the future. The scenario pairs can be given descriptive titles such as

- progressive/conservative scenario
- optimistic/pessimistic scenario
- having/being scenario
- continuity/discontinuity scenario

– harmony/disharmony scenario
– ecology/economy scenario

Such a list of contrasting scenario titles can be extended indefinitely; it normally reflects the tenor of the scenarios and expresses the main planning aspects for the company in question.

At this point it is advisable to carry out another system analysis along the lines of step 2, i.e. to draw up a network analysis and a system grid for the different scenarios. While in step 2 the influencing factors in their present form provided the basis of the network analysis, in step 5 the scenarios in their various future forms provide the point of reference for the analysis. In this way the following can be ascertained:

1. the difference between the scenarios and the present situation and the dynamics of development from the present to future A or B

2. the difference between the two future scenarios and their system dynamics

The results of this system analysis will be linked back once more with the parameters of the master strategy in step 8 (scenario transfer) to ensure that the master strategy is founded primarily on the system behaviour of the active areas of influence and that these are used to optimum effect for the company.

Step 6: Consequence Analysis

Thinking alone sets nothing in motion until it is focused on a purpose and on an action.

(Aristotle)

It is not that we do not dare because it is difficult, but because we do not dare, it is difficult.

(Seneca)

The aim of this step is to derive from the scenarios possible opportunities and risks for a company, to evaluate these in terms of their importance for the company and to designate measures or activities for them. The purpose of

the activities is for opportunities to be exploited as quickly and optimally as possible, and for risks to be reduced as far as possible or turned into opportunities. It is also necessary to note whether these opportunities and risks might be relevant in the short to medium term or in the medium to long term. Activities for the short to medium term can clearly be distinguished from the activities for the long term, since developments as far as the first scenario horizon can be different from developments between the first and second horizon; for example, scenario development as far as the

1st horizon: continuous development incorporating innovative improvements (related to a specific technology)

2nd horizon: substituting this technology with completely new methods (not compatible with the former technology).

The following activities/measures could be considered:

Activities for the 1st horizon:
- Fully exploiting the existing technology, no more basic research but only optimisation of the application at no great cost
- "Milking" existing applications (cash cow principle)
- Cooperation in respect of know-how
- Contact with developers, etc., to build up know-how in possible substitute technologies.

Activities for the 2nd horizon:
- Technology and R & D monitoring system (to find which substitute technology is in the lead)
- Transferring from the existing to a new technology
- Solving compatibility problems
- "Marrying" the old technology with the new, etc.

The consequence analysis in step 6 is the most important step in the entire scenario process for strategic planning, because it is at this stage that the foundations of company strategy are developed. Accordingly, a large amount of time should be allocated to this work.

Here, too, the two scenarios can be used as a basis for answering the questions posed in step 1; for example, how would one solve this or that problem named in step 1 if scenario A or B were reality.

Clearly the questions can be answered very differently on the basis of scenario A or B, but there will also be a certain degree of overlap between scenario A and B answers.

From the different results of the consequence analysis – one based on scenario A and one based on scenario B – an interim attempt is now made, without involving the entire scenario team, to generate a provisional master strategy. (See step 8: scenario transfer).

Step 7: Analysis of Disruptive Events

> *If you want a man not to tremble in the face of danger, then train him early in the ways of danger.*
>
> (Seneca)
>
> *If you are wise, then mix one with the other: do not hope without doubt, and do not doubt without hope.*
>
> (Seneca)

The aim of this step is to identify possible abruptly occurring internal and external events that could substantially affect the company or change it (either positively or negatively), to evaluate their significance for the company, and to work out suitable preventive and response measures in the form of avoiding action and crisis plans.

Once identified, the disruptive events should not be analysed in terms of the probability of their occurrence, because experience shows that disruptive events that would put a company at great risk are usually classified by the scenario team as relatively improbable.

Some actual examples will illustrate the danger of such probability analyses: When Shell was experimenting for the first time with scenario techniques by trial and error at the end of the sixties and beginning of the seventies, a serious oil crisis such as actually occurred in 1973 had already been postulated as a disruptive event. In the probability analysis, however, what came out was that the team classified the probability as very low and believed that such an event could not occur until the mid to late eighties at the earliest. But the fact was that this event occurred in 1973, posing the entire mineral oil, energy, chemical and automobile industries severe problems.

Another instance in which probability analyses and calculations misfired is Chernobyl. According to the experts the probability of such an event occurring was less than one per cent and was hence believed to be negligible for the relevant companies. But the Chernobyl case did occur and has led to a rethink

about probability calculations. It shows very clearly that the criterion for considering disruptive events must be not their probability, but their effect.

Though it may be amusing to speculate on the probability of certain events occurring – my advice would be to discuss this after work over a drink – one should be aware of the dangers of this type of probability analysis and rule it out. When selecting disruptive events, it is sufficient to limit oneself to assessing their significance, in other words, to considering those scenario disruptive events that could have a crucial effect on the company or cause it severe problems.

Once the question of the magnitude of their effect has been clarified and the main disruptive events have been selected for further processing – it is advisable, if possible, to analyse disruptive events from different areas such as the economy, technology, society, legislation, politics, sales market, procurement market, competition and internal company events – the events selected are briefly defined. This definition is important for recognition of their effects; if the definition is omitted, this can often lead to misunderstandings in the analysis of the effects.

At this point the question is often asked whether catastrophic events such as war in Europe, a third world war or the like should be considered. My recommendation is to leave out events of this nature because a company or organisation can scarcely work out preventive or response measures for these. Moreover, including them could lead to fatalistic attitudes and negatively influence processing of events that are relevant to the company. Apart from such global catastrophes there are numerous disruptive events which have to be taken seriously and which a company should tackle.

Analysing the effects of disruptive events is carried out as follows. If a disruptive event affects and changes the scenarios, which is normally the case for events originating in the economy, technology, society, politics and legislation, their effects both on the scenarios and on the company are considered. Such events can cause the scenarios to develop in a different direction (disrupted scenarios). Disruptive events originating in the market normally only change the customer market, procurement market and competition part of the scenario and have effects on the company. When analysing the effects, both the effects of the scenario changes and also the direct effects of the disruptive events on the company must be taken into account.

Dealing with disruptive events in this way can also have the effect of sensitising management to disruptive events and can be used as a type of crisis training: how can such events be handled? And the crucial question: what advantages for the company can be retrieved from disruptive events? Seneca once said: "If you want soldiers not to tremble in battle, you should train them early in the ways of danger." This old saying can easily be applied to present-day

companies, and it would seem a minimum requirement for companies to train their management personnel to deal with such disruptive events in good time and even before they occur.

Another advantage of disruptive event analysis is that it clearly pinpoints a company's weak points or Achilles heel. In many cases different disruptive events when analysed show that quite specific areas of a company are affected again and again, and the consequence for the company is then to work as quickly as possible on eliminating these weak points.

The preventive measures sketched above are integrated into the master strategy in step 8. In many cases the preventive measures reinforce specific activities in the master strategy.

The effects of disruptive events can best be grasped with the aid of the table below.

Disruptive event:
Brief description (definition)

Effects on the scenario (changes to the scenario under the influence of the disruptive event).	Direct and indirect effects on the company (i. e. arising from the changed scenario).	Preventive measures (avoidance or security measures)	Response measures (crisis plans)
...

Preventive measures for internal disruptive events in the company are usually aimed at preventing or avoiding their occurrence in the first place, or their triggering a crisis. Such considerations can show up weak points in the company very clearly. Experience shows that companies often produce their own disruptive events which are then reinforced by external events; for example, a wine scandal in Austria and Germany would not have occurred if certain substances had not been added to the wine. For many companies this means investigating their internal affairs to find where the course is set for possible disruptive events that could hit them very hard. An example of this is inferior quality of certain products that could later lead to a product scandal, increased product liability, and the product being withdrawn from the market.

Response measures to such disruptive events can also be called crisis plans. In many companies the opinion prevails that such crisis plans can be made when the event occurs. But experience shows that it is much more sensible to think about possible crises in advance and to draft suitable statements for the media that can then be released if such an event occurs. Statements drafted in advance are as a

rule considerably better than those issued under the pressure of events, which often damage the company image rather than improving its reputation.

Step 8: Scenario Transfer

> *Oh, what good it would do many people if they once left their track.*
>
> (Seneca)
>
>
> *He who knows the goal can decide, he who decides finds peace, he who finds peace is certain, he who is certain can reconsider, he who reconsiders can improve.*
>
> (Confucius)

The aim of this step is to use the opportunity and risk activities worked out in step 6 to formulate a master strategy, define alternative strategies and establish a system of monitoring the environment.

For this purpose it is necessary to refer back to the results of the consequence analysis in step 6. A master strategy is now formulated on the basis of like and similar activities and answers to the list of questions.

Like activities and answers to both scenarios are, however, insufficient on their own for the development of a solid master strategy. Answers and activities that are particularly attractive and innovative are therefore further analysed, and tests carried out to find whether an idea worked out, for example, by the scenario A group would also be effective in the conditions of scenario B, and vice versa. In this way about two thirds of the activities and answers from step 6 can be integrated into a master strategy. In some circumstances it may be necessary to reformulate the activities to make them compatible with both scenarios. The activities left over for the two scenarios A and B now form the basis for the alternative A and B strategies. In many cases, alternative A and B strategies form a supplement to or a closer definition of the master strategy if scenario A or B becomes reality.

To further safeguard the master strategy against possible external and internal disruptive events, the preventive measures worked out in step 7 are integrated into the master strategy.

The master strategy is then divided according to the different functions and divisions of the company so that each division is given concrete instructions in terms of the master strategy, such as:

- General company alignment (business policy, corporate identity, corporate design, diversification, acquisition policy, expansion, etc.)
- Master strategy for research and development
- Master strategy for production
- Master strategy for sales and marketing
- Master strategy for public relations

The master strategy thus determined is now connected back once more with the starting situation for the company in step 1 in order to find the extent to which the goals and strategies listed in step 1 coincide with the master strategy now designed, and if there are weaknesses that might prevent certain goals being reached, or strengths that could be helpful in realizing the master strategy.

Two basic types of company attitude emerge from this.

Companies with predominantly rigid and conservative attitudes concentrate on aspects of the master strategy that relate to strengths in the starting situation, but will be less inclined to concentrate on aspects that lead to much change in the company (strengths, weaknesses and internal organisation).

Companies with a more progressive attitude do not just exploit aspects of the master strategy that build on strengths, but at the same time try to change the internal starting situation (strengths, weaknesses and internal organisation) in order to reach attractive new goals that come to light during the scenario process.

At this point it also becomes clear that, even if an industry-wide scenario is carried out, the individual companies in this industry will favour different realisation strategies depending on whether their basic orientation is progressive or conservative.

The next step is to construct an environment monitoring system that links the external developments which are most important for the company (in the form of descriptors with alternative developments and clear development) with the company functions and places the influential descriptors resulting from this in a monitoring system. It is necessary to refer once more to the sensitivity analysis from step 4 if it was produced by computer. The sensitivity analysis shows very clearly what factors in the external environmental system of a company are, as it were, the driving forces which, if they were changed, would cause most of the other scenario descriptors to change too. By directly correlating the factors of direct importance for the company, and by analysing which external influencing factors have, as it were, the greatest dynamic effect in the system, it is possible to concentrate monitoring on the external factors of most importance for the company.

The function of the monitoring system is to link the actual development of

external factors with the master strategy and, if necessary, to make careful adjustments or adaptations to the master strategy if deviations occur. This means that, after a certain monitoring period, if certain changes become apparent, the master strategy must be carefully adapted.

A mistake that is very commonly made is that, when companies suddenly discover during monitoring that things are developing in a different direction from that projected by the scenarios, they abandon their master strategy completely and embark on new strategies with the aim only of, for example, making a short-term change in the market. After a further monitoring period the development then frequently reverts to its original position, making the frantic activities introduced absurd. All companies that introduce a monitoring system are therefore recommended to begin by simply observing calmly external developments and, only after several monitoring periods, if a change occurs, to adapt the master strategy carefully without changing it fundamentally. Another reason for this is that there is a relatively long time before the envisaged scenario horizon is reached. One is observing, planning and working for the decisions of *tomorrow*, and for this reason short-term activities that contradict the master strategy are to be avoided.

At this point a so-called target portfolio can be produced on the basis of the master strategy. It is known what goals are to be reached with what strategies, and this knowledge can now be converted into a corresponding portfolio. It is interesting to compare actual and target portfolios. Under no circumstances should the target portfolio be created on the basis of the actual portfolio; on the contrary, it is advisable to wait for the scenario to be developed, to work out the master strategy and only then to convert the master strategy thus obtained to a target portfolio, because this type of target portfolio will take into account all external developments, their alternatives, possibilities, opportunities and risks (see Chapter 6 for further details on realisation).

A leader personality is one whom failure does not throw off course, whom a temporary affliction does not cause to despair, and who calmly accepts passion and suffering.

(Mokshadharma)

5

Examples of Scenario Applications

Note: to guarantee confidentiality to our clients the following examples have been somewhat modified.

Example I: Management in the Future

Note: This case study was developed for a presentation and should not be regarded as specific to a particular company. However, as management is an important subject for management personnel and companies in different sectors of industry, it is very suitable as a general example.

Step 1 of the Scenario Technique: Task Analysis

1.1 What does Management mean today?

Management means guiding, motivating and monitoring people in terms of company goals, and achieving these goals with suitable strategies and human resources.

Although in most companies management is practised with the main emphasis on the present, the task of management always includes future aspects because its function is to achieve a company's future goals, to motivate people towards future goals and strategies, and to involve them in drawing up the strategy.

1.2 How is Management practised today?

There are nowadays a large number of different management styles, the one used depending on the company style, the personality of the management staff, the types of task to be carried out and the personnel to be managed. Management styles today range along a spectrum varying between authoritative and participatory, task-oriented and employee-oriented, situational and long-term.

Despite intensive searching for generally applicable management guidelines – a kind of universal panacea – there still exists no standard principle of management. On the contrary, more and more new management styles and principles are coming into being, usually in the USA, from where they are imported to Europe. Attitudes to new management concepts are often euphoric because they are expected to provide a new remedy for the problems of the future. But, in practice, the new methods too prove to have their limitations despite offering new approaches and certain advantages.

1.3 What Questions are relevant to Management Styles of the Future?

Management being a complex task that depends both on many internal factors relating to the company and to individuals, and on external factors in the form of influences from the company environment, the external environments must be examined with the aid of a short scenario, if the issue of the future of management is to be addressed meaningfully.

These scenarios should then provide suitable answers to, for example, the following questions:

How can we produce management which:
– adapts to changing social values?
– achieves a synthesis with new technology?
– adapts to new corporate and organisational forms?
– is generally more future-orientated (management on the basis of future rather than past requirements)?
– is shaped and influenced more actively by all those involved, both managers and managed?
– takes appropriate account of the dynamics of a company and its environment?
– in the way it is practised and experienced achieves a high degree of acceptance?
– in style and substance constitutes an ongoing, continuously changing process?
– leads to employee satisfaction?

Such a list of questions could be continued indefinitely, though if this is done for a specific company emphasis should be placed on the particular company situation.

1.4 What are the strengths and weaknesses of management at present?

This question should on no account be omitted in an internal company scenario. This means that all strengths and weaknesses of management that are now apparent should be listed, catalogued and assessed in terms of their significance for the management style practised within the company.

1.5 Horizons

The task is now to define suitable scenario horizons or milestones for the future. In company-specific scenarios based on the period required for innovation plus a time buffer of about 5 to 7 years, it is normal to set a first horizon of about 5 to 7 years and a second horizon of about 10 to 15 years. For the example in hand, i. e. management, it is sufficient to set the present year (1988) and, say, the year 2000.

Step 2 of the Scenario Technique: Influence Analysis

2.1 What external Areas of Influence outside the Company is Management affected by?

The next task is to find the external areas of influence – but not individual influencing factors – that are significant for management. The following areas of influence have proved relevant in this case:

A Sales markets
B Competition
C Technology
D Society
E Economy

It is not clear just from looking at these headings how the areas of influence will affect management. The next step must therefore be to find the relevant factors within these areas.

2.2 Ascertaining the Influencing Factors within the Areas of Influence

The following influencing factors have emerged as the most prominent:

A – Sales Markets

- Customer structure
- Customer demand for products and services
- Customer attitudes
- Customer behaviour
- Substitution trends in the sales markets

B – Competition

- National and international structure of the competition
- Development of relevant competitors (goals and strategies)
- Competition from substitutes (incomers and substitute products)
- Behaviour of competitors
- Market shares
- Innovative potential

C – Technology

- Information technology
- Development of media
- Possibility of linking different information technologies
- New developments in company administration, management, etc.
- Replacing human work with technology

D – Society

- Demand for self-realisation (both at and outside work)
- Social attitudes to career, profession and leisure
- Professional qualifications
- Attitudes to responsibility and entrepreneurship within the company
- Sociodemographic structure

E – Economy

- Economic development at home and, if applicable, abroad (depending on whether a company is nationally or internationally oriented)
- Economic climate
- Investment climate
- Development of the labour market
- Development of purchasing power
- Development of currency relationships (relevant for exporting companies or those operating abroad)

2.3 Network Analysis

The aim of this step is to discover what types of interaction, interconnection and mutual effect exist between the areas of influence as characterised by their factors. The object is to find which of these areas of influence are particularly active or dynamic and will thus play an important part in the future management behaviour of the company, and which are more passive, in other words, adapt to the active areas. These interrelationships are normally analysed with the aid of a network matrix.

In the network matrix, the extent to which each area influences every other is ascertained from left to right. This results in an active total which states to what extent each area is influenced by all the others. The results of the network matrix (active and passive total) can then be represented as a whole in a system grid in analogue form.

The system grid consists of a vertical active axis and a horizontal passive axis. The limit of the axes results from the number of areas of influence minus 1 times 2 (= maximum possible value on active and passive axis). In this case five areas were analysed [(5 minus 1) times 2 = 8]. This gives a limit of 8 on the passive and the active axis. The point where the active and passive axes cross results from the overall total (all active totals added together and all passive totals added together should give the same value). In this case 24 divided by the number of areas of influence; $24:5 = 4.8$.

	A	B	C	D	E	Active total
A Sales markets	X	2	1	0	0	3
B Competition	2	X	1	0	0	3
C Technology	2	2	X	1	2	7
D Society	2	1	1	X	1	5
E Economy	2	2	1	1	X	6
Passive total	8	7	4	2	3	24

Scale for the network matrix:
0 = No influence
1 = Weak or indirect influence
2 = Strong influence (the influenced area depends heavily on the influencing area)

Figure 7: Network matrix

In this way the system grid is divided into four fields.

The most important field is the top left quadrant which contains the so-called active areas of influence . It may be noted that all elements in this quadrant have relatively high activity but low passivity. This means that they have a relatively strong influence on the other areas but are little influenced by them.

The next most important field is the top right quadrant, the so-called ambivalent field. The areas in this field are characterised by both high activity and high passivity (in this case, however, none of the areas are in the ambivalent field).

The third field is the bottom left quadrant, known as the buffering field. All elements in this field have relatively low activity and relatively low passivity.

The fourth field is the so-called passive field – the bottom right quadrant. All areas located here have relatively high passivity but low activity.

According to the network analysis and the system grid the following areas have emerged as dynamic and active: technology, economy and society. Sales markets and competition, on the other hand, can be regarded as clearly passive.

What does the result of this analysis mean for management? In the external system surrounding management, the most powerful impetus comes from technology, economy and society. This means that in order to stay in tune with its environment, management must orientate itself to the developments existing and coming into being in these areas.

This may be illustrated by those technologies which, with their new opportunities for decentralized working and new ways of monitoring success, are

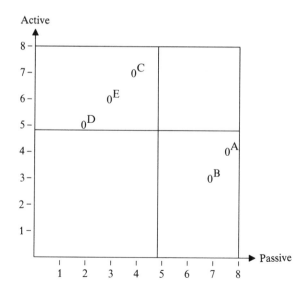

Figure 8: System grid

having a powerful effect on sales markets, competition, economic developments and social values.

The economy (likewise positioned in the active field) provides a framework of conditions within which companies can act, and so a dependent relationship exists for management here too. Experience shows, for example, that in times of economic severity, management styles tend to become more rigid in many companies, though this is not necessarily the case.

The structure, attitudes and behaviour of society affects human potential and the behaviour of managers and managed. This means that society can enable or prevent a company's success in its markets, its competitive behaviour, the introduction of new technologies and also its management style.

Sales markets and competition are heavily influenced by the three active areas, which means that the behaviour of customers and competitors may change as a function of general technological, economic and social conditions.

In many cases, however, it is apparent that sales markets and competition have a strong direct influence on the company itself, while the global areas have a more indirect influence on the company by way of the sales market and the competition.

What this means for a company is that, in respect of management and management styles, the active areas must be carefully observed and new developments – especially in technology and society – taken into account and turned into new management concepts.

Step 3 of the Scenario Technique: Projections

The aim of this step is to work out projections about the future development of the areas of influence on the basis of the influencing factors ascertained in step 2.

People working out future projections often have the feeling that they are up against the limits of their knowledge; they are unable to work out exact predictions as to how certain things are going to develop in the future. Where such uncertainty exists it is important to recognise possible alternative developments, define them in writing and take all the alternatives into account for further processing.

It is also important to state the reasoning for all future projections that are assumptions and not facts.

In the table below some of the influencing factors mentioned in step 2 are projected into the future.

Descriptor	Actual status	Projection 2000

Technology

Information technology	Mature over wide areas; new applications opening up thanks to miniaturisation	Dynamic further development of information technology. Further simplification and reduced cost of hardware and software, opening up new possible applications. Improvement of storage (greater miniaturisation). Increasing interlinking between different DP systems. Further development of expert systems and artificial intelligence
Area of application of information technology	Mainly centralised, but decentralised data input and processing in some areas such as subsidiary companies	2 alternatives: a) Increased tendency towards centralisation due to better security of highly sensitive data; data input mainly decentralised b) Widely implemented decentralisation. All data is entered and processed in decentralised systems and linked by networks

Society:

Social demand for self realisation	Relatively high; the demand increases with the level of education	Continuing to increase due to high levels of education and better information. Self-realisation is accomplished partly at work and partly in leisure time
Attitudes to work and leisure.	Radically changing values; work is no longer everything. Family and leisure move to the fore	2 alternatives: a) Leisure ranks higher than profession or career. Trends towards the leisure society. Self-realisation is accomplished in one's free time (the new hedonism) b) Greater value is attached to work, performance and career; emergence of a new professional elite with a strong technological orientation (tendency towards the information society)

Descriptor	Actual status	Projection 2000
Economy		
Development of the economy	Moderate to relatively good growth in the face of existing structural problems in the economy (too many stagnating and dying sectors with outmoded technologies), relatively high unemployment.	2 alternatives: a) Relatively stable growth; structural problems in the economy solved; economic boom due to new technologies and new sectors that replace the structurally weak sectors
		b) Stagnating economic growth because the structural problems are not solved; the state continues to invest in stagnating and dying sectors instead of in growth areas. The European countries fall further behind the economic and technological leaders (USA, Japan, ASEAN countries)
Unemployment rate	Approx. 9% to 10%	2 alternatives: a) Large reduction in unemployment due to demographic developments. This is reinforced by favourable economic development (emergence of sectors which absorb the labour force freed by rationalisation)
		b) Unemployment rate stagnates at a high level because the weak economic growth is not sufficient to create new jobs that could absorb the labour force freed by rationalisation
Competition		
Structure of the competition	A mixture of large, medium and small companies; the majority of competitors are small companies.	2 alternatives: a) Surge of concentration; multinationals acquire small and medium-sized companies to gain a foothold in regional markets

Descriptor	Actual status	Projection 2000
		b) Small, dynamic, innovative companies dominate; they occupy the market niches not occupied by the large companies
Sales Markets		
Customer attitudes	High expectations in respect of quality and service	Increased expectations in respect of quality and service, with appropriate prices. Service is gaining increasing importance over products, because the competitors are largely comparable in respect of their products

Step 4 of the Scenario Technique: Grouping Alternatives

The aim of this step is to check the various alternatives identified in step 3 against each other for possible consistency in the future and to group them into two basic scenario group structures that meet the following criteria:

– The maximum possible harmony, freedom from contradiction and consistency within a scenario group.

– There should be the maximum possible difference between the two scenario groups.

This consistency evaluation can be carried out both intuitively as a whole, for example by grouping alternatives on a flip chart according to consistency and difference, or by computer.

The consistency evaluation produces the grouping of alternatives in a possible basic scenario A and scenario B structure as can be seen on page 69.

Step 5 of the Scenario Technique: Scenario Interpretation

The aim of this step is to integrate the structures ascertained on the basis of the consistency analysis with the definite, clearly projectable forecasts to form an overall scenario. These scenarios can both be described verbally and charac-

Area of influence	Desciptor	Alternative A	Alternative B
Technology	Use of information technology	Centralised	Decentralised
Society	Attitudes to leisure and work	Leisure orientation	Career orientation
Economy	Economic development (GNP)	Stagnation	Growth
	Unemployment rate	Stagnating at a high level	Falling
Competition	Competitive structure	Concentrated, large companies dominate	Small, innovative companies dominate

terised graphically. The important thing in the interpretation of scenarios is to take into account possible interactions in accordance with the network analysis and system grid of step 2, and include them in the interpretation.

Scenario A

Technology

Advances in information technology bring further drops in hardware and software prices at the same time as opening up new possibilities for storage, networking and access capability. The development of expert systems is largely completed. Artificial intelligence and computer simulation have matured and are capable of being implemented on PCs. Computer-aided design, production, quality control and logistics now represent the state of the art in the form of multi-computer systems.

Decentralised data processing applications have only been implemented to some extent. Decentralised terminals are used primarily for data input, and less for processing complex problems.

The opportunities offered by technology of working at home with a PC are only used by very few, because the need for human contact militates against all isolated work.

Economy

The economic growth rate fluctuates annually between 0.5 and 1.5%. This growth rate is not, however, sufficient for the European countries to keep pace with the economic leaders (USA, Japan, ASEAN states). Urgently needed structural change in the economy fails to materialise, because an inappropriate policy of subsidisation keeps the stagnating sectors alive and provides too little support for growth sectors.

The mood is largely muted, and the mainstays of the economy hope for state aid and better times without themselves showing much commitment to improving the situation. Corporate investment is mainly concentrated on rationalisation rather than on developing new products and methods. The catch-phrase is cost reduction, leading to still more staff being shed. The relatively high unemployment rate is further aggravated by the baby-boom age group looking for training and work. Too few jobs are created in growth sectors, so that the unemployment rate stays at a relatively high level.

Society

Social demands for self-realisation both at and outside work have risen sharply. People who cannot develop their potential at work because of the unfavourable economic situation do so in their free time to compensate, and this leisure orientation is assisted by the decline in annual working hours and the lower retirement age. People join self-help groups and clubs; a large proportion of an individual's energy is devoted to leisure activities of various kinds. Jobs are regarded merely as a necessary money-earning adjunct for financing leisure time activities.

High educational levels cannot be used in appropriate professional positions due to the restricted situation in the labour market and career bottlenecks in many companies. Instead they are used in extraprofessional commitments, individual prestige being sought less through achievement in a career and more through responsible and attractive leisure activities. People try to create meaningful and fulfilled leisure time despite scarce resources.

Competition

The competitive pressure in national and international markets has further increased, and the situation is exacerbated by high quality, low-cost products from ambitious threshold or newly industrialised countries that are putting pressure on the markets of the established industrialised countries. In the face of this pressure many small and medium-sized companies with insufficient ca-

pital, creditworthiness and ability to innovate are forced to retire from competition.

The consequence is a new surge of concentration, because in many sectors the only possibility of survival lies in being absorbed by a large, strong group of companies. Moves towards concentration largely originate from multinationals whose aim is easier market access by acquiring regional companies.

Sales Markets

Customers too are heavily affected by the unfavourable economic climate, and the losers here are ailing companies and sectors. Nevertheless customer expectations of good quality and skilled advice and service at appropriate prices grow.

Scenario B

Technology

Advances in information technology bring further drops in hardware and software prices at the same time as opening up new possibilities for storage, networking and access capability. The development of expert systems is largely completed. Artificial intelligence and computer simulation have matured and are capable of being used on PCs. Computer-aided design, production, quality control and logistics now represent the state of the art in the form of multi-computer systems.

The dynamically developing information sector has a powerful effect on economic stimulation and sales markets.

The possibilities of information technology reinforce the tendency for decentralisation both of information entry and processing and of responsibility. This decentralisation is embodied in a complex network that embraces whole companies and industries. Decentralised working is implemented at first hesitantly, then very successfully. Technological possibilities combined with the social will to achieve, encourage goal-oriented, entrepreneurial, decentralised work.

Economy

Thanks to the impetus provided by technological progress and entrepreneurial, future-oriented economic policies, the growth rate stabilises at about 3-4 % per annum. Growth sectors are consistently encouraged and the subsidies for stagnating and dying industries are massively cut. On the one hand this releases labour and on the other hand it creates new jobs in the sectors of the future.

New careers and training schemes balance the potential of the labour freed as

a result of rationalisation and bankruptcy. A wave of retraining schemes surges through the economy; at the same time companies commit themselves heavily to creating training and study courses, which as a result are much closer to practice. New models of work and working hours are developed, tested and implemented.

There is greater willingness to experiment and take risks on the part of both employers and employees.

Society

With the increasing spread of information technology, economic growth and the more attractive job market connected with this, social demands for self-realisation have increased.

For many people, especially young people, self-realisation means constructive movement and change. The much quoted and evoked professional elite now becomes reality. In the labour market companies find high achievers with excellent training in both technology and management. Members of the new professional elite no longer see themselves as executive employees of a company, but as highly responsible, highly competent entrepreneurs within that company who are willing to take risks.

Taking calculated risks, daring to try out new things, implementing innovations, practising participative communication - these are the values of the new management generation. These managers are adept at using all the opportunities offered by technology to rationalise their work and so still have time left over for their personal relationships, children and leisure activities.

Competition

In spite of increasing competitive pressure in all markets, the European countries succeed in maintaining and expanding their position by concentrating on high technology, know-how, and intelligent services.

At the same time, small innovative companies spring up in many fields and occupy hitherto unnoticed market niches with their good ideas. Since the implementation of new technology, general economic growth and a high degree of specialization have increased the need for consultancy services, it is mainly in the service sector that new companies are founded.

Sales Markets

Customers expect not only high quality but also good implementation and advice. The requirement for tailored solutions will be met less by the large established companies than by small, specialist providers with outstanding expertise.

Step 6 of the Scenario Technique: Consequence Analysis

The aim of this step is to derive consequences for management on the basis of the two scenarios. From this consequence analysis a synthesis is produced; this synthesis concentrates on those aspects that can be realised within the frameworks of both scenarios. Some of the possible consequences for management that can be realised in both scenarios are listed below.

6.1 Consequences for Future Work Organisation

- Using all available techniques for improving information logistics and company planning, such as
 - CAI (computer-aided information)
 - CAP (computer-aided planning)

- Constructing a system of information logistics, in other words, treating all information coming into, used in or going out of the company like a logistical system.

- Using expert systems and artificial intelligence instead of time-consuming and costly consultations with specialists.

- Setting up a decentralised management system on a trial basis, for example, by setting goals and defining strategies for reaching these goals within a project framework, and otherwise allowing staff maximum freedom to organise themselves within this framework. The consequence of this will be a move away from rigid nine to five office hours and towards individual hours which suit personal efficiency peaks, it being well known that morning and evening people work to their own individual rhythms. Communication is ensured with electronic media.

- Attractive job-sharing models for jobs and places on training schemes.

- Creating a system of tutoring in which older management staff leave the rank and file and operate as full-time or part-time career advisers for the up-and-coming management generation.

- Job rotation with the aim of increasing skills, motivating staff and improving information exchange. This can take place within a company, a group, or between suppliers and customers or associated companies.

- Operating pools of employees or specialists among several companies; deploying staff in these different companies as required.

- Scheduling more flexible working hours that enable both spouses to take turns at looking after the family, by working partly centrally, partly with a work station at home.

- Flexible personnel requirement and career planning, for example, using managers in a specific function for specific time (troubleshoooters or innovators).

- Rotating managers with special skills in ways that suit their personality, such as using crisis managers to solve problems in specific areas, or dynamic innovators to develop and carry through new systems, products, and business units.

- Decentralising tasks and responsibility for personnel and costs, with a corresponding share by staff in success.

6.2 Consequences for Staff

- Staff participation models, for example, financial schemes, changes in company policy, organisational schemes.

- Involving staff more in the formation of company strategies, in organisational development and in job design with appropriate financial and non-financial incentives while at the same time increasing their willingness to take risks within a clear framework.

- Promoting staff idea competitions and publicly recognising the best proposals once a year.

– Long-term skill and career planning to suit individual staff qualifications and requirements and company needs.

– Increasing staff acceptance of decisions by applying the Japanese model in a modified way.

6.3 Consequences for Further Training

– Diversification of further training, in other words training not one-track specialists but "hybrid" experts who are at home in several specialist fields and are at least familiar with and capable of assessing some related fields.

– New methods of further training: 'model-based' training methods (supported by seminars and computers) and 'on the job' learning with knowledge transfer (employees training their fellow employees).

– Retraining, job-sharing or part time working instead of redundancy, or help in looking for a new job.

– Further training of management staff:

 – Consistent, comprehensive computer-assisted training in information technology, communications, and simulation to clarify management problems.

 – Training management staff to think and act in interconnected systems (networks): managers learn to apply leverage at that point in the system where it will have the greatest effect, the aim being optimal exploitation of rationalisation and synergy effects while still taking company and staff interests into account.

 – Further training of management staff in optimum use of person-machine and person-to-person communication (the more technology, the more important is personal contact, discussion and motivation; in the words of John Naisbitt: "the more high tech – the more high touch").

– Training in innovation, acquisition and fusion management.

– Survival and crisis training.

6.4 Consequences for Management

– Using the time gained through consistent application of information technology for staff discussions, advising staff on career planning and staff motivation

– Reinforcing the feeling of belonging to the company so as to promote assertiveness against outside competition

– Improving the climate of innovation by increasing credibility and readiness to take risks (within reasonable limits it is permissible to make mistakes from which lessons can be learned for the future)

– Creating an anxiety-free atmosphere in which all those involved can learn from the mistakes that are made

– Motivating staff towards common objectives and clarifying the long-term company orientation (leading personalities with charisma and vision)

– Seeing management and problems as a task and a challenge

6.5 What are the Tasks of Management in the Future?

– Recognising and utilising the company/organization system and the surrounding environmental system; this means using the most dynamic factors internally and externally to further the objectives and letting them work for the company

– Taking justifiable risks within a clear framework, trying out new approaches, and granting the right to make mistakes

– Pointing to visions of the future and making them reality jointly with the staff

Step 7 of the Scenario Technique: Analysis of Disruptive Events

The aim of this step is to analyse abruptly occurring external and internal events that can change and adversely affect the scenarios and the subject under discussion, i. e. management.

After the main disruptive events have been analysed, their effects are worked out so as to obtain a picture of possible changes they could cause. Preventive measures designed to avoid or prevent such disruptive events are then worked out, and so-called response plans or crisis plans made.

No further attention will be given to disruptive events here.

Example II: The Car Industry

This example is not tailored to a particular manufacturer but concerns the general situation of the motor car.

Step 1 of the Scenario Technique: Task Analysis

1.1. Description of the Actual Situation of Cars

– The motor car is an individual and very widely distributed means of transport in western Europe and the USA

– It is a high value commodity and to some extent a status symbol

– Cars need an infrastructure of roads, motorways, parking places and garages

– The car industry is an important factor in the economy, every seventh job in the Federal Republic of Germany being dependent on cars

– Cars are a means of expressing personal mobility and individuality; different types of car correspond to different scales of social value

1.2 Strengths and Weaknesses of Cars

Strengths

– Cars are a personal means of transport

– The car industry is an important employer and customer for many supply sectors

– Cars are a symbol of technological progress

- They provide personal mobility

- They benefit the national economy

- They express personal scales of value such as sportiness, comfort, transport of goods and passengers, prestige, economy, etc.

Ambivalent Aspects

- Cars have only limited reliability (complex system, short life)

- Cars function as technological toys offering prestige and individual freedom

- Cars are subject to fashion and its fluctuations

- Cars act as status symbols for the affluent society

etc.

Weaknesses

- Cars use energy inefficiently

- Their raw material consumption is high

- They limit disposable income.

- To some extent they cause personality changes (aggressiveness of car drivers)

- Cars need roads and parking spaces

- Car exhaust fumes pollute the environment

- The infrastructure needed for cars (roads, motorways) results in destruction of the landscape

etc.

1.3 Horizons

To allow for the long development times in the industry, the following scenario horizons were set:

- End of the eighties
- 2000
- 2010

Step 2 of the Scenario Technique: Influence Analysis

The aim of this step is to define the external areas of influence affecting the subject of investigation – the car – to extract and assess the influencing factors in each area, and to work out the interrelationships between the areas.

2.1 Defining the External Areas of Influence

A Legislation
B Economy
C Consumers/Society
D Technology
E Competition from substitutes

2.2 Ascertaining the Influencing Factors within the Areas of Influence

A – Legislation

- Taxation
- Road traffic legislation
- Driving licence qualification
- Vehicle test
- Registration

B – Economy

- Disposable income
- Standard of living
- Operating costs
- Infrastructure
- Unemployment rate

C – Consumers/Society

- Mobility requirement
- Demand for quality and convenience
- Demand for safety
- Image of the car in society

D – Technology

- Materials development
- Energy technology (drive systems and energy sources)
- Safety engineering
- Electronics
- Production engineering

E – Competition from Substitutes

- Local public transport
- Long-distance public transport
- Bicycle
- Air travel

2.3 Establishing the Interrelationships between the Areas of Influence

The influence analysis instructions need not be repeated here as they have already been fully described in the "management in the future" example.

2.4 Interpretation of the Network Analysis and the System Grid

In first place is area A (legislation), and in second place comes area D (techno-logy). These two areas are in the active field (relatively high influence on the overall system but low susceptibility to being influenced by all other elements). In third place follows area C (society) and in fourth place area B (economy). Areas C and B are in the ambivalent field. This means that they both have a powerful influence in the system and are themselves relatively strongly influ-enced by the system. In fifth position in the passive field is E (competition). This field is very strongly influenced by all the others but itself influences the system very little.

 For a company in the car industry, this order of rank means that it should carefully observe legislative developments in the environment of the personal motor car and, if necessary, anticipate developments. In some instances the technological area can be actively influenced by car manufacturers, and if this

	A	B	C	D	E	Active total	→ Car	← Car
A Legislation	×	2	1	1	2	6	1	0
B Economy	1	×	2	1	2	6	2	2
C Users/ society	2	2	×	1	1	6	2	2
D Technology	0	2	2	×	1	5	2	2
E Competition from substitutes	0	1	0	0	×	1	1	2
Passive total	3	7	5	3	6	24 : 5 = 4,8		

Scale for the network matrix
1 = No influence
2 = Weak or indirect influence
3 = Strong, direct influence

Figure 9: Network matrix

is not possible (use of other technologies) a company should then strive to integrate existing technologies into car construction. As far as the areas of society and economy in the ambivalent field are concerned, car manufacturers must observe the trends and behavioural patterns in society and the framework of economic conditions very carefully in order to develop appropriate long-term concepts.

The aim of the system analysis is to filter out which areas are the driving forces of the system so that these driving forces can be used to implement company goals and strategies. Leverage must deliberately be applied at points where with little strategic expenditure the greatest possible synergy or reinforcement effect can be achieved. If a company decides to influence areas in the passive field, this is certainly possible, but these areas cannot be expected to become active for the company as they behave relatively passively.

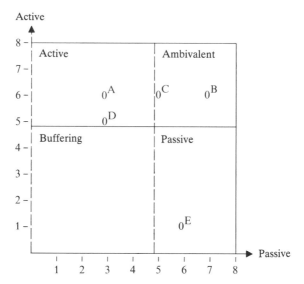

Hierarchical order of the areas:
1 = A Legislation
2 = D Technology
3 = C Society
4 = B Economy
5 = E Competition from substitutes

Figure 10: System grid

Step 3 of the Scenario Technique: Projections

The aim of this step is to work out projections about the future development of the areas of influence on the basis of the influencing factors ascertained in step 2.

People working out future projections often have the feeling that they have come to the limits of their knowledge and will be unable to work out exact predictions as to how certain things are going to develop in the future. Where such uncertainty exists, it is important to recognise possible alternative developments, define them in writing and take all the alternatives into account for further processing.

It is also important to state the reasoning for all future projections that are assumptions rather than facts.

In the table below some of the influencing factors mentioned in step 2 are projected into the future.

Descriptor and actual status	Projection 2000 and reasons	Projection 2010 and reasons
Legislation		
Taxation: varies from country to country (e. g. luxury tax in Austria); indirect taxation through high fuel costs	2 alternatives: a) Taxation cannot be further increased due to social pressure (car continues to be status symbol and important for mobility) b) Heavy tax increases to reduce the number of vehicle registrations and restrict imports	2 alternatives: a) Reduction of tax which is in part very high; standard vehicle tax; ownership of a car is taken for granted in society b) Taxation continues to be extremely high, because the state regards vehicles as an ideal cash cow
Road traffic legislation: regulations extended; but adherence to the regulations and knowledge of the road traffic law lag behind legislation	Further expansion of the regulations due to increasing traffic	2 alternatives: a) The road traffic legislation regulations have reached their high point and are more and more adapted to general technological developments; road safety is an important part of primary education b) The road traffic legislation becomes to some extent superfluous due to technical control systems; parts of the legislation are dismantled
Driving licence qualification: the test system lags behind actual requirements; training for the driving licence qualification is given privately by driving schools, the test is held by state institutions	Greater orientation in training to practical requirements	2 alternatives: a) Driving test no longer relevant because of an ingenious system of traffic observation and points allocation in accidents; driving skills are part of school education

Descriptor and actual status	Projection 2000 and reasons	Projection 2010 and reasons
		b) Strict testing training, and supervision both by state and private organisations; training for practical conditions with simulators in driving schools
Vehicle roadworthiness test: regular vehicle checks in various European countries	2 alternatives: a) The scope of the test increases due to environmental awareness; aspects relevant to the environment are included in the vehicle test b) The test becomes irrelevant to some extent due to technological developments and regular checkups in workshops.	2 alternatives: a) Tests are made easier by new technology b) Electronic diagnosis and self-repair systems replace former regular checks
Registration: relatively high	Simplified registration due to increasing use of DP and networking	2 alternatives: a) Scope of registration increases so as to prevent criminal offences in connection with cars b) No more personal registration because cars are common property
Technology		
Vehicle materials: current materials: iron (which rusts), high weight; plastics, light alloy, materials that are liable to break down; general multiplicity of materials	Increased replacement of components with short life; less use of high weight materials that rust; increase in plastic and ceramic materials	2 alternatives a) Heavy increase in plastics due to advances in R&D in this area (improved surface finishing, greater loading capacity, plastics that meet requirements due to "tailor-made materials")

Descriptor and actual status	Projection 2000 and reasons	Projection 2010 and reasons
		b) New materials dominate, especially fibre-reinforced materials and materials not yet known; decline of traditional materials in vehicle construction
Energy: adequate availability but low efficiency (approx 10 %) and low energy density	2 alternatives: a) Energy continues to be available in sufficient quantities; efficiency increases to 20 % b) Energy supply bottlenecks; improvement in efficiency of energy use (approx 50 %); alternative energy sources begin to be used	2 alternatives: a) Enough new types of energy and energy production methods including alternative sources of energy available; increase in efficiency (60 % to 70 %) b) Energy becomes a luxury commodity; further increase in energy efficiency to approx 80 %; alternative energy remains stuck in infancy
Safety: only passive safety systems exist in cars with appropriate bodywork, seat belts, to some extent air bags and antiblock systems	2 alternatives: a) Increase in passive safety in cars by improved design; start of active safety in cars (adapting technology to suit humans) b) Passive safety with heavily restrictive measures (safety acts outwards)	2 alternatives: a) Human error in respect of safety is virtually eliminated by control systems; safety becomes more active and remote controlled b) Passive safety dominates because the car no longer plays a leading role due to environmental problems

Descriptor and actual status	Projection 2000 and reasons	Projection 2010 and reasons
Electronics in vehicles: control systems for engine and brakes; transfer of conventional functions (diagnosis systems, etc.)	2 alternatives: a) Use of duplex systems; transfer of additional functions (not only fault diagnosis but also fault rectification); start of external control systems b) Development as in (a) but very much slower	2 alternatives: a) Fully automatic monitoring systems (diagnosis and repair) for vehicle operation are state of the art. Electronic navigation and steering for motor vehicles are reality thanks to complex communications systems (autopilot); existing air navigation systems transferred and adapted to cars b) Only little electronics research and development on vehicles, because the car is no longer a central economic and social topic
Production engineering in the vehicle sector: CAD/CAM largely implemented; flexible automation; dangerous jobs in manufacturing have been replaced by machines	2 alternatives: a) CIM widely implemented due to the low-cost and individually flexible manufacturing possibilities b) No significant improvement over the current status, because the automobile industry has lost its function as a key industry and no great investment can be expected in this sector	2 alternatives: a) Start of individual influence on design (lot size 1 is reality); users state their requirements to the car industry at home by electronic communication media and obtain an individually developed vehicle b) See 2000; beginning of disinvestment in the vehicle sector

Descriptor and actual status	Projection 2000 and reasons	Projection 2010 and reasons
Consumers/Society		
Mobility requirement: high	2 alternatives: a) Decreasing due to improved town planning and flexible job patterns b) Increasing leisure time and need in society for personal mobility	2 alternatives: a) Low mobility requirement due to improved traffic planning, communication development and changing social values b) Very high mobility requirement because of the need for contact and individual life and leisure time planning.
Quality and convenience expectations not yet adequately met	Rising expectations; increase in personal desire for quality and convenience and increasing restrictions	2 alternatives: a) Cheap single-purpose cars dominate due to the critical economic position and changing values in respect of cars b) Rising expectations due to high mobility requirements, growing incomes and need for self-realisation with the motor car
Vehicle safety expectations: not satisfactorily met	Rising expectations due to high traffic density, increased risk of accident and increasing sense of personal responsibility	Safety expectations continue to increase due to high technologisation (safety requirements can to some extent be met with technology)

Descriptor and actual status	Projection 2000 and reasons	Projection 2010 and reasons
Image of the car in society: split; views range from condemnation of cars as destroyers of the environment to their glorification	2 alternatives: a) Cars continue to be an object of prestige and means for individual mobility b) Green policies gain ground; cars are condemned as environmentally destructive	2 alternatives: a) New vehicle concepts thanks to new technologies; energy is used in ways that are less harmful to the environment; therefore cars are socially accepted b) Communal means of transport dominate; cars are no longer objects of prestige; ecologically oriented policies widely accepted

Economy

Disposable income: at present relatively high	2 alternatives: a) Increasing due to continuous economic growth b) Falling slightly due to economic problems (inadequate structural change, technological lead of the USA, Japan, and ASEAN countries)	2 alternatives: a) Rising due to technological boom and successful structural change; boom in accompanying services and information technology b) Incomes still falling due to economic problems; introduction of a basic income not related to output
Standard of living: high on average	2 alternatives: a) Polarisation between high living standard and lower living standard; middle ground thins out due to structural changes in society b) Levelling out downwards due to legislative intervention and inadequate economic growth	2 alternatives: a) Further polarisation, rich and poor in society drift away from one another b) Levelling out enshrined in legislation

Descriptor and actual status	Projection 2000 and reasons	Projection 2010 and reasons
Car operating costs: relatively high proportion of available income	2 alternatives: a) Increasing due to taxation and high cost of safety engineering and environmental protection	2 alternatives: a) Rising drastically; car driving is now only a privilege for the rich
	b) Decreasing due to falling energy prices	b) Heavily falling operating costs; free travel, cars are regarded as common property
Infrastructure: variable in the different European countries; especially good in the Federal Republic of Germany	Infrastructure extended but no longer to the same extent as in the fifties and sixties	Less quantitative but rather qualitative growth of infrastructure as a result of environmental aspects and new technologies
Unemployment rate: relatively high in all European countries	2 alternatives: a) Falling due to reduced working hours and new jobs created by the economic boom	2 alternatives: a) Low unemployment rate due to successful structural change, economic growth and new values in respect of work and leisure
	b) Unemployment rate rising steeply due to automation and inadequate economic growth (growth sectors cannot offset rationalisation by the industrial sector)	b) Unemployment rate relatively high due to structural unemployment

Competition from Substitutes

Air travel: Small share of regional and local travel, larger share of long-distance travel	2 alternatives: a) Distribution the same due to competition from long-distance public transport	2 alternatives: a) The same, or slight expansion in air traffic due to economic growth and expansion of the air traffic network

Descriptor and actual status	Projection 2000 and reasons	Projection 2010 and reasons
	b) Falling due to poor economic situation, energy problems, and to some extent substitution of business travel with communication sytems	b) Falling due to competition from the other long-distance transport systems
Local public transport: inflexible, relatively expensive and unprofitable, not individual enough	2 alternatives: a) Substantial expansion towards better connections and greater flexibility (city bus which can be ordered in advance by telephone); individualisation of local transport systems b) Slight improvement against the present situation with extended route network and greater frequency	2 alternatives: a) Individual cabin system with electronic ordering and individual electronic billing (drawing board systems of the 80's are now reality) b) Marginal improvements over the year 2000
Long-distance public transport: relatively inflexible, slow and too expensive; start of high-speed trains, e. g. in France, Japan and other countries	2 alternatives: a) First experiments with container systems for rail and road; expansion of high-speed trains b) Only marginal improvements over the present status	2 alternatives: a) Individual long distance transport system (individual units independent of wheel and rail) b) Amalgamation of car and public transport (car as piggyback system on rail)
Bicycle: mainly for sport; used in rural areas and as a means of short-distance transport	Bicycles continue to be mainly for sport, due to lack of infrastructure; increase in inner city areas	2 alternatives: a) Bicycles continue to be limited to sporting activities b) Bicycles become a competitive factor in local transport (society more sport oriented, and lack of resources for cars)

Step 4 of the Scenario Technique: Grouping Alternatives

The aim of this step is to check the various alternatives identified in step 3 against each other for possible consistency in the future and to group them into two basic scenario frameworks that meet the following criteria:

a) Maximum harmony, freedom from contradiction and consistency within a scenario group.

b) There should be the maximum possible difference between the two scenario groups.

This consistency evaluation can be carried out both intuitively as a whole, for example, by grouping alternatives on a flip chart according to consistency and difference, or by computer.

The consistency evaluation produces the following grouping of alternatives into a possible basic scenario A and scenario B structure:

Area of influence	Descriptor	Scenario A	Scenario B
Legislation	Taxation	Reduced	Extremely high
	Road traffic legislation	Superfluous	Necessary
	Vehicle test	Test inapplicable	Test
	Registration	Rising	No individual registration
Technology	Materials	New materials dominate	Plastics dominate
	Availability of energy	Adequate	Scarce
	Safety engineering	Rising	Unimportant
	Electronics	Autopilot	No longer an important subject
	Production techniques	Total flexibility	No longer an important subject
Society	Need for mobility	Very high	Low
	Quality and convenience expectations	High expectations	Cheap, basic car

Area of influence	Descriptor	Scenario A	Scenario B
	Image of the car	Good (new personal vehicle concept)	Now a local means of transport only
Economy	Income	Rising	Falling
	Standard of living	Polarisation	Levelling down
	Operating costs	Falling	Rising
	Unemployment rate	Falling	Rising
Competition from substitutes	Local public transport	Status quo	New systems
	Long-distance public transport	Car dominates	Long-distance transport systems dominate
	Bicycle	Falling	Rising
	Air travel	Increasing	Status quo

Step 5 of the Scenario Technique: Scenario Interpretation

The aim of this step is to integrate the structures ascertained on the basis of the consistency analysis with the definite, clearly projectable forecasts to form an overall scenario. These scenarios can be either described verbally or characterised graphically. The important thing in the interpretation of scenarios is to take into account possible interactions in accordance with the network analysis and system grid of step 2, and include them in the interpretation.

Scenario A

Legislation

High taxation is reduced due to social resistance; the car is no longer society's cash cow, but a realistically regarded though important factor in economic growth. As a result of using new technology, the car has become environmentally sound and is no longer condemned as harmful to the environment. Luxury, environment and danger taxes are no longer levied.

The road traffic legislation is largely replaced by control systems. Improved knowledge about causes of accidents and human error leads to safety systems

both inside and outside the car. A new infrastructure for controlling road traffic similar to air safety systems develops.

The driving test becomes an operator's test that is based on conditions found in practice and uses simulators, improved system comprehension and comprehensive technical support.

The former vehicle test is replaced by active systems installed in vehicles featuring remote diagnosis, internal checks and self-repair and fault elimination capability. For serious faults there is automatic reporting by the vehicle safety system to the control centre and automatic vehicle disconnection.

Registration continues to be personal and is rationalised by using data processing systems and decentralised registration, for example, via videotex and home computers. The networked systems enable continuous checking of user authorisation and user monitoring. All types of traffic offence can be recognised and monitored by the system.

Technology

Materials development has made dramatic progress; new "tailor-made materials" which can be regenerated now predominate. Customers can personally influence the design and form of vehicles. Regenerating materials are used; light construction predominates, special attention being paid to environmentally harmless materials. Basic long-life vehicle designs with modular replacement parts are now reality. The new technologies mean that car maintenance and servicing have been reduced and are now considerably simpler.

The efficiency of energy use has been optimised and much improved; cars have an energy store. The ceramic/carbon fibre engine is now reality. Low weight electric engines are predominant in local transport. To some extent solar energy is converted into energy for vehicles.

Safety has been considerably improved by an autopilot system. Thanks to control systems, cars can drive virtually without being steered. Safety is largely controlled externally by induction loops coupled with autopilot and navigation instruments. Electronic systems have proved their worth and are a permanent feature of cars; they undertake all the operational and technological control, fault diagnosis and fault elimination, and provide support for the driver or recommend suitable routes.

Lot size 1 has become a production reality. Designs are determined individually by customers and CAD systems calculate all other data not defined by the customer.

Society

Mobility needs in society continue to be high. Vehicles do high mileages and traffic density increases. Thanks to technological support, fatigue effects can be prevented. Individual mobility has been optimised. The demand for quality and convenience has considerably increased. The vehicle industry adjusts itself to meet these individual requirements.

Cars have become one of the safest means of local and long-distance transport thanks to the possibilities of technological control.

Cars continue to have a very good image, and a car is regarded as a self-evident basic requirement. New techniques such as modular construction, etc., mean new car concepts such as flexible cars that can be adapted to individual and family needs.

Economy

Purchasing power in society continues to develop positively thanks to healthy economic growth, successful structural change, and the boom in new technology and accompanying services. A car is still within the means of all. Living standards are polarised into relatively low and relatively high incomes, and the middle ground has further thinned out. But because cars still represent an important social value, all social strata consider it desirable to own one. Depending on income, either a luxury car or a basic car is preferred.

Operating costs for vehicles have fallen due to energy saving design and more efficient energy utilisation. Manufacturers are producing designs that simplify maintenance and servicing and hence also reduce costs.

The unemployment rate has fallen due to reduced working hours and positive economic development (high technology and transfer of expertise to other countries). This development is encouraged by demographic developments.

Competition from Substitutes

Local public transport has developed dynamically with individual cabin systems and piggyback systems for car and rail. The same development can be seen in long-distance public transport, so that cars can easily be transported by rail. Compatibility between the various transport systems has been improved by innovative solutions.

Bicycles continue to be used mainly as sports equipment, separate bicycle lanes and bicycle zones being expanded in inner city and rural areas.

Air travel becomes the main means of long-distance transport, transporting cars in aeroplanes being now easier and cheaper.

Scenario B

Legislation

Due to further visible environmental damage, environmental awareness has a higher status in society and the economy. Heavy legislative interventions in the car industry lead to a reduction in road traffic. Road traffic legislation is taught at primary school level. Driving tests using simulators are also reality. The vehicle test covers the whole car, but has been made simpler and more consumer-friendly by technology. Because of legal restrictions on traffic and unfavourable economic developments the number of new registrations falls considerably.

Technology

Plastic has made strong headway in what remains of the future potential for cars. The trend is towards easier processing with modular construction using interchangeable components. Expenditure on energy is improved by considerably increased efficiency. Energy consumption falls due to the lower number of vehicles.

The topic of safety has become unimportant because the number of cars has been very much reduced due to the legislative measures. Research and development is only carried out in the area of passive safety.

Electronic systems have won through in test procedures and in fault diagnosis and elimination, but there is no dynamic development in the field of car electronics.

Only rationalising investments are made in car manufacture, because the car industry has lost to other sectors its function as an important economic factor.

Society

Mobility needs are still very high, but people are trying to implement this mobility without using cars, in other words, with bicycles and other environmentally harmless means of transport. People driving cars either use a so-called ecocar, or a high value car with integral environmental protection.

User safety demands have increased, though attempts are made to achieve safety with less use of electronics.

The image of the car has suffered greatly, partly because of legislative restrictions and environmental awareness, and there is polarisation between cars and environmental protection. Simple mass means of transport predominate; cars are seen rather as a communal means of individual transport and are regarded as general property and used by all, luxury being reduced to a minimum.

Economy

Real incomes fall due to poor economic growth. To cover basic needs a basic income not dependent on output is agreed in many countries. Standards of living are likewise characterised by a policy of redistribution (basic income not dependent on output). Fixed prices for basic foodstuffs, rents and other basic needs are set.

Operating costs for vehicles have risen further so that individuals can now scarcely afford vehicles, but so-called vehicle owner associations are set up which operate cars and use them jointly.

The unemployment rate has risen further because of automation. Despite favourable demographic developments, labour shed by industry cannot be employed in other sectors. The state intervenes to some extent with employment programs.

Competition from Substitutes

Local public transport continues to develop, but there is no incentive to improve it significantly because there is no alternative available; it has a quasi-monopoly.

Long-distance public transport is expanded with state subsidies; an important aspect of transport policy is to largely ban cars from the road and to contain the environmental problem caused by cars.

Bicycles are a genuine alternative to local public transport for short distances and are not only used for hobby purposes.

The amount of air traffic falls due to a worsening economic situation and is partly replaced by telecommunications media. This especially applies to business travel.

Step 6 of the Scenario Technique: Consequence Analysis

The aim of this step is to derive consequences for the car industry on the basis of the two scenarios. From this consequence analysis a synthesis is then produced; this synthesis concentrates on those aspects that can be realised within the frameworks of both scenarios. Some of the possible consequences for the car industry are listed below.

Consequence analysis for scenario A (measures / activities)

– Standards and legislative actions force modular construction and customer-oriented specifications (prizes for customers who express their wishes and make proposals for improvements)

– Development of environmentally neutral concepts in respect of propulsion, materials and other wearing parts of cars

– Cars are more individually matched to needs, with for example young people's or senior citizens' cars, family cars or goods cars. These car designs can be modularly interchanged, for example, from a one-person car to a family car to a goods car.

– New materials in vehicles may be used ("tailor-made materials")

– Research and development cooperative ventures in respect of new "tailor-made materials" and fibre-reinforced plastics

– Lobbying with local and long-distance public transport

– Cooperation with electronics manufacturers in developing control systems and integration in cars (cooperation with the aerospace industry for transferring navigational concepts already available there to cars)

– Joint development with an electronics manufacturer for an optimum control system and optimal safety for individual transport

– Development of cars into communication centres by integrating personal computers and on-line networked systems, since if drivers are controlled by control systems they have time for other things

Consequence Analysis for Scenario B

– Research and development on environmentally neutral cars without harmful substances, noise, with low energy consumption, flexible and adaptable interior construction and multifunctionality

– Translation of R & D concepts into active and passive safety

– PR campaigns for environmentally harmless cars by lobbying (presenting the ecocar concept to legislators as a standard and thus influencing the setting of standards)

– Presenting the car as a environmentally harmless means of personal transport

– Promoting traffic simulators for all types of school

– Countering the contraction of the vehicle market with an ecological car concept

– Using electronics for detecting and eliminating faults and environmental problems

– Installing recyling processes in cars such as for exhausts, waste heat, combustion residues, etc.

– Implementing the concept of preventive instead of passive environmental protection in cars

– Cooperation with various materials developers

– Testing pilot materials

– Cooperation with energy companies

– Offering the company as a pilot company for testing and optimising new types of energy in cars

– Designing cars as simply as possible with modular components (modular construction system for factory production and DIY car building or conversion); these modular parts can be interchanged in the event of accidents

– Developing an environmental simulator for the vehicle testing authority and legislative institutions: simple self-regulation system

– Using modern production plant, if necessary, by leasing (CIM)

– Lobbying with local and long-distance transport operators to combine car with rail and possibly air transport

Step 7 of the Scenario Technique: Analysis of Disruptive Events

The aim of this step is to analyse abruptly occurring external and internal events that can change and adversely affect the scenarios and the subject under discussion, i. e. the car industry.

After the main disruptive events have been analysed, their effects are worked out so as to obtain a picture of possible changes they could cause. Preventive measures designed to prevent the occurrence of such disruptive events are then worked out, and so-called response plans or crisis plans prepared.

In this example the subject of disruptive events will not be further described.

Step 8 of the Scenario Technique: Master Strategy

On the basis of the various consequence analyses for scenarios A and B, an approach is made to formulating a master strategy as follows:

Provisional Master Strategy

1. General Orientation

– Two fundamentally different product lines

a) A top-of-the-range family of vehicle products (luxury, convenience, high-tech, preventive environmental protection)

b) A bottom-of-the-range family of vehicle products (basic, value for money, environmentally neutral, DIY)

– To suit these two different product concepts, form two companies – possibly under a common holding company – with different corporate identities, sales, service, marketing, publicity, etc.

2. Research and Development

2.1 Environmental Protection in Cars

– Environmentally neutral tyres (new material)

– Use old oil and other solids such as biomass and organic wastes to manufacture biofuel

– Develop a ceramic carbon fibre engine

– Develop fuels without exhaust fumes and harmful substances, including designs for using hydrogen, solar fuel and biofuel

- Implement recycling processes in cars (reconditioning and transforming all residual substances, gases and liquids that occur)

2.2 Safety in and on the Car

- Improve passive safety with, for example, air bags, new antilock systems, collapsible and regenerable materials

- Improve active safety with sensors for distance measurement and simultaneous automatic speed matching; control and navigation systems (if necessary, carry out trials with electronics developers for control and navigation systems)

- Improve operational reliability with electronic monitoring, diagnosis and self-repair if faults occur (design fault diagnosis and elimination as a control loop)

- Design the operational reliability systems for cars to suit the two basic product lines, with greater or less expenditure and greater or less use of electronics

2.3 Product Development

- Two basically different product lines (see point 1)

- Modular construction including DIY kits

- Interior fittings to suit fashion and individual requirements (replacement modules)

- Develop cars into mobile communication centres with radio, PC, telephone, facsimile

- Provide for easy attachment and removal of car parts, for example, by docking for loading

- Cars compatible with other traffic systems (shuttle, piggyback, docking facilities, etc.)

- Within the two basic lines, individual car designs for specific target groups such as:

Senior Citizens' Car
- Easy to get in and out
- Analogue rather than digital displays
- Enlarged displays
- Automatic handles
- Acoustic signalling

High-Tech Car
- Fully electronic means of transport with all electronic communication media on board

Ecocar
- Degradable materials
- Recyclable components
- Use of biofuel
- Minimum discharge of harmful substances

2.4 General R & D Aspects

- A monitoring system to observe technology, energy, safety and environmental aspects

- Cross licensing, with observation of international developments in Japan, USA, newly industrialised countries and ASEAN countries

3. Diversification

- Diversify into
 - Road safety education
 - Environmental safety with the aid of simulator programs

- Diversify into components development (can be used in other products and means of transport)

- Develop and manufacture environmental products and systems such as retrofittable kits for the short term, and new systems for transport and the environment in the medium to long term

4. Cooperative Ventures

– Cooperate with companies with expertise in fields that are complementary to car construction

– Cooperate with developers of materials, electronics, energy technology, high-tech, aerospace, biotechnology, safety systems, other appropriate industries, incomers to the car industry, R & D institutes, suppliers, consumer groups, environmental organisations, etc.

– Joint development work, for example, by networking all CAD systems of associates such as suppliers, manufacturers of other traffic systems and car companies

– Mutual testing of new developments in materials, engines, gears, energy systems, etc; availability as pilot users for new developments

5. Production

– Use the most up to date production technology (CIM)

– Modular, flexible, low cost production

– If necessary, lease high investment production plant

– Preventive environmental protection in production with recycling and avoidance of harmful residues

6. Lobbying

– Influence standardising institutions such as legislators in the direction of separate standards, for example, by offering legislators active environmental protection concepts developed for cars and getting these to become a standard

– Lobby jointly with associates in cooperative ventures

– Hold events to find out customer and legislator requirements (if necessary, with help from psychologists)

7. PR

– Provide explanations and information on the reliability of environmental protection systems in cars

– Win over opinion formers and multipliers in society

– Change social consciousness: cars actively contribute to protecting the environment with environmentally harmless systems

8. Marketing

– Two basically separate selling methods corresponding to the:

– Top-of-the-range: direct selling (personal and electronic), ascertain individual customer requirements, customer specification of the design (transmission by computer)

– Bottom-of-the-range: direct selling (mainly electronic), use of environmental associations, DIY clubs and communities

Example III: The Retail Company

Step 1 of the Scenario Technique: Task Analysis

Starting situation:
In recent years a retail company operating as a chain of department stores with 12 branches in south Germany, 8 of which are on the outskirts of town and 4 in city centres, has experienced slightly falling profits while at the same time turnover rose by about 2 %. Costs have risen as a result of rationalisation and modernisation measures and higher personnel costs.

The company outlook tends to be conventional and conservative. All departments normally found in a department store are represented, and the main target group is the well-to-do middle class which includes few young people.

The company has a well run and comprehensive data processing department, a central purchasing department and a separate import department. The sales personnel consists mainly of very well-trained staff, close personal attention to customers being a typical characteristic of this company.

The company's competitors are specialist shops, specialist chains and large department stores.

The market share lost by the company has gone to the specialist chains (mainly franchise concerns) and department stores run on the "shop in a shop" principle.

The ever increasing pressure of competition is forcing the company both to rationalise internally and to rethink its range of goods and services.

The management has therefore proposed a systematic examination of the company's opportunities and risks with the aid of the scenario method.

1.1. Company Image

– The company sees itself as a retail company with a customer oriented range of goods and services

– Continuous long-term profit optimisation is preferred to short-term maximisation

– The company sees itself as a leader in respect of services and quality; outstanding customer service and special service for regular customers are also part of the company's self-image

1.2. Goals and Strategies

Goals	Strategies
– Short-, medium- and long-term improvement of the profit situation and continuous increase in turnover	– Improve marketing measures (particulary PR and advertising) and open up new target groups
– Image adjustment: attractive not only to the elevated requirements of the middle and higher salary and age classes but also to the elevated requirements of younger target groups	– Change the image and corporate identity, it not yet being clear in what direction the corporate identity should change
– Intensification of the service for regular customers and stronger links between this target group and the company	– Incentive and loyalty campaigns for long-term loyal customers
– Winning new customers in the target group of young people with high incomes	– Develop a new range of products and services for this target group and a more up-to-date advertising approach

1.3. Strengths and Weaknesses

Strengths	Weaknesses
– Healthy equity base	– Conflicting opinions about a strategy for reversing the fall in profits; only piecemeal approaches to improving the situation exist, no overall concept
– Management is aware of the problems and ready to change	– No agreement yet on the focal points at which change must start; no clear concept of what must be changed, how, and in what time
– Long-term relationship with a loyal group of regular customers, with a good reputation in this target group	– No strategy for approaching and winning young high-income target groups as customers; in this area there is too much experimentation with campaigns in which there is no clear direction

1.4 Definition of the Topic and the Horizon

Development of the retail company until the year 2000.

Step 2 of the Scenario Technique: Influence Analysis

The aim of this step is to define the external areas of influence affecting the subject of investigation – the retail company – to extract and assess the influencing factors in each area, and to work out the interrelationships between the areas.

2.1 Defining the External Areas of Influence relevant to the Retail Company

A Sales market
B Supply market
C Competition
D Economy
E Technology
F Society
G Legislation

2.2 Defining and Analysing the relevant Influencing Factors within the Areas of Influence

The following influencing factors were regarded as relevant (extract from a complete list of influencing factors):

A – Sales Market

1. Customer requirements in respect of range of goods and presentation
2. Customer requirements in respect of location (proximity)
3. Structure of customer and target groups
4. Attitudes of customers to different stores (image of stores from the consumers' point of view)

B – Supply Market

1. Supply conditions and prices
2. Supply monopolies and concentration of power in the supply market
3. Suppliers' marketing concepts
4. Policies of countries of origin

C – Competition

1. Image of competitors
2. Behaviour of competitors (strategies and market aggressiveness)
3. Market structure and market shares
4. Competitors' financial strength and innovative ability

D – Economy

1. Development of consumer spending
2. Regional unemployment rate
3. Price levels and price structures
4. Exchange rates and terms of trade

E – Technology

1. POS (point of sale) systems and inventory systems
2. Electronic selling (videotex, computer, video)
3. Self-service from vending machines
4. Cash management (fully automated financial flow)

F – Society

1. Demographic structure
2. Development of leisure time / working hours
3. Quality expectations
4. Attitudes to technology

G – Legislation

1. Local authority rights (building plans, subsidies, taxes, dues)
2. Employment law (regulations covering working hours, holidays, the disabled, etc.)
3. Law governing the hours of trading
4. National and international law on competition

2.4 Analysis of Interrelationships with a Network Matrix

To understand the interactions between the various areas of influence as characterised by their factors, the extent to which each area of influence affects all the others and is affected by them is ascertained in a network matrix. The scale on page 108 (Figure 11) is used for this:

0 = No influence
1 = Weak, indirect influence
2 = Strong influence

System Grid

To better illustrate the active to passive relationships of the individual areas of influence or system elements, the active values can be transferred to an active axis and the passive values to a passive axis. The limit of the active and passive axis is given by the number of elements minus 1 times 2 (strongest possible influence). In this case the maximum value on the active and passive axis is 6 x 2 = 12. The sum of all active and passive totals (which must be the same), divided by the number of elements, gives the point of intersection of the active and passive axis (this takes into account the different system dynamics in various systems with the same number of areas of influence).

	A	B	C	D	E	F	G	Active total	→ Retail trade	← Retail trade
A Sales market	×	1	2	1	1	0	0	5	2	1
B Supply market	1	×	2	0	0	1	0	4	2	1
C Competition	2	2	×	1	1	0	0	6	2	1
D Economy	2	2	2	×	0	2	1	9	2	0
E Technology	2	2	2	1	×	1	0	8	2	0
F Society	2	1	1	2	2	×	1	9	2	0
G Legislation	0	1	1	1	0	0	×	3	1	0
Passive total	9	9	10	6	4	4	2	44 : 7 = 6,3		

Figure 11: Network matrix

Hierarchical order of areas of influence in the network matrix and the system grid:

1 = F Society
2 = E Technology
3 = D Economy
4 = C Competition
5 = A Sales market
6 = B Supply market
7 = G Legislation

Notes on the System Grid

In first place are the elements in the active field (high activity and hence great influence on the other areas; relatively little influenced by other areas).

In second place are the elements in the ambivalent field (high activity and high passivity; in most cases activity and passivity balance each other out).

In third place are the elements in the passive field (high passivity, low activity) In fourth place are the elements in the buffering field (low activity and low passivity).

Rule 1 of system dynamics is, if possible, to use active elements and ambivalent elements that are predominantly active (elements on or above the diagonal line; this means they have balanced or high activity) to implement company goals and strategies; this is done by utilising the trends existing there and adding them to company strategies in order, for example, to influence elements in the passive area. In this way a greater synergy effect can be achieved with less effort than if the passive elements were influenced directly.

The second rule of system dynamics is not to fight the system and, if possible, not to develop any strategies that only aim at passive and buffering fields.

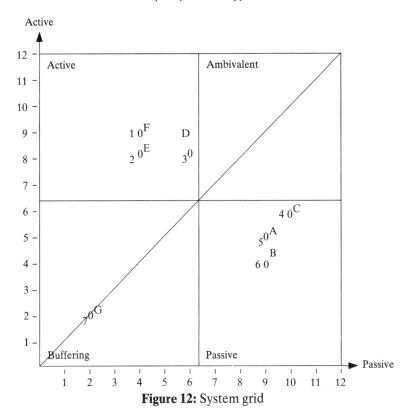

Figure 12: System grid

Positioned in the active field and hence acting as driving forces on the system are society, technology and economy, and these areas of influence exercise a powerful effect on the elements positioned in the passive area, namely competition, sales market and supply market.

The system grid clearly shows the extremely dominant position of the global areas compared with the areas relevant to the market. This is particularly clear in the case of the retail trade, because here sales markets (customers), competition and supply market are very dependent on social attitudes and behaviour (acceptance or rejection, customer response, etc.) and technological developments in the retail trade and on general economic conditions.

Legislation is positioned in the buffering field; it sets guidelines and boundaries in the environmental system of the retail trade but has no central influence within the system.

What consequences can be drawn from these system dynamics for a retail company?

It is very apparent that the retail company has no influence on society, technology and the economy, which are all in the active fields, but has a weak influence on the competition, sales market and supply market, which are all in the passive field. Compared with the usual retail trade strategies of intensive concentration on sales markets, and compared also with competition strategies, price campaigns, range displays, aggressive advertising etc., greater concentration should, in view of the system dynamics,

be placed on using the active elements to further the company strategies. This may mean, for example, recognising and anticipating social trends and developments, and adapting the range policy and product presentation to suit these trends. As far as technology is concerned, its use in the customer area depends on the degree of its acceptance in society. Within the company itself, much use should be made of technology for rationalisation, stock reduction and greater efficiency. Another determining factor for product policy and range presentation is the economic environment, which decides whether the aim should be for quality, top consultation, purchase stimuli or for basic, value-for-money self-service ranges.

An example of successful utilisation of the system dynamics is a chain of department stores which offers a special low-price range for the unemployed in towns in the Ruhr area with high unemployment.

If the retail company uses these insights and takes advantage of developments in the active elements to implement its own goals and strategies, less effort need be expended on direct strategies for sales market, competition and supply market and a much more efficient influence can be exercised on these areas.

The important thing is for the company to understand the system dynamics, accept them and respond appropriately; in no circumstances should attempts be made to alter the behaviour of the system or to work against the system forces.

Step 3 of the Scenario Technique: Projections

The aim of this step is to describe the present status on the basis of the influencing factors and their interrelationships ascertained in step 2, and to work out future projections for the year 2000 including reasoned justifications. The most important thing is to define and justify alternatives in every case where from the present point of view there is uncertainty about future developments. If future developments are clearly determinable, only a single definite development for the future is defined and likewise justified.

Descriptor	Actual status	Projection 2000	Reason
Society			
Demographic structure	Adequate youth market share (years with high birth rate)	Falling youth market share, decreasing population and growing senior citizens market share	Increase in the percentage of old people, birth rate slump caused by the pill
Working hours	Working week approx 38–40 hours	2 alternatives: a) Reduction in the hours	Increasing rationalisation and mechanisation enable higher productivity and fewer working hours
		b) Stagnation or increase in working hours	No general mechanisation; much work is still carried out manually to save jobs; shortage in some professions
Attitudes of society to technology	Largely positive, some indifference, some rejection	2 alternatives: a) Broad acceptance	Positive experience of technology, reduction of routine work, more freedom of scope for individuals and more attractive organisation of jobs
		b) Rejection	Fear of unemployment and fear of technology, which is seen as a job killer, negative experiences of technology (misuse of data, the identity card society, etc.)

Descriptor	Actual status	Projection 2000	Reason
Quality expectations	Desire for quality very high	2 alternatives: a) Quality expectations rising	Positive economic environment enabels an improvement in the quality of life; on the technical side there are product innovations that reinforce the desire for more quality and convenience
		b) Quality expectations cannot be met; basic, value-for-money goods are preferred	Negative economic development, falling incomes, forced restriction of consumption
Technology			
POS systems	Scanner systems exist in stores but there is no overall network (under test only)	2 alternatives: a) Total networking (inventory systems and POS linked)	Agreement between retail trade and banks in respect of assuming POS costs; high acceptance of technology in society and readiness of the retail trade to invest
		b) POS = flop	Social fear of data misuse, no agreement between retail trade and banks in respect of assuming POS costs; retail trade not ready to invest
Videotex	Approx. 50 000 users, of which 30 000 are information providers; network exists but costs for private providers high; system still relatively slow	2 alternatives: a) Wide distribution and use of videotex, like television (approx 95 % of households connected)	Cheaper hardware, better use of information, improved system (faster, more convenient, better access; videotex becomes a social status symbol)

Descriptor	Actual status	Projection 2000	Reason
	and not sufficiently attractive from the point of view of what is offered		
		b) Slight increase in numbers of users	No acceptance of technology and in particular of videotex; benefit to users not clear; equipment still too expensive
Vending machines	At present only in cafeterias and personal purchase of certain simple products not needing explanation	2 alternatives: a) High proportion of self-service from vending machines not only for standard products but also for individual products down to electronically measured tailormade suits and electronic ordering and payment from one's home	High acceptance of new technologies; new systems provide good information quickly and of high quality; reduced need for consultation
		b) Individual consultation dominates; vending machines do not gain acceptance	Rejection of technology in shopping; desire for personal contact and service; shopping still an important experience
Economy			
Consumer spending	55 % of the gross national product goes on consumer spending	2 alternatives: a) Proportion of consumer spending rising	Rising gross national product, consumer-oriented economic policy, rate of saving falls
		b) Falling consumer spending	Falling gross national product; higher taxes and a higher share of

Descriptor	Actual status	Projection 2000	Reason
			spending by the state; worsening pension problems; fear of the future leads to panic saving
Unemploy-ment rate		2 alternatives	
		a) Stagnation at the same level	Structural problems not overcome; social rejection of technology leads to delayed investment in technology; not enough jobs are created in the high tech and service sectors to offset the decline in secondary industry
		b) Unemployment rate falls	Positive economic development, rational economic policy, structural problems overcome; jobs in the secondary industries which have been rationalised away are offset by new jobs in the high tech and service sectors
Prices	Price stability, but consumer goods relatively expensive	2 alternatives: a) Prices of consumer goods stable	Higher productivity due to cheaper production (greater use of technology)
		b) Higher prices and flight to real values	Fear of the future, falling productivity because too little use of technology; dear imports
Value of the deutschmark abroad	Relatively high	2 alternatives: a) Rising sharply	Positive economic development, sound budgetary policy, innovations for export

Descriptor	Actual status	Projection 2000	Reason
		b) Falling	High budget deficits, fall in international competitiveness of the Federal Republic of Germany, high inflation

Competition

Descriptor	Actual status	Projection 2000	Reason
Image of competitors in the retail trade	Relatively poor (conservative, inflexible)	2 alternatives: a) Improved image	Reorientation of the retail trade, better image with customers, good price/performance ratio; attractive selling techniques that correspond to social needs
		b) The poor image remains	The retail trade does not reorient itself, adjust structurally or make its mark on customers; this development is reinforced by a negative economic environment
Competitive structure and behaviour of competitors	Dominance of specialist trade, low share of department stores and mail order firms, relatively high share enjoyed by discount stores; intense competition because there is no market growth	2 alternatives: a) Peaceful market response	High degree of segmentation and specialisation of retail trade, hence decrease in predatory competition
		b) Cut-throat competition (competition for survival)	Battle for survival; concentration tendency in retail trade; retail companies taken over

Descriptor	Actual status	Projection 2000	Reason
			by financially powerful multinationals
Financial strength of the retail trade	More or less adequate for all types of company	2 alternatives: a) Financial requirements are so high that only large companies can still survive	High competitive pressure, great need for investment in technological systems
		b) Relatively low financial requirements	High flexibility of retail trade, smaller companies win through; no concentration of power

Sales Market

Descriptor	Actual status	Projection 2000	Reason
Consumer expectations in respect of presentation	Presentation by media, press, catalogues and trained personnel	2 alternatives: a) Advertising intensified via technical media and personal consultation	Social acceptance of technology
		b) Technical presentation does not gain ground	Social rejection of technology
Consumer expectations in respect of depth and breadth of product ranges	Relatively good	Heavier concentration on certain articles (quick selling leisure, hobby and ecological products)	Framework of social conditions
Consumer expectations in respect of location	Mainly on the outskirts of town, relatively little in the centres	2 alternatives: a) Decentralised locations dominate	As technology does not gain ground in customer relations, the retail trade must go to the customer in order to have a chance in the market
		b) Central locations	Technology used (socially accepted), so questions of location are not so important

Descriptor	Actual status	Projection 2000	Reason
Supply Market			
Policies of the countries of origin for the products to be supplied	Little state regulation, export oriented policies, large-scale exploitation of the raw material resources of these countries	2 alternatives: a) Protectionism (export monopolies), export restrictions, increasing prices of products based on scarce raw materials	Political radicalisation (e g. Islamisation), promotion of the domestic economy, fear of dependence on industrial countries, political influences
		b) Creation of liberal markets	Reduction of debts and increase in competitiveness; liquidity problems in the supply market countries
Supply monopolies and concentrations of power	Cooperation and restriction of competition, market displacement	2 alternatives: a) Supply monopoly, forward integration of suppliers and vertical diversification	Power in the concentration of supply market, higher prices obtained by avoiding the retail stage, greater market proximity
		b) Atomistic supply structure, small flexible supply units	Rigorous monopolies and competition law; assistance for small companies
Marketing concepts of suppliers	In part favouring the retail trade, in part direct selling	2 alternatives: a) More direct selling of high value products; preference for specialist shops (exclusivity)	Exploitation of selling know-how and market power of manufacturers
		b) No restriction on supply to the retail trade, including for high-quality products; little direct selling	Market power of the retail trade

Descriptor	Actual status	Projection 2000	Reason
Legislation			
Local authority policies	Restrictions, subsidies and high taxation	2 alternatives: a) Restrictive policies	Financial need of local authorities, need for redevelopment in cities
		b) Liberal policies	Promotion of the market economy and free competition to attract companies; reduction of rate of tax
Trading hours	Very restricted with few exceptions	2 alternatives: a) Liberalisation of the trading hours legislation	Consumer pressure; opportunity of promoting consumption in unfavourable economic situation
		b) Trading hours legislation continues to be restrictive	Inertia of legislators; new technologies circumvent the opening hours legislation because they enable round-the-clock shopping
Competitive rights	Little influence	2 alternatives: a) More restricted competitive rights	State intervention in the market economy; individual companies prevented from becoming too powerful
		b) Competitive rights continue liberal	Promotion of the free market economy and international competitiveness

Step 4 of the Scenario Technique: Grouping Alternatives

The aim of this step is to cross-check the various alternatives identified in step 3 against each other for possible consistency in the future and to group them into two basic scenario frameworks which meet the following criteria:

a) Maximum harmony, freedom from contradiction, and consistency within a scenario group.

b) There should be the maximum possible difference between the two scenario groups.

This consistency analysis can be carried out both intuitively as a whole, for example, by grouping alternatives on a flip chart according to consistency and difference, or by computer.

On the basis of the consistency analysis the alternatives can be grouped into a possible basic scenario A and scenario B structure as follows:

4.1 Grouping Alternatives

Area of influence	Descriptor	Alternative 1	Alternative 2
Society	Working hours	° Decreasing	* Increasing
	Attitude to technology	° Acceptance	* Rejection
	Quality expectations	° Rising	* Falling
Technology	POS	° Success	* Flop
	Videotex	° Success	* Flop
	Automatic vending machines	° High	* Personal selling
Economy	Consumption	* Less	° More
	Unemployment rate	° Less	* More
	Prices	° Cheaper	* Higher
	Value of the deutschmark abroad	° Higher	* Lower
Competition	Image	° Better	* Worse
	Competitive structure	° Polypolistic	* Oligopolistic

Area of influence	Descriptor	Alternative 1	Alternative 2
	Strong financial position	° Important	* Less important
Sales Market	Presentation	° More technical	* More personal
	Locations	° Central	* Decentralised
Supply Market	Policies of countries of origin	° Protectionism	* Liberalism
	Market structure	° Concentration of power	* Atomistic market
	Marketing	° Exclusivity	* Supply to all
Legislation	Local authority policies	* Restrictive	° Liberal
	Hours of trading	* Restrictive	° Liberal
	Competition Rights	* Restrictive	° Liberal

° = scenario A * = scenario B

4.2 Consistency Matrix

Extract from the Consistency Matrix

		1 a	1 b	2 a	2 b	3 a	3 b	4 a	4 b	5 a	5 b	6 a	6 b	→
1) Working hours	a) More / b) Less	×												
2) Attitude to technology	a) Positive	0	1	×										
	b) Negative	1	0											
3) Quality expectations	a) Higher	0	0	1	0	×								
	b) Lower	0	0	0	1									
4) POS	a) Success	0	0	2	−1	0	0	×						
	b) Flop	0	0	−1	2	0	0							
5) Videotex	a) Success	0	0	2	−1	0	0	2	0	×				
	b) Flop	0	0	0	2	0	0	0	2					
6) Vending machines	a) Success	0	1	2	−1	0	0	2	0	2	0	×		
	b) Flop	1	0	0	2	0	0	0	2	0	2			

Selection of suitable Basic Scenario Structures

The following scenarios were selected on the basis of the intuitive and computer-aided consistency analysis.

Area of influence	Descriptor	Scenario A	Scenario B
Society	Working hours	Decreasing	Increasing
	Attitude to technology	Acceptance	Rejection
	Quality expectations	Rising	Falling
Technology	POS	Success	Flop
	Videotex	Success	Flop
	Vending machines	High	Personal selling
Economy	Consumption	More	Less
	Unemployment rate	Less	More
	Prices	Cheaper	Higher
	Value of the deutschmark abroad	Higher	Lower
Competition	Image	Better	Worse
	Competitive structure	Polypolistic	Oligopolistic
	Strong financial position	Important	Important
Sales Market	Presentation	More technical	More personal
	Locations	Central	Decentralised
Supply Market	Policies of countries of origin	Protectionism	Liberalism
	Market structure	Concentration of power	Atomistic market
	Marketing	Exclusivity	Supply to all
Legislation	Local authority policies	Liberal	Restrictive
	Hours of trading	Liberal	Restrictive
	Competition rights	Liberal	Restrictive

Step 5 of the Scenario Technique: Scenario Interpretation

The aim of this step is to use the projections worked out in steps 3 and 4 and their groupings as well as their system dynamics to point out routes into the future situation and to describe the target year.

A network analysis is also carried out as in step 2 to clarify the different system dynamics in the various scenarios.

Scenario A

Descriptor and present status	Developments up to the year 2000

Society

1.
Demographic structure: adequate youth market

Changing population structure due to falling birth rate and increased life expectancy (medical advances) and policies that do not favour the family (taxation, etc.). Increase in the percentage of old people with a declining population overall (declining youth market and growing senior citizens market).

2.
Working hours: about 38 to 40 hours per week

Further reduction of weekly, annual and lifetime working hours due to the efforts of trade unions and technological advances, which transfer more and more work from people to machines. As a whole, working hours are not only reduced but are also more flexible, with agreements between companies and employees.

3.
Social attitudes to technology: the majority have a positive attitude

Acceptance of technology is increasing steadily due to continuing reduction of fears and inhibitions about technology and thanks, too, to the coming of age of the computer generation. Society is turning more to technology because it enables easier work, less routine work and more opportunities for arranging one's own job.

4.
Quality expectations: high

Quality expectations continue to grow, favoured by a positive economic environment; this development is reinforced by increased market transparency (information provision via media). Consciousness is quality rather than quantity oriented. Higher incomes are converted to better quality consumption.

Descriptor and present status	Developments up to the year 2000

Technology

5.
POS and inventory systems: scanners already exist in the retail trade, inventory systems to some extent implemented but no overall interlinking as yet

Technological advances lead to complete interlinking between supplier, retailer, customer and bank. This development is favoured by enlightenment in the retail trade (readiness to invest and need to rationalise) and the positive attitudes of society to technology. POS is much favoured, and there is a standard card or all payments.

6.
Videotex: the technology exists but costs are high and distribution low; system not yet user friendly enough, still too complicated and too slow

Improved technology, better structure, higher transmission speeds and greater acceptance as well as attractive facilities provided by the system lead to widespread use.

7.
Vending machines: relatively poor distribution, limited to a few standard products (in cafeterias, at motorway, restplaces etc.)

Dynamic increase in vending machines due to social acceptance of the technology, improved systems and standardised products. Products are available round the clock.

Economy

8.
Consumption: consumer spending approx. 55 % of the gross national product

Greater productivity as a result of using new technology leads to falling costs, rising incomes and higher consumption. This development is reinforced by innovative products and services from suppliers and more leisure time, hence more shopping time and stimulated consumption.

9.
Unemployment rate: approx. 8 %

Structural unemployment has been overcome by the boom in new technologies and creation of new jobs (positive gross national product development). The jobs lost in secondary industry have been more than offset by jobs connected with new technology and accompanying services. This development is further favoured by the reduced number of people in the labour market (demographic development).

Descriptor and present status	Developments up to the year 2000
10. Prices: relatively stable	Thanks to the use of technology, productivity increases are greater than cost increases and lead to stable prices.
11. Value of the deutschmark abroad: high	The value of the deutschmark abroad remains high due to positive economic conditions, price stability, reduced unemployment, stable political conditions and confidence in the deutschmark as a hard currency. This development is reinforced by innovations developed in the Federal Republic of Germany that go to export.

Competition

12. Image of competitors in the retail trade: relatively poor because conservative and largely inflexible	Improved image as a result of product innovations, improved service and introduction of new services as well as new electronic selling methods including new delivery services. The retail trade adjusts to the changed situation and becomes more flexible (shift in demand).
13. Competitive structure: fragmented (department stores, mail order firms, discount stores, specialist retail shops, specialist chains, franchise concerns, etc.)	Retail companies, which up to now have had a non-profiled structure, are becoming increasingly specialised because of the pressure to reduce costs, higher quality expectations, and pressure from competitors. The market in the year 2000 will be polypolistic (different retail groups and segments for different target groups)
14. Financial strength: generally adequate	Investments in new technology require large financial resources; retail trade survives the structural change and can maintain its financial strength.

Sales Market

15. Presentation of goods: via media and personally, ranges have both breadth and depth	The high quality expectations of consumers promote specialisation in the retail trade; standard products are largely presented via technical media, while specialised products are offered with skilled individual consultation. Within the ranges there is emphasis on fast-selling products and innovative products, especially in the fields of leisure and ecology.

Descriptor and present status	Developments up to the year 2000

16.
Customer requirements in respect of location: essentially in the vicinity of consumers, on the outskirts of towns and in town centres

Return to central locations, because the use of electronic media has made the question of location insignificant; most communication between retail trade and customers takes place electronically.

Supply Market

17.
Policies of countries of origin: little regulation and export orientation

Increasing self-confidence in developing countries and the necessity of eking out raw materials lead to increased solidarity in the supply countries and to the formation of supply monopolies. Market power shifts to the suppliers. This development is aided by liberal monopoly and competition laws.

18.
Concentration of power: between cooperation and concentration

Formation of supply monopolies; beginnung of shifts of market power to suppliers.

19.
Marketing by suppliers: partly supply to the retail trade, partly direct supply

Because of their strength, and by using new technology, suppliers can largely circumvent the retail trade by direct selling. The suppliers decide which types of retailer they supply their products to (certain products exclusive to certain selling methods).

Legislation

20.
Local authority policies: high taxes, restrictions and subsidies

Implementation of liberal, stable policies that promote the economy and entrepreneurship so as to promote the market economy.

21.
Hours of trading: restrictive

No change in the law governing the hours of trading; the restrictive law is subverted by technological possibilities (round-the-clock shopping possible).

22.
Competition rights: liberal

Liberal policies that favour entrepreneurship continue.

Interpretation of the Network Matrix and the System Grid for Scenario A

As in the present situation, society remains in the active field. Technology and the economy continue to be of central importance, although in scenario A in the year 2000 they have moved to the ambivalent field, albeit to a position that is still very close to the boundary between the active and the ambivalent fields. Technology has considerably added to its absolute active sum, because in this scenario technology plays a central part due to society's positive attitude to it and to its advance.

Altogether one can say that the economy and technology respond more sensitively to trends in society. Area C - competition – has moved from its original position in the passive field to the ambivalent field, which can be interpreted as the retail trade having largely solved its present structural problems by the year 2000 and hence having assumed a stronger position.

Compared with its present situation in the passive field, the supply market has shifted to the centre of the system because of the concentration of power on the side of suppliers (supply cartels).

As in 1986, the sales market stays in the passive field. The same applies to legislation, which is still in the buffering field.

In summary, one can say that society will continue to play a central role for the retail trade in the future. In second place is technology, which substantially influences the scenario in interaction with society and the economy. For a retail trade strategy, in this scenario special emphasis must be placed on developments in the supply market which are tending in a direction that does not favour the retail trade (shift of power to the suppliers).

	A	B	C	D	E	F	G	Active total	→ Retail trade	← Retail trade
A Sales market	×	0	2	1	2	0	0	5	2	1
B Supply market	2	×	2	1	1	0	0	6	2	0
C Competition	2	2	×	1	2	0	0	7	2	0
D Economy	2	2	1	×	0	2	1	8	2	0
E Technology	2	2	2	1	×	2	1	10	2	0
F Society	2	0	1	2	2	×	1	8	2	0
G Legislation	0	0	1	1	0	0	×	2	1	0
Passive total	10	6	9	7	7	4	3	46:7=6,5		

Figure 13: Network matrix – scenario A

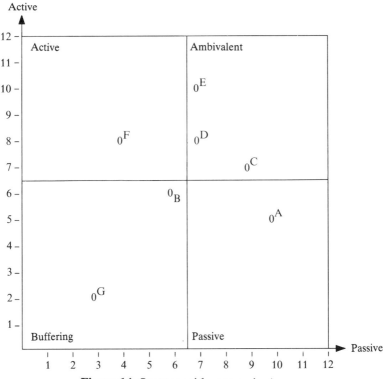

Figure 14: System grid – scenario A

Scenario B

Descriptor and actual status	Developments until the year 2000

Society

1.
Demographic structure:
adequate youth market

Changing population structure due to falling birth rate and increased life expectancy (medical advances) and policies that do not favour the family (taxation, etc.). Increase in the percentage of old people, while at the same time the population as a whole falls (declining youth market and growing senior citizens market). Due to the low use of technology the education sector declines while old people's welfare and the services sector grow

Descriptor and actual status	Developments until the year 2000
2. Working hours: about 38 to 40 hours per week	No further significant reduction in working hours, because humans are not replaced by technology. Scarcity in certain professions. Unemployment is largely regarded by this society as leisure time (making a virtue of necessity).
3. Social attitudes to technology: the majority have a positive attitude.	Fear of the possibilities of technology such as misuse of data and rationalisation lead to a largely negative attitude on the part of society
4. Quality expectations: high	Attitudes to the quality of life change; quality of life is not equated with consumption. Due to the unfavourable economic environment, quality expectations are forced to drop; quality expectations are dominated by price

Technology

5. POS and inventory systems: scanners already exist in the retail trade, inventory systems implemented to some extent, but no overall interlinking as yet	Due to people's fears (the identify card society, 1984) POS cannot be implemented. Efforts made by the retail trade in this direction fail
6. Videotex: the technology exists but costs are high and distribution low; system not yet user-friendly enough, still too complicated and too slow	Only a slight increase in the videotex medium; social attitudes to electronic media are generally negative, providing a considerable obstacle to further development of this medium; hardly any technical improvements and simplification for users; the number of providers in the system stagnates or even goes into decline
7. Vending machines: relatively poor distribution, limited to a few standard products (self-service in cafeterias, at motorway service areas, etc.)	Here, too, social rejection of technology leads to stagnation in the use of vending machines; instead of vending machines people desire personal service and consultation

Descriptor and actual status	Developments until the year 2000

Economy

8.
Consumption:
consumer spending approx.
55 % of the gross national
product

The proportion of consumer spending in the gross national product falls heavily due to poor economic development, restrained or even non-existent consumption, and rising rates of saving (panic saving in times of economic hardship). Falling consumption also leads to less investment in the economy and to reduced demand from abroad

9.
Unemployment rate:
approx. 8 %

Rising unemployment rate due to poor economic development; jobs rationalised away in secondary industry cannot be replaced by high tech and service jobs (lack of investment activity in the economy, structural unemployment not overcome); this problem is somewhat reduced by the falling numbers of people of employable age (demographic development)

10.
Prices:
relatively stable

Rising prices due to stagnating productivity (little investment in technology for cost-effective production) and dear imports

11.
Value of the deutschmark
abroad:
high

Falling value of the deutschmark abroad due to falling budget deficits, rising inflation and hence a reduction in the international competitiveness of the Federal Republic of Germany

Competition

12.
Image of competitors in the
retail trade:
relatively poor because
conservative and largely
inflexible

The retail trade does not succeed in adjusting to different target groups and changing its profile by providing new services; its image remains poor. Only a few retail companies stand out positively from the other competitors.

13.
Competitive structure:
fragmented (department
stores, mail order firms,
discount stores, specialist
retail shops, specialist chains,
franchise concerns, etc.)

Due to the poor economic development and the resulting competition for survival, only a few financially powerful concerns can survive. These few concerns divide up the market between them; the market becomes oligopolistic

Descriptor and actual status	Developments until the year 2000

14.
Financial strength: generally adequate — For those companies that have survived the competition, the financial situation is good

Sales Market

15.
Presentation of goods: via media and personally, ranges have both breadth and depth — Structural shifts in supply correspond to social developments (low purchasing power). Media developments are hesitant due to social rejection of technology. Presentation of goods is more personal. The retail trade concentrates on fast-selling products (variety reduces)

16.
Customer requirements in respect of location: essentially in the vicinity of consumers, on the outskirts and centres — Leisure and status consumption decrease; the locations become decentralised once again to ensure proximity to the customer who is looking for personal contact in the shopping experience. The use of technology is relatively low

Supply Market

17.
Policies of the countries of origin: little regulation and export orientation — Increase in imports from low wage countries, because these countries are export-oriented and pursue liberal policies

18.
Concentration of power: between cooperation and concentration — Atomistic structure of suppliers; market power is concentrated on the trade; restrictive competition and monopoly laws prevent the suppliers becoming too powerful

19.
Marketing by suppliers: partly supply to the retail trade, partly direct supply — Reduction in the variety of goods; all retail organisations are supplied. Manufacturers make use of all selling opportunities

Legislation

20.
Local authority policies: high taxes, restrictions and subsidies — Continuing restrictive with rising taxes due to the high need for finance caused by a new policy of redistribution

Descriptor and actual status	Developments until the year 2000
21. Trading hours: restrictive	Due to falling incomes and increased working hours, there is growing pressure to liberalise the trading hours legislation. The trading hours legislation is liberalised so that shopping is possible in the evenings and at weekends
22. Competition rights: liberal	Increasingly restrictive so as to counterbalance the monopolies

Interpretation of the Network Matrix and the System Grid for Scenario B

The presently dominant areas of society, technology and the economy remain in the active field. Technology and the economy have fallen in importance due to social hostility to technology (inadequate implementation of new technology and poor economic growth due to lack of technological impact).

Sales market, supply market and competition stay in the passive field, the sales market gaining in activity due to its demand for decentralised locations (caused by rejection of technology). The position of competition in the retail trade is considerably above

	A	B	C	D	E	F	G	Active total	\rightarrow Retail trade	\leftarrow Retail trade
A Sales market	×	1	2	1	2	0	0	6		
B Supply market	1	×	2	0	0	1	0	4	2	1
C Competition	2	2	×	1	0	1	0	6	2	1
D Economy	2	2	2	×	0	1	0	7	2	0
E Technology	2	2	2	1	×	0	0	7	2	0
F Society	2	1	2	2	2	×	1	10	2	0
G Legislation	0	1	1	1	1	1	×	5	2	0
Passive total	9	9	11	6	5	4	1	$45:7=6{,}4$		

Figure 15: Network matrix – scenario B

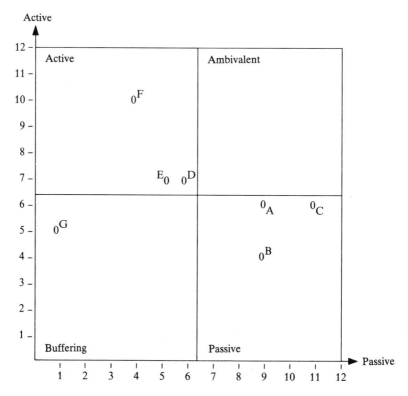

Figure 16: System grid – scenario B

that of the supply market, because in this scenario market power is concentrated in the retail trade.

Legislation, though still in the buffering field, has considerably gained in activity because in unfavourable economic conditions legislators see themselves as obliged to intervene more in the economy.

For a retail trade strategy this means that a central role is played by society with its attitudes, trends and behaviour and and the implementation of technology (rejection of technology).

Step 6 of the Scenario Technique: Consequence Analysis

The aim of this step is to derive opportunities and risks for the retail trade on the basis of these scenarios, and to work out suitable activities on the basis of these opportunities and risks. These activities then provide the basis for the master strategy to be developed later.

Working out opportunities and risks from the scenarios and development of activities

Scenario A – Consequence Analysis

Descriptor	Opportunities/ risks (O/R)	Activities
Society		
1. Demographic structure	R – Drop in sales O – More leisure time	– Senior citizens market: high quality range to suit senior citizens requirements for products and services
2. Working hours		– Youth market: extended range for special interests of young people (computer shops, hifi shops, special clothing, etc) – Expand the leisure market with watersports shops, handicraft shops, etc.
3. Social attitudes to technology	O – Full automation	– Replace people with technology (introduce automatic cash machines, entrance doors with selenium cells) – Use personnel saved for other purposes (consultation, etc)
4. Quality expectations	O – Increased turnover	– Stock higher quality goods (high-class boutiques, designer clothing with advertising generally more restrained)
Technology		
5. POS and inventory systems	O – Complete transparency on the supply and sales side (identity card customers)	– Create networked systems starting with suppliers, through goods and finance, down to the customers)
6. Videotex	O – Transparency of product groups for customers R – Transparency of the market for customers	– Videotex info shop – Offer PC courses especially for young people and in combination with sales programs – Analyse present pricing policies, regroup products and services

Descriptor	Opportunities/ risks (O/R)	Activities
7. Vending machines	O – Reduction in sales price due to self service by customers R – Older customers suspicious of too much technology in shopping	– Separate into target groups for self-service and non-self-service shopping – Group goods in accordance with the requirements of target groups – Segment product groups by self-service and individual service; create a senior citizen's segment with good consultation

Economy

8. Consumption	O – High value products R – Wrong product range	– Introduce technical innovations (trend setters) – Organise training courses, workshops and seminars for customers to achieve closer links with customers
9. Unemployment rate	O – Skilled personnel R – Competition for personnel	– Company training schemes – Bonus systems – Commission – Reward special consultation activities in selling – Benefits for employees – Incentive systems for improvement suggestions
10. Prices	O – Better basis for calculation R – Price competition	– Reduce prices for loss leaders – Comparative advertising possible – Expand customer service (e. g. home deliveries)
11. Value of the deutschmark abroad	O – Cheap imports R – Foreign suppliers	– Send buyers to trade fairs abroad – Form partnerships with foreign companies with exotic goods (campaigns at home) – Implement the "shop within the shop" principle in the company

Descriptor	Opportunities/ risks (O/R)	Activities
Competition		
12. Image of competitors in the retail trade	R – Out-of-date range R – Low flexibility and high cost of changing the range	– Reduce high stocks (less tied-up capital) – Specialise range to suit target customer groups, and offer complete ranges within these target groups (e. g. complete range for senior citizens, high salaried middle class, young people)
13. Competitive structure	R – Technological development missed R – Out-of-date selling methods	– Reduce the numbers of personnel – Do not replace staff who leave
14. Financial strength	O – Market leader with new products O – Short-term change of product range possible without great expense O – Leading role in implementation of technology	– Encourage voluntary redundancy with redundancy payments – Introduce personnel development programs to keep skilled staff – Introduce a new market research department – Introduce a company suggestions scheme (ideas competition) – Training activities: information about new technology so as to increase its acceptance within the company – Develop sales staff into qualified consultants and advisers for customers – Concentrate on six centres in south Germany and in the major cities – Close branches with a low contribution margin and unfavourable location (sale or rent) – Buy POS and vending machines with freed capital
Sales Market		
15. Presentation of goods	O – Top-of-range consultation O – Goods on offer	– Keep training for staff who stay (retrain sales staff to become consultants) – Move away from good quality only, and polarise the range to standard and exclusive goods – Expand the leisure market – Start to include environmental products – Reduce the depth of the standard range

Descriptor	Opportunities/ risks (O/R)	Activities
16. Customer requirements in respect of location	O – Concentration on one store in city centres R – Dependence on technology	– Adapt and change selling methods – Long-term reduction of staff in the branches – Introduce videotex and electronic data processing in house, and train staff and customers

Supply Market

17. Policies of countries of origin	R – No price influence possible R – Uncontrollable costs O – Concentration on a single supplier possible O – Less negotiating O – Necessity to use alternative products	– Lay in stocks of products subject to supply risk – Search for alternative products and suppliers (extend supply market research) – appointment of a local representative in the supply countries – Long-term price regulations with supply countries
18. Concentration of power	R – Dictated prices O – Retail trade prepared for greater solidarity (buyer monopolies)	– Form a retail trade lobby to counteract the suppliers' monopoly – Long-term supply contracts – Test the extent to which goods can be made or the finishing stage carried out in-house
19. Marketing by suppliers	R – Dependence on single customers R – Direct complaints R – Necessity for inefficient deliveries O – Better chances of persuasion O – Cross selling O – Forming close links with regular customers	– Technical training for staff – Announce prizes for ideas competition – Inform customers of special offers via electronic media – Buy up top quality brands – Marketing concept for regular customers (separate credit cards, clubs, target group magazines)

Scenario B – Consequence Analysis

Descriptor	Opportunities/ risks (O/R)	Activities
Society		
1. Demographic structure	O/R – Fewer new custo- mers, more middle aged and elderly customers	– Divide ranges into groups for middle aged and elderly people (lifestyle, health, services, etc)
2. Working hours	R – Less shopping time	– Intensify links with young customers through loyalty discounts, direct mai- ling, attractive events
3. Social attitudes to technology	O – Willingness for per- sonal contact, less market presence	– Customers must be helped to decisions by qualified consultants (train sales staff to become consultants)
	R – Existing technology can only be used conditionally	– Train sales staff in behavioural skills (contact and communication as well as skilled individual customer counselling)
		– Take into account social fears and scep- ticism when introducing new technolo- gy; carefully introduce customers to new techniques with games; two pilot systems with technology freaks and sceptics; use experiences from these trials for a technology concept
4. Quality expec- tations	R – Turnover risk	– Develop product ranges for the respec- tive target groups and offer them to spe- cific target groups
	O – Freedom to inno- vate	– Continue organisational development
Technology		
5. POS and inventory systems	R – Possible rationalisa- tion is slowed down	– Decentralised locations
		– Little technology seen by customers
		– Technology only in the background for internal handling and rationalisation
6. Videotex	R – Fewer selling me- thods possible	
7. Vending machines	O – Personal contact in- creased	

Descriptor	Opportunities/ risks (O/R)	Activities

Economy

8.
Consumption | R – Reduced sales | – Develop services in addition to the products offered e. g. financial services, budget advice, bookkeeping, budget account

9.
Unemployment rate | O – High availability of personnel | – Flexible working hours
– Reduce fixed costs
– New methods of selecting personnel
– Reduce wage costs

10.
Prices | R – Difficult to pass on increased prices to customers
R – Profit margin smaller | – Improve calculations through more efficient inventory systems
– Reduce overheads by saving on personnel and rationalising internal procedures.

11.
Value of the deutschmark abroad | R – Dear imports | – Build up alternative domestic supplies.
– Form buyers' associations (possibly with complementary competitors)

Competition

12.
Image of competitors in the retail trade | O – Distinctive company profile
R – Negative profile due to negative influence of the sector | – Specialise the range (more specialist retail shops, increased services, intensive customer service
– Sell complete solutions with consultation and support
– "The store for sensible products" as a slogan

13.
Competitive structure

14.
Financial strength | C – Increased market share due to purchase of companies or shareholdings
R – Suppression due to increasing influence of competitors | – Improve the financial situation by retaining earnings
– Increase capital resources by employee shareholding
– Reconstitute the company into a joint stock company and increase the capital
– Access financial markets directly

Descriptor	Opportunities/ risks (O/R)	Activities
15. Presentation of goods 16. Customer requirements in respect of location	O – Reduction of capacity O – Shift to profitable products	– Implement the "shop within the shop" concept – Let unused capacity as part of the "shop within the shop" principle – Market the distinctive company concept
Supply market		
17. Policies of countries of origin 18. Concentration of power 19. Marketing by suppliers	O – More favorable conditions due to increasing market power R – Dependence on a few suppliers	– Give preference to suppliers (short-term contracts) – Buy up their entire production – Forward integration (take over the finishing stage in production)
Legislation		
20. Policies of local authorities	O – Increase in consumer liquidity R – Risk in respect of consumers' credit standing	– Financing function through own bank – Credit insurance and negotiation – Cooperation with banks to cover risks and increase services
21. Trading hours	O – Flexible opening hours R – Collapse in turnover	– Employ staff by the hour (implement capacity-oriented variable working hours)

Step 7 of the Scenario Technique: Analysis of Disruptive Events

The aim of this step is to identify possible external and internal disruptive events, and analyse and select them according to their significance – in other words their effect on the company. The disruptive events are then analysed for their effects both on the scenarios and on the company in order to work out effective preventive and response measures.

Note: preventive measures are integrated into the master strategy to be worked out in step 8.

7.1 Compilation of External and Internal Disruptive Events

Disruptive Events from the area of Technology

- Luddism
- Operator strikes
- Shortage of raw materials for high tech

Disruptive Events from the area of Legislation

- Nationalisation of retail trade
- State controlled prices
- Change in the trading hours legislation (opening hours 0800 to 2400 hours)

Disruptive Events from the Sales Market

- General strike
- Restricted customer mobility (ban on cars)
- Boycott of certain retail companies

Disruptive Events from the Supply Market

- Data processing: files destroyed (suppliers)
- Blockade of transport routes
- Delivery stop

Internal Disruptive Events

- Accountants defraud the company
- Death of the owner
- Bomb attack

Step 8 of the Scenario Technique: Scenario Transfer

The aim of this step is to work out a master strategy on the basis of the activities and preventive measures worked out in steps 6 and 7.

A master strategy is required to be robust and flexible in different external situations. The activities for scenario A and B that were mentioned for both scenarios are therefore integrated into the master strategy. Attractive ideas that were only worked out in one scenario are also tested to see whether they suit the other scenario, and if so they are also incorporated into the master strategy.

8.1 Development of the Master Strategy

1. General Alignment

Goal:

– Selling methods and ranges of goods directed at specific target groups.

Strategy:

– Resolve the formerly unprofiled department store structure into individual companies for specific segments (everything under one roof for one target group), for example, young people's store, senior citizen's store, yuppie store, high-class store, self-service store (basic requirements and low-cost range)

– In the young people's store, senior citizen's store, yuppie store and high-class store, develop suitable selling methods (tailored solutions and ranges of goods for the respective target groups)

2. Corporate Identity

Goal:

– Match the corporate identity to the specific target groups.

Strategy:

– Adapt the corporate design, presentation of goods, shopping experience, range of goods and services to suit the above- mentioned separate companies

– Reconstitute the new companies

– The former company operates as a holding company for the individual firms, which now only have financial planning, technology and central purchasing in common, and otherwise operate as independent units which are not recognisable from the market as belonging to a common holding company)

3. Diversification

Goal:

– Complete the range of products for specific target groups.

Strategy:

– Include new services such as *financial services* (savings and capital services for young people, insurance, tax saving products for upper market segments), *general services* (delivery service for electronic orders or delivery service for senior citizens and the handicapped)

– Backward integration: take over the finishing stage, which adds the most value; individual products for specific target groups are developed from standard modules

4. Selling Methods

Goal:

– Selling methods specific to target groups

Strategy:

– Divide into:
 a) Self-service line (electronic and non-electronic) for standard products and basic requirements (cheap)
 b) Personal service line for e. g. *senior citizens*: conventional, respectable; *one* salesperson acts as adviser for *all* the problems of a particular customer; *high-class segments* (image enhancement by including designer labels or creating in-house top-of-the-range brands with restricted quantity and high exclusivity), consultation as in the senior citizens segment; *DIY line* with intensive customer advice and training (linking product and services to one particular solution)

5. *Products*

Goal:

– Range of products for specific target groups

Strategy:

– Analyse target group needs in respect of products, training and other services

– Develop strategic target group/product units (analagous to strategic business units in strategic planning)

– Continuously update target group product units via technical support, consumer questionnaires, events, competitions, etc.

– Develop after-sales service and marketing as part of the product

– Involve customers in the shaping of their target group product units (via incentives, discounts, customer cards, exclusive clubs and other privileges)

6. *Supply Marketing*

Goal:

– Ensuring supply at suitable prices

Strategy:

– Cooperate with supply countries (use shop in the shop campaigns and integrate products from supply countries)

– Form buyers' cooperative associations

– Flexible supply contracts

– Buy goods on commission

– Backward integration (take over the finishing stage which adds high value)

7. Technology

Goal:

– Increase rationalisation and productivity

Strategy:

– Concentrate initially on internal implementation of technology for data processing, inventory systems, scanners, cash flow and networking

– As in the scenario development, transfer technology to the customer area if society develops in the direction of accepting technology

8. Employees

Goal:

– Staff as entrepreneurial, customer-oriented advisers and consultants

Strategy:

General:
– Keep qualified staff through flexible working hours (including capacity-oriented variable working hours), involvement by individual staff members in the organisation of their job (staff competitions for ideas), incentives (financial and non financial), awards (such as the friendliest staff member of the month, the best problem solver of the month)

Further training:
– Train staff from salesperson to consultant
– Introduce behavioural training for salespeople so that they can relate optimally to customer requirements and problems
– Ability to innovate (train staff to recognise, develop and promote ideas for improvement and new ideas)
– Train staff to use and implement technology

The possibility of victory should not be sought in others but must be found in oneself.

(Lu Bu We)

6

Application of the Scenario Method in Planning

The Scenario Method in Strategic Planning

In the mid seventies it was generally accepted in Europe that strategic planning is an important means of ensuring a company's future. This realisation went hand in hand with the development and spread of the scenario technique, which for its part profited from the awareness of the importance of strategic planning and long-term orientation. Now that the scenario method has been available for 15 years, companies are in a position to use it for many applications under the broad heading of strategic and operative planning. The oil crisis was a major factor in spreading the scenario method, and for this reason the first companies that tried the method out were companies from the oil industry, shortly followed by the sectors that were most heavily affected by the oil crisis such as the chemical industry, which depended on oil as a raw material, and also the car industry, which was directly affected by the energy crisis as a result of increasing petrol prices.

The next sector to use the scenario technique as a tool was the mechanical engineering industry, which went through a major structural change as a result of the conversion from mechanical to electronic engineering. At the beginning of the eighties the pharmaceutical industry showed an increased interest in the scenario method, having been forced to adjust to present and future environmental developments as a result of changed environmental influences such as scepticism about orthodox medical treatment and chemical products, cost-curbing laws and a changed relationship of confidentiality between doctor and patient.

At the same time the electronics industry discovered the scenario method because it had to make long-term decisions about what aspects of research and development to concentrate on in the future. Next followed the retail trade, forced to tackle environmental developments as a result of structural crises

and far-reaching changes in its range of goods, presentation and overall concept.

In the mid-eighties banks and insurance companies too recognised that the scenario method is a useful tool enabling external developments to be more effectively put to work and their opportunities exploited. As a result of strong growth in the financial services sector, banks had to face up to the fact that a large number of new competitors had penetrated their market, and the scenario method was introduced in this sector, too, so that the competition could be faced with future-oriented concepts.

To sum up, one can say that many sectors first needed an external impetus to change their planning techniques and methods. A certain amount of pressure caused by problems from outside caused companies to look round for new concepts that above all took into account the unpredictability of the environment.

Meanwhile those who were using the scenario technique in the early days have now reached the point of re-examining their existing scenario planning and developing new scenarios that reach further into the future.

Developing and Testing Corporate Identity

Corporate identity can be worked out in a great variety of ways. Often this is done by questioning management and staff in order to define the company image and by developing a suitable philosophy from this in connection with the company strategy. To add the external image to the company's image of itself, companies also conduct surveys among their customers.

Here too the scenario method can be useful, but it is only very rarely that a scenario is used for the sole purpose of developing a corporate identity. In most cases this will be carried out in conjunction with strategy development on the basis of scenarios.

This method is useful in that, having developed the scenarios, companies will work out a master strategy – in other words define the direction to be travelled in future – and based on this their corporate identities are made concrete or worked out for the first time. The other advantage of this method is that, through scenarios, companies know in what direction they want to develop in future, how they see themselves as companies, and what position they want to occupy in terms of market and technology.

At this point a few basic remarks should be made on defining a corporate identity:

1. A corporate identity is only as good as the degree to which it is *translated into action* and *lived* by the company staff.

2. A corporate identity should not be too detailed, because otherwise it must be revised with each change of strategy; it should include the basic internal and external company view and be valid for a fairly long period.

3. A good corporate identity should not include more than seven main points (it is well known that the human short-term memory cannot contain, store and apply more than seven different things at the same time).

4. A good corporate identity should not be a secret strategy for top management, but should be publicised throughout the company so that it can be appropriately applied and experienced.

5. A good corporate identity can be recognised by the fact that it is applied at the level of the company porter or receptionist (for example, attitudes to customers, interior design and business documentation).

Typical errors made by many companies when creating their corporate identities are as follows:

The corporate identity is much too comprehensive, covering four to five pages and so watering down the clear and precise statements of how the company sees itself and how it wants to be seen. Such a corporate identity is too complex to be used and lived at all company levels. Thus a corporate identity is not yet a strategy, but contains the company philosophy and its self-image.

Good corporate identities are often to be found in American and Japanese companies. The most important basic company rules are known to all employees and formulated in such a way that they are understood and applied in all divisions and at all hierarchical levels. The hallmark of good corporate identities is that they always function as criteria for company decisions.

A good corporate identity generally covers the following aspects:

– What is our view of ourselves?
– What is our relationship with our customers?
– What significance does technology have for us?
– What is our relationship with our competitors?
– What is our relationship with our staff?
– How do we see our role in the sociopolitical environment?

Using these questions any company can formulate, on the basis of its scenarios, a corporate identity that contains its future orientation and at the same time is in harmony with the company's self-image and style.

Development of Goals and Strategies (Master and Alternative Strategies)

The main function of scenario projects is to develop goals and strategies. What is meant by this is that scenarios can be used to establish and define future goals and to develop suitable strategies for reaching these goals. As already described in steps 6 and 8 of the method description, most companies are concerned with working out an appropriate master strategy that is robust and flexible under different environment conditions. A robust strategy means one that is successful irrespective of the external situation; this is known as a safety strategy, and is the type that most companies adopt nowadays on the basis of their scenarios.

The usual procedure for developing an appropriate master strategy is firstly to extract those activities from the two scenarios that are the same. This is not yet enough to give a master strategy that is both robust and flexible; to flesh it out with future-oriented aspects, those innovative initial strategies that were worked out, for example, under the conditions of scenario A, are now tested to see whether they apply under the conditions of scenario B. If this test is positive, these aspects can be incorporated in the master strategy. The same approach is used for the future-oriented aspects of scenario B which can also be implemented in scenario A conditions.

In some cases it will not be possible to carry out the activities named in one scenario in the conditions of the other scenario, and in this case the activities must be modified or reformulated.

Experience has shown that by this method about two-thirds of the activities for the different scenarios can be transferred to a master strategy, and this can be regarded as an initial collection of material for the master strategy.

The collected material is then classified according to various aspects of company strategy. These can be, for example:

1. General company orientation
2. Corporate identity
3. Diversification
4. Research and development
5. Product planning
6. Production
7. Marketing

8. Sales
9. PR
10. Lobbying
11. Personnel
12. Internal organisation

The above classification clearly shows that the scenario application provides a broad base for the company overall, so that, for example, not only marketing or development planning can be worked out on the basis of scenarios, but a coherent general plan for the entire company or strategic business unit. Another advantage is that planning in the various divisions rests on a common basis, namely the scenarios, and in this way the planning discrepancies that

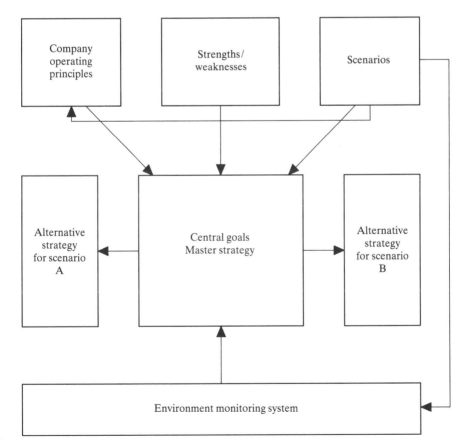

Figure 17: Incorporating the scenarios and strategies into the corporate planning system

frequently occur between individual divisions can be avoided. A further positive effect is that different management staff from the different company functions are included in the project and this means that a coherent procedure based on a common foundation can be aimed at from the start. Thus management staff responsible for translating strategy into action are committed to a common basis; they are all in the same boat and work together and not – as unfortunately often occurs – against each other.

Alternative strategies are those elements that were named in scenario A and B but could not be included in the master strategy because they would only succeed in the particular conditions of either scenario A or B.

This can also be represented graphically with the master strategy occupying a broad block in the middle, and branches emerging from it for individual company divisions in the event that scenario A or B actually occurs (see Figure 17).

The environment monitoring system (see Chapter 6) can be used to help decide whether further elements of the alternative A or B strategies are to be added to the master strategy.

Re-examining Existing Goals and Strategies

As many companies have already defined goals and strategies for the future, it has become more and more important to check these goals and strategies against external developments in the environment by using scenarios.

Here, too, the existing goals and strategies are used as a starting point, scenarios being developed independently and then used to check the existing goals and strategies. It is important to make sure that the scenario team does not consist only of people who developed the existing strategies, but that other rank and file staff are included who can enrich the scenarios through their view of the company environment.

When the scenarios are completed, the existing goals and strategies are tested against them. This is done with the aid of an abbreviated scenario, the so-called scenario descriptor list. Each scenario is characterised by its main descriptors and their typical development (this forms one axis of a matrix). On the other axis of the matrix are placed the strategies or just one strategy already worked out by the company. It is then possible to test (possibly also by weighting the various strategy elements and by weighting the scenario descriptors) to what extent these strategies suit the various scenarios (See Figure 13).

Various ratings are then assigned in respect of whether a strategy fits or does not fit the scenarios, and these are then combined to find an overall rating for each strategy.

It is also important not only to give a quantitative rating but also to make a qualitative statement about the extent to which a specific strategy will act on or react to certain scenario developments. The question here is whether the strategy makes good time and responds to them.

In this way one can arrive at an overall assessment for each strategy and each scenario.

It is quite possible for a specific strategy to be admirably suited to scenario A but not scenario B or vice versa. A strategy may of course already be correctly oriented in respect of both scenarios.

If, however, the existing strategy or, for example, two strategies turn out to fit one scenario but not the other, it is advisable now to carry out the consequence analysis as described in step 6, so as to arrive at a strategy which promises success in different scenario conditions. If it is found, for example, that a strategy only fits both scenarios moderately well, it would be advisable at this point to analyse the scenarios once more in terms of opportunities and risks and to develop suitable activities that can be integrated into the formerly only moderately suitable strategy.

It should be noted that, if the original strategy developers work out the scenarios alone, there is a certain risk of their manipulating the scenarios to suit the strategy already defined. This can be avoided by using a completely different team to work out the scenarios from that which developed the original strategies, or by making the strategy team a mixture of people who developed the original strategy and people who as yet have had nothing to do with strategy development.

The crucial point is for management to be willing to concentrate on new strategy concepts which promise success in both scenarios, and not to stick to the old strategy which would only be successful in one scenario.

The normal procedure in planning is therefore to concentrate on pursuing that strategy which promises success in different scenario frameworks. However, this should not be understood in the sense of a *standard strategy*; it is perfectly possible for a company to follow a completely different path, and this will apply, for example, to a company which sees a certain scenario as a type of guiding image or objective and is now concentrating all its forces on aligning those developments that it can influence in this direction and developing an appropriate strategy. Clearly such a procedure is considerably more risk-prone than concentrating on a strategy that fits both scenarios.

The question is, what companies can allow themselves such a procedure? The first companies that come to mind are those with a strong market position, possibly even a monopoly, and who are market leaders with clear technological superiority over the other competitors. Using these criteria, the companies that could favour such a strategy would of course be limited to multinationals

and dominant companies. But it is possible for small and medium-sized companies to implement a strategy of this kind, if the following conditions are met. For example: Take a company that, as a new technology emerges, develops one or more new techniques which open up a completely new market for which

Strategies already adopted or envisaged are projected into the scenarios and assessed

Scenario A

Set of descriptors	Strategy I	Strategy II	Strategy III
D1	+2	−1	+1
D2	+1	−1	0
D3	+2	0	+1
D4	−1	+1	−1
D5	0	−1	+1
D6	−1	+1	−1
.			
.	+3	−1	+1
.			

Scenario B

Set of descriptors	Strategy I	Strategy II	Strategy III
D1	−1	+1	+1
D2	−1	+1	0
D3	0	−1	−1
D4	+1	0	+1
D5	−2	+2	+1
D6	+1	0	−1
.			
.	−2	+3	+1
.			

Assessment scale:
+2 = Very good
+1 = Correct
 0 = Neutral
−1 = Does not fit well
−2 = Contradictory

Figure 18: Strategy assessment – testing strategies with scenarios

there are as yet no concrete consumer needs and no competitors. A development of this nature has loomed since the mid-eighties in the USA in a number of genetic engineering and biotechnology enterprises which, by developing new techniques, have created new markets and hence new environments for these products. There is a possibility here that such a company can exercise a certain influence on external developments. By pioneering a new development, a company will have extensive opportunities to markedly influence the development of its direct environments.

Both for large market leaders and for small companies pursuing a strategy that concentrates on one scenario only, the most important thing is: a very well-worked out strategy that fits the other scenario, too, and a well-functioning environment monitoring system designed to find out *in good time* whether developments are in fact going in the other direction. The main danger in this method is recognising too late that the trend is not in the desired direction *after* important decisions (e. g. about investments) have already been taken in the direction of a *particular* scenario.

The advantage of this procedure is that only relatively few competitors decide in favour of it (most companies these days take the path of the more risk-free safety strategy fitting both scenarios) and not until one is successfully established in these new sectors will it be necessary to deal with imitators and new competitors. This method can thus give a considerable competitive advantage.

Scenarios for Assessing Strategic Decisions

This is the oldest type of scenario application. Whenever the question is one of long-term decisions about a company's future - decisions about investment, joint ventures, acquisition of other companies – it is always important to provide the strategy with sufficient safeguards enabling it to be implemented in both scenario frameworks.

The procedure here is first to specify all alternative decisions; if possible, there should be more than two alternatives, because experience has shown that the quality of a management decision grows with the number of alternatives. Some examples of this are given below:

Rather than specifying expansion of business activities in South America (yes or no), this should be stated as follows:

1st alternative decision:
 Joint venture with a regional marketing company and supplying this marketing company with, for example, products from Europe.

2nd alternative decision:
 Set up company's own sales organisation in South America, with products
 supplied from Europe.

3rd alternative decision:
 Set up a company production plant in South America and operate a joint
 venture with a marketing company.

4th alternative decision:
 Set up a separate strategic business unit in South America which covers all
 functions of production, sales, marketing and control, possibly also deve-
 lopment.

5th alternative decision:
 No activity in South America.

Since the alternative decisions have already been defined in step 1 of the
scenario method – task analysis – the task now is to use scenarios to work out
the economic, political, social, technological and legislative environmental sit-
uations in South America and those relating to the competition and the sales
market. After the scenarios have been worked out, these five alternative deci-
sions are projected into the two scenarios and qualitative and quantitative
assessments made as to how well the alternative decisions fit the scenarios (see
Figure 19).

	Alternatives				
	1	2	3	4	5
Scenario A					
Area of influence X					
Descriptor 1	–	–	–	–	–
⋮	–	–	–	–	–
Descriptor n	–	–	–	–	–
	6	4	6	0	0
Area of influence Y					
Descriptor 1	–	–	–	–	–
⋮	–	–	–	–	–
Descriptor n	–	–	–	–	–
	4	2	4	1	0

	Alternatives				
	1	2	3	4	5
Area of influence Z					
Descriptor 1	—	—	—	—	—
⋮	—	—	—	—	—
Descriptor n	—	—	—	—	—
	3	2	2	2	1
Total for scenario A	13	8	12	3	1
Scenario B					
Area of influence X					
Descriptor 1	—	—	—	—	—
⋮	—	—	—	—	—
Descriptor n	—	—	—	—	—
	6	2	7	12	0
Area of influence Y					
Descriptor 1	—	—	—	—	—
⋮	—	—	—	—	—
Descriptor n	—	—	—	—	—
	4	1	4	5	0
Area of influence Z					
Descriptor 1	—	—	—	—	—
⋮	—	—	—	—	—
Descriptor n	—	—	—	—	—
	2	1	2	1	1
Total for scenario B	12	4	13	18	1
	Rank 1	Rank 3	Rank 1	Rank 2	Rank 4
Total for scenario A + B	25	12	25	21	2
Susceptibility of alternatives to disruption	High	Medium	Low	High	0
(× factor 3)	3×3	2×3	1×3	3×3	0×3
	-9	-6	-3	-9	0
	Rank 2	Rank 4	Rank 1	Rank 3	Rank 5
Overall assessment of scenario suitability and susceptibility to disruption	16	6	22	12	2

Figure 19: Alternative decisions

Interpretation:

Looking at the analysis of this assessment, the following options are open:

1. The Safety Strategy

The alternative finally chosen must fit both scenarios equally well and have a relatively low susceptibility to disruption; this means that possible disruptions cannot put the strategy at substantial risk, or that internal safeguards can guard against possible disruptions.

2. The Entrepreneurial Risk Strategy

In this case one is committed primarily to one scenario and puts all the company effort into making sure that this scenario actually comes into being. To limit the risk, a carefully worked out alternative strategy is necessary, as is intensive monitoring of external developments so as to be able, if necessary, to switch to the alternative strategy before substantial investments have been made. In this strategy too it should not be forgotten to monitor the susceptibility to disruption of the various alternative decisions.

Taking into account only whether the alternative strategies fit the two scenarios, it is apparent that alternatives 1 and 3 fare the same in the scenarios, both fitting relatively well in scenarios A and B with 25 points each. In second place is strategy 4 with 21 points. After analysing their suitability for the scenarios one will still not be certain which of the alternative strategies to opt for finally. If the factor of susceptibility to disruption is now added to the alternatives, the picture becomes considerably more differentiated. The susceptibility to disruption of the alternatives is analysed by introducing possible external disruptive events that have not yet been considered in the scenarios and testing their effects on the various alternative strategies. If certain alternative strategies are particularly susceptible to external disruption and it is found that the company itself can do nothing either to prevent these disruptions or to safeguard the company internally to the extent that it is not significantly affected by these disruptions, then a high susceptibility to disruption must be assigned. If it is found that, while a certain alternative strategy can be significantly impaired by external disruptions, there is a possibility of taking preventive measures, the susceptibility to disruption can be designated medium. Low susceptibility to disruption means that external disruptions can do relatively little harm to the alternative strategies under consideration. The estimated susceptibility to disruption is then also quantified:

- High = 3
- Medium = 2
- Low = 1
- No susceptibility to disruption = 0

This value is multiplied by 3 and the total subtracted from the overall result reached in the scenarios, given a ranking order that may differ considerably from the pure scenario evaluation.

If after analysing both scenarios for robustness one was undecided between alternative strategies 1 and 3, after evaluating the susceptibility to disruption it is apparent that strategy 3 now has a considerable lead over alternative strategy 1.

Companies that want to minimise their risks as far as possible whilst favouring a strategic alternative which promises success in different external frameworks will on this analysis choose strategy 3.

Proponents of the more entrepreneurial risk strategy (strategic alternative 4) will normally be convinced by such a susceptibility analysis that the strategy originally favoured after all contains too many dangers, which exceed the limits of calculable entrepreneurial risk.

All important corporate decisions relating to the future should be made in this way. To further safeguard the decision made, it is in any event prudent to set up an environment monitoring system, which serves as a feedback or control instrument for the strategic alternative adopted. In this way, despite having made a clear decision for one alternative, it is possible to optimise and adapt the strategy to conditions as they develop.

Use of Scenarios in Testing Short- to Medium-Term Operative Planning

If, in addition to its medium- to long-term planning, normally covering five to seven years, a company is going through a scenario process, this provides a good opportunity to check and, if necessary, correct the short- to medium-term planning, which will have been extrapolated mainly from the past, with the aid of scenarios.

This planning, based on past and present figures, is normally occupied in a very detailed way with the next planning year. Precise information about goals, strategies and individual measures and the necessary budget are defined, and the second, third, fourth and fifth years are usually projected from the first planning year. The problem with this type of planning is that relatively little thought is given to how planning figures lying further in the future materialise. In this case, the past and present are merely extended into the future.

What method should be adopted here? As scenarios are normally set up for

a company with two horizons, the first one being the present year plus five to seven years, the second one being the present year plus about ten to fifteen years, the first scenario horizon provides an opportunity to check the operative planning. One could ask, for example, whether the figures extrapolated from the past, such as the market share of product X in market segment Y in year Z, are feasible in the first horizon of both scenarios. If the scenarios do not indicate any risk to the medium-term planning, it is possible to continue as before. But if one of the scenarios shows that the extrapolated figures are not feasible within the first horizon, the long-term scenario view must be used once more. If both scenarios should then show that the medium-term planning is not feasible, this rapidly means a change to the former plans. If both scenarios show that present planning cannot be implemented in the various environmental conditions within the first horizon, and the external environmental conditions are still more unfavourable by the second horizon, this means that short-term planning should be readjusted very quickly to align with these scenarios, and the former five-year plan should be abandoned.

The advantage of scenarios is not only that they show companies what cannot be implemented in the future (in this case medium-term plans), but that they also show possible alternative developments to these activities. For this reason, if the scenarios do not coincide with medium-term planning within their first horizon, it is advisable to use the scenarios as the basis for new planning activities. So that the adjusted plans can then be aligned in the long term, the scenarios of the second horizon should be used as the second criterion for evaluation, and the question asked how can we gear our short-, medium- and long-term planning to long-term successful development? (see also Figure 20).

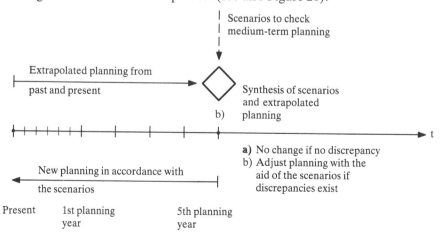

Figure 20: Testing the five- to seven-year plan (from present and past) with the aid of scenarios (1st horizon)

The Scenario Method as a Basis for Environment Monitoring

> *Man has three ways of acting wisely:*
> *1. by reflection, that is the noblest,*
> *2. by imitation, that is the easiest,*
> *3. by experience, that is the bitterest.*
>
> (Confucius)

Environment monitoring should on no account be omitted in a scenario development as it is the link between the external future possibilities (scenarios), the strategies oriented towards this future, and actual development. The process of scenario development has already created part of the structure of such an environment monitoring system by virtue of the fact that the external developments most important for the company have been worked out in the form of descriptors.

Theoretically an environment monitoring system can be established in a company without going through the scenario development process. Experience shows, however, that most companies find it very difficult to recognise which external developments, particularly with reference to the future, will have a crucial influence on the company itself and on its various external areas of influence.

Structure and Organisation of an Environment Monitoring System

As remarked in the previous section, the scenarios supply the most important external developments that a company must observe in order to check, monitor and, if necessary, adjust its master strategy.

From experience, in scenario projects about 70 to 100 different external factors are found that shape the scenarios in various forms and are hence important for the company. To reduce the number of descriptors to a practical level that is possible to handle, and at the same time to ensure that the company concentrates on monitoring those developments that are genuinely of crucial significance, it is advisable to carry out two further analyses to select the descriptors.

The first analysis in the form of a matrix determines the direct influence of the scenario descriptors on the various internal parameters, functions or main products of the company. In most cases the various functions of a company or a strategic business unit are entered on the horizontal axis of the matrix. These may be, for example:

- research and development
- marketing
- sales
- logistics
- production
- procurement
- control
- personnel

This list will vary depending on the company concerned.

On the vertical axis of the matrix the descriptors are listed once for scenario A in their typical A form and once for scenario B in their typical B form, for example:

- economic development: growth
- new technology: wide implementation
- social attitudes to new technology: broad acceptance
- customer expectations: rising
- innovative capability of competitors: increasing
- producers' liability: more severe (This is only one possible example for a general scenario.)

The same scenario descriptors as listed above are naturally also entered on the vertical axis in their B form.

The extent to which the external factors directly influence the internal parameters and functions is then assessed, usually using the following scale:

0 = no effect
1 = weak or indirect effect
2 = strong effect

After all the separate assessments have been made, the rows are added for each descriptor to find the ranking order of the descriptors in terms of their influence on the different company parameters. The sums for the second scenario must also be considered, so that the effects of the descriptors from the totals of A and B, which may be different due to the different scenario developments, result (see also Figure 21). The most influential descriptors significant for most company divisions are then placed in order of rank.

Note that there will also be some scenario descriptors that are only of major importance for a few internal areas of influence, but not for the other areas; these should on no account be neglected.

The normal procedure is for the external factors that are significant for most company divisions (the first six to ten ranks in the hierarchy) to be continuously analysed by observers in a few central divisions and used as feedback for the other divisions. External factors that only relate strongly to a few divisions should be monitored directly by these divisions and the results of these analyses likewise used to evaluate the master strategy.

In most cases, development, production and technical staff analyse external factors from the areas of science, technology and (if necessary) legislation, while marketing and sales staff monitor the external factors of sales markets and competition. Factors from the global areas such as economy, society and to some extent legislation should therefore be analysed in preference by the planning, control and personnel departments.

Another quite different analysis of this matrix results if the scores of the internal divisions (their ability to be influenced from outside) are added and likewise placed in ranking order. This clearly shows which internal divisions are most dependent on external developments. This means that for all activities in the short, medium and long terms, a precise analysis must be made of to what extent one can work with these external developments rather than against them, thereby exploiting the synergy effects from the system dynamics.

A second analysis to determine the most important external developments relates to their environmental system dynamics. As mentioned in steps 2 and 5, the interrelationships of the external areas of influence are analysed and interpreted by means of the network analysis and the system grid. This normally shows that global areas of influence such as economy, technology, society and legislation often have a dominant function in the system. Transferred to the monitoring system, this means that developments and changes begin here in the global areas and make their presence felt to the company only in their effects on markets and in the competition; one can say therefore that the factors with the greatest dynamic force often have a rather indirect influence on the company. So in this matrix, in which the direct influences from outside to inside are ascertained, it often occurs that the global factors have a subordinate role, because their effects are only indirect. But in order to adjust in time to changes and above all to use the period of change - normally a fairly long time elapses until changes in the global areas affect markets and then companies – it is essential to include these global factors in the monitoring process too.

To provide further safeguards it is advisable, if a computer-aided consistency analysis is carried out (step 4) at the same time, to carry out a sensitivity analysis. This can be used to ascertain how a scenario will change if a descriptor takes the opposite form to the one it has in the original scenario. The

Description – scenario A	Internal company parameters								Total scenario A	Total scenario A+B*
	Research and development	Market-ing	Sales	Logis-tics	Produc-tion	Procure-ment	Controll-ing	Person-nel		
Economic development: growth	1	2	2	1	1	0	0	0	7	15
New technology: broad implementation	2	1	1	2	2	0	1	0	9	20
Social attitudes to new technology: high acceptance	1	2	2	2	0	0	1	1	9	19
Customer expectations: rising	2	2	1	1	1	1	1	0	9	18
Innovative ability of competitors: increasing	2	2	1	1	1	1	1	2	11	21
Manufacturer's liability: extended	2	1	1	1	2	1	2	1	11	22
....
Total dependence of internal parameters on external developments	10	10	8	8	7	3	6	4		

* In scenario B the forms taken by the descriptors to some extent contradict A

Figure 21: Environment monitoring system – matrix to find the most important scenario descriptors for the company

system dynamics of the global areas can be confirmed once more on the basis of such sensitivity analyses. In most cases it is apparent that, when global descriptors such as economic development, social attitudes to technology, implementation of new technologies change, most of the remaining scenario also changes.

However, if a descriptor from, for example, the sales market or competition of a specific scenario is given its opposite form, this normally only results in changes in the markets but not in any change to the scenario as a whole. It is clear from this that there are two levels of monitoring:

The *first* level is that of direct effects on the company; the changes apparent here in most cases act very quickly and have a very short-term effect on the company.

The *second* level is the indirect level. The changes detected here act on the company with a certain delay via the direct areas of influence (markets and competition). Changes noted here, however, – and herein lies their danger and their significance – usually cause radical changes in the scenario and the direct areas of influence.

With regard to changes in the indirect level, the advantage is that there is often more time to adjust to these shifts and – if a sensitivity analysis has been made – one can determine very precisely what other scenario factors might also change with a delay, and then lead to direct effects on the company.

The environment monitoring system should be organised with division of labour. Scenario team members, having been attuned through their work on scenarios, are obvious people to use for monitoring. A coordinator should also be appointed to obtain the monitoring results from individual team members at periodic intervals of about three to six months, combine these into an overall picture, and call a meeting of the scenario team once or twice a year to discuss and evaluate the results.

It is important to ensure that all scenario team members and observers are informed of overall developments and do not just see a small part of the area which they themselves are analysing. Viewing things as a whole makes it easier to see global developments, which might later have repercussions on the markets and on the company itself, as they arise. Such a procedure will also improve the members' ability to think in networked systems. People are then less likely to concentrate on monocausal relationships and can better see the systematic overall relationships and chains of interaction in the system.

Environment Monitoring to check and bring into line the Master Strategy

The main purpose in setting up such a monitoring system is not just to attune the team members to the environment; at the same time this produces a valuable monitoring and feedback instrument for the master strategy.

As the master strategy is divided into short-, medium- and long-term activities, which also encompass certain decisions, before decisions about, for example, investment or possible development are made, it is necessary to check the extent to which the master strategy adopted fits in with the possible external developments and changes.

If there have been no significant changes in the company environment, the master strategy can continue to be pursued and decisions made in accordance with the specified plan. However, if deviations are found in the external development, careful checks must be made to ascertain whether the existing master strategy should be pursued or whether careful adaptation is necessary. The word careful is deliberately used here because it is a common mistake when changes are detected to abandon the original master strategy and to start completely new activities that may even partly contradict the master strategy. Short-term tactical thinking and acting may lead to sight of the long-term company orientation being lost, and the master strategy being abandoned unnecessarily. If deviations occur, it would be more appropriate to check whether there are short-term measures that contain a response to changes but do not deviate from the master strategy or contradict it.

In most cases when a company has completely abandoned the master strategy due to external changes, after a short period of observation it has become apparent that developments were swinging back again in the direction of the original master strategy. If tactical activities are necessary, these should therefore be within the framework of the master strategy and under no circumstances contradict it.

Furthermore it is not very good for the company image either in the market or internally if it makes short-term panic responses to changes, only to find that this panic has brought nothing more than confusion. As the master strategy should be regarded as a long-term orientation with a high degree of continuity, it should be adjusted very carefully indeed. The adjustment should be a fine one, not an abrupt change or radical alteration of course.

Figures 17 to 19 are intended to show how the master strategy and environment monitoring system can be used as an instrument to safeguard company planning and to make the right decisions at the right time.

Figure 22: 1st phase

At the end of a scenario project when the master strategy has been adopted in respect of its short-, medium- and long-term activities, specific times are defined on the time axis at which observations of the environmental system will be used as feedback, and at which decisions will be made about further action. To prepare for such a decision point, both the results of environmental monitoring and those of the internal projects defined from the master strategy are used. The external and internal developments are then linked with the master strategy and the question asked whether the master strategy should be continued as planned under the given developments. The question is asked whether the external and internal developments provide any indication, for example, as to whether certain projects should be favoured or abandoned. This question should always be asked if, for example, at the beginning of the master strategy it has been decided to work on five different development projects and it is necessary to decide in the course of time on which developments one's efforts should be concentrated.

Figure 23: 2nd phase

After several observations it has transpired that external developments show a certain tendency in the direction of scenario B. Since this causes a slight shift that is still within the framework of the master strategy, it would not be appropriate here to abandon the master strategy and concentrate on scenario B activities. Instead, further observation times are introduced for the short term so as to find out within short intervals whether external developments are actually moving towards scenario B.

Figure 24: 3rd phase

As a result of the additional observation times it has been shown that the trend is moving away from scenario B and towards scenario A. Observations are now made, if necessary at short intervals, to find whether the trend towards scenario A will be confirmed or not.

It having been confirmed that the situation is definitely developing towards scenario A, the phase is now reached where concrete decisions have to be made, e. g. about investments. Here the main factors are the mentality and readiness to take risks of planners and decision makers. The more daring and entrepreneurial type of planner will align the strategy with scenario A and make certain decisions towards scenario A at an earlier moment. More cautious planners and decision makers will wait and make further observations and wait for feedback until they are sure that they cannot make a mistake by deciding in favour of scenario A.

The advantage of more daring and entrepreneurial behaviour is that there is a good chance of being the first to seize on new developments, of being the first on the market and of achieving a competitive advantage. The disadvantage is that, if the trend definitely changes, the decision is difficult to correct.

The advantage of more cautious behaviour is that the most important decisions, for example, about investments, are delayed until it is certain that the trend is in the direction of scenario A. The disadvantage is that by delaying the decision, competitors can take the lead; it may no longer be possible to achieve a strong market position.

Figures 22 to 24 show that in scenario planning, in contrast with portfolio analyses, it is not possible to talk about standard monitoring systems. The translation of scenarios, linked to an environment monitoring system, gives planners a sure decision-making aid for the future and leaves it up to them whether they want to be progressive or cautious.

Using the Environment Monitoring System to detect new Developments

An environment monitoring system can be used not just to adapt and monitor the master strategy, but also to recognise possible changes in the various company environments at a very early stage.

If a monitoring group works with this system for a certain time, the observers are so well attuned that in the environment of the developments to be observed changes can be detected early, as well as analysed and interpreted better. When detecting developments that previously did not exist or were not yet relevant for the company, it is also necessary to check in what form they will affect the company goals and the master strategy. Only then should tests be made to find out the extent to which such new developments will cause goals and master strategy to change.

An experience shared by many monitoring groups is that in many cases, when a system of this type is initially set up in the company, too many external factors are observed. With time, it is realised that the key variables in the external environment are limited to relatively few characteristic variables and that a series of other factors depend on and adapt to the behaviour and development of the key variables.

Revising Scenarios with the Aid of the Environment Monitoring System

In scenario seminars and projects the question is often asked how frequently a new scenario should be developed or an existing one revised. Opinions on this differ considerably. There are major companies which, thanks to large planning departments, are able to carefully adapt or change their scenarios every other year. These biennial corrections do not significantly change the scenarios but are merely adjustments. In most cases the expenditure on adjustment is greater than the immediate benefit for the master strategy that can be derived from it.

Companies that want to keep expenditure at a realistic level should concentrate on adapting their master strategy to suit any changes in environmental developments and revising their scenarios approximately every four to six years.

When revising a scenario it is not necessary to start the whole process over again, but the results of the environment monitoring system are used instead. The following are checked:

1. Which of the descriptors/characteristic variables processed in the original scenario are still relevant due to their influence on the company and also due to their environmental system dynamics?

2. Which former scenario characteristic variables can be classified as less important or neglible as a result of the monitoring system?

3. What new developments discovered as a result of the monitoring system must be noted in the new scenario development, which did not exist or were not so crucial in the original scenario development?

On this basis the expenditure on steps 2 and 3 can be considerably reduced. If some fundamental interactions between the descriptors have changed, or if a relatively large number of new factors must be taken into account – this can also result from a changed company objective – it is anyway advisable to carry out another consistency analysis as in step 4 (grouping alternatives). For scenario revision the horizon should normally lie 10 to possibly 15 years beyond the existing horizon, because the first horizon is being approached on the time axis and it is now necessary to know how external developments will continue. On the basis of the newly calculated basic scenario structures the scenarios are reinterpreted and analysed in terms of their interrelationships and the changes connected with these.

In step 6 (consequence analysis) it is advisable deliberately not to take the

results of the first consequence analysis as the basis, but to derive the consequences afresh from the scenarios now developed. This enables one to move somewhat further into the future from the existing master strategy, and means that new approaches that may result from the scenarios are not neglected due to the shape of the original master strategy.

The disruption analysis should also be carried out once more, especially with regard to possible new disruptions which may even already have been detected as a result of completing the disruption check list. On the basis of the new consequence analysis and the preventive measures for disruptions a new master strategy should now be conceived which can then be linked back with the existing master strategy in step 8.

The next step is to harmonise the first or medium-term and the new long-term master strategy. This harmonisation can be carried out in two ways:

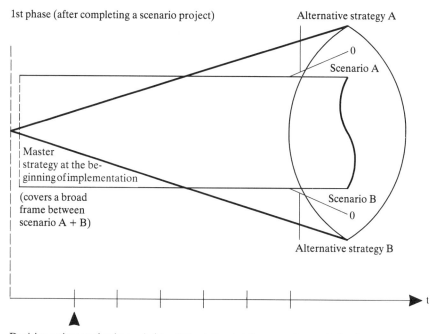

Decision points on the time axis (should be defined at the start of scenario implementation)
The following tasks are carried out at the decision points:
a) Feedback from the environment monitoring system
b) Analysis of the progress of the projects defined within the central strategy (e. g. development projects, market analyses)
c) Linking the results of a) and b) to the central strategy
d) Decision about selection of projects or, if necessary, careful correction of the central strategy

Figure 22: Central strategy implementation after adjusting to external developments with the aid of the environment monitoring system

1. Adapting the existing (old) master strategy to the master strategy that extends further into the future, so as to give the master strategy a progressive and more innovative character, or

2. Adapting the second master strategy to the first, which, however, removes part of the more forward looking, innovative cautious master strategy. This synthesis would then rather correspond to a cautiously operating master strategy.

Experience shows that the first method is to be preferred, so as better to utilise the possibilities of the future and adjust to them.

2nd phase (after two to three observation and decision phases)

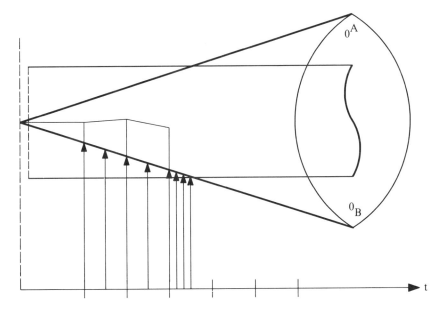

Activities:
a) Feedback from the environment monitoring system
b) Analysis of the progress of the projects defined within the master strategy (e. g. development projects, market analyses)
c) Linking the results of a) and b) back to the master strategy
d) Define further short-term observation points to check whether the trend continues in direction B

Figure 23: Master strategy implementation after adjusting to external developments with the aid of the environment monitoring system

3rd phase (after five to six observation and decision phases)

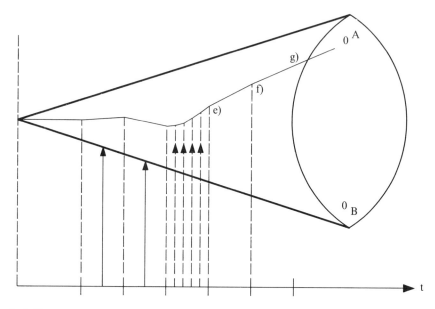

Activities:
a) Feedback from the environment monitoring system
b) Analysis of the progress of the projects defined within the master strategy (e. g. development projects, market analyses)
c) Linking the results of a) and b) back to the master strategy
d) Define further short-term observation points to check whether the trend continues in direction A
e) In this phase entrepreneurial planners steer the master strategy more towards future A; first decisions taken in direction A
f) Cautious planners only now steer the master strategy towards scenario A; more entrepreneurial planners are already making decisions towards A (e. g. investment decisions)
g) Cautious planners make decisions towards scenario A

Figure 24: Master strategy implementation after adjusting to external developments with the aid of the environment monitoring system

The Scenario Method as a Basis for Separate Topics

> *He who places too much value on short-term success*
> *will be thrown by a reversal.*
>
> (Horace)

Scenarios for Innovation Planning

Scenarios for innovation planning can be used in two different ways: firstly, if one already has a new product under development or being planned and wants to know in what future environment this product is bound to be successful; and secondly, when one has realised that new products are needed, but one does not know yet which new products are the right ones for the future.

In the first case, when a new product is already at the planning or development stage and there is uncertainty about the final production and market introduction decision, it is advisable to develop scenarios relating to the future environments of this product. The scenario process is the same as in the conventional strategic planning procedure. The only difference is that in the task analysis the actual product is dealt with in its structure and its strengths and weaknesses. In the consequence analysis it is then possible to see what new requirements will be made of this new product in the future, how the requirement profile could look and what could be the risks and threats for this product. From this, product modifications or better plans for existing or new products can be developed.

In the worst case, it can be seen that the newly planned product has relatively little chance of future success. In this case it is advisable to derive ideas from the consequence analysis about new products that could be developed and marketed in its place.

If it has been realised that new products are important for the company but it is not yet known in what direction to go, it is advisable to base the task analysis (step 1) both on the existing product range of the company and on the company strengths and weaknesses. In this case the consequence analysis (step 6) will concentrate on deriving ideas for new products and the master strategy will then choose those product proposals that can be successful in both scenario frameworks. As the scenarios give a comprehensive insight into the future development of the environment, this often gives rise to ideas for a new product family or a system of products and services that suits various environmental developments.

Scenarios for Diversification Planning

Scenarios for diversification planning can, as in innovation planning, be used for two different tasks:

1. If the direction of diversification has already been chosen and relatively little knowledge exists about the future environments of the diversification fields, it is advisable to use scenarios so as on the one hand to test the planned diversification against future scenarios, and on the other hand to incorporate suitable improvements, modifications and additions.

2. If, however, the task is to plan diversification for the company and it is not yet known in what direction to go, it is advisable to carry out scenarios to find future diversification fields. Here the starting point is the existing strengths of the company and the first task is to use a search field matrix to work out which company strengths best fit particular search fields. After analysis has shown what search fields are suitable for diversification, these search fields are made the centre of the project in their structure and requirements. The subsequent influence analysis and projections are then concentrated on the external environments of these search field areas.

 The consequence analysis in step 6 concentrates on deriving opportunities and risks from the search fields selected in the first step and developing suitable activities within the search fields. The various search fields can also be tested against the different scenarios (see "Testing existing goals and strategies" and "Scenarios for evaluating strategic decisions"). Testing different search fields against the scenarios gives planners a decision-making aid as to which search field contains the most opportunities for the future.

Frequently specific search fields emerge with clear relevance to the future which exist in both the different scenarios and offer attractive opportunities.

In many cases this means that new products are found for existing markets or new markets for existing products. As the scenario is monitored far into the future and monitoring covers the entire environment very systematically, there are also opportunities for diversification in respect of new products for new markets. However, this is normally seen as a long-term prospect for a company.

It is then advisable to enter the diversification lines on the time axis, for example, for the short to medium term:

– old products for new markets, including the development of new selling systems, and

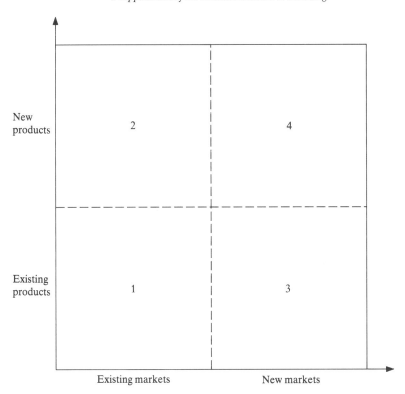

Figure 25: Diversification matrix

1 Existing products for existing markets (present company position)

2 New products for existing markets (first attempt at diversification)

 Advantage: The company stays in its known markets and uses new products

 Task: Development of new products to suit the requirements of known markets; the innovation task is concentrated on development

3 Existing products for new markets (can also be the first attempt at diversification)

 Advantage: No new product development but, if necessary, adaptation of existing products to new market and user needs

 Task: Opening up new markets and users; the innovation task is concentrated on the user side (market innovation)

4 New products for new markets (always the last stage in diversification; it is unimportant whether 4 is reached by way of 2 or 3)

- new products for old markets. In the medium to long term the following can then be considered:
- development of new products for new markets, it being possible to use experience from short- to medium-term diversification for this (see also Figures 25 and 26).

Linked in this way with an environment monitoring system, planning for diversification away from the original business can be made very reliable and future orientated.

When a company plans extensive diversification (new products for new markets) with the aid of a joint venture or acquisition, it is important to check this strategy with scenarios and to secure and modify it appropriately.

Scenarios for Production Planning

A company's production planning is normally dependent on its strategic and long-term planning as well as its investment planning. If scenarios are developed for a manufacturing company in which the issue is the future of the company as a whole, the theme of production is handled within the master strate-

Figure 26: Diversification on the time axis

gy. The scenarios produce future requirements for rationalisation, automation and quality control. In most cases it is sufficient to handle production planning within the framework of an overall strategic plan, if the above-mentioned aspects are involved. However, if a company is planning to introduce a new system such as PPS or CAD/CAM or CIM, this decision must also be looked at from the strategic point of view. In this case it is advisable to carry out special scenarios for production planning.

In step 1 (task analysis) both the long-term goals and strategies of the company and the long-term goals and strategies for production are defined. The strengths and weaknesses analysis concentrates on the strengths and weaknesses of present-day production. Since in a specialised topic of this nature the internal company framework has an important influence on production planning, it must be dealt with in step 1 as a so-called internal area of influence or in the form of internal conditions. This internal area of influence should be seen as a further circle around the central topic of production planning and should in no circumstances be treated in the same way as the external areas of influence. This procedure ensures that later in the consequence analysis both the internal conditions and the company as well as production planning are dealt with. If the company were treated as a further area of influence like all the other external areas of influence, due to their lower system dynamics in comparison with all the other areas of influence the internal conditions would only have passive or buffering significance. So the company cannot be projected into the future as a scenario area of influence because in most cases company development is heavily dependent on external areas of influence.

Scenario developments	Opportunities/ risks for the company	Activities to exploit opportunities/ minimise risks	Production requirements arising from the scenarios and the company activities	Concepts for production, manufacturing systems, organisation of production, staff needed

Figure 27: Consequence analysis for production planning

In step 6 (consequence analysis) there are two stages: first, consequences for the company itself are derived from the procedure in the form of opportunities and risks and suitable activities.

In a second stage future production requirements are ascertained on the basis of the opportunities, risks and activities for the company and the scenario developments. Based on this, concepts for production, possible production systems, and the organisation of production are developed. From this can be derived not only the basis for decision making about a new system, but at the same time concepts for organising the production and the production environment as well as personnel planning.

Personnel planning for production should be both quantitative and qualitative. The qualitative analysis states what employees with what profile of characteristics and qualifications are needed, the extent to which the existing personnel meets these requirements, and what retraining or further training is necessary. The subsequent quantitative analysis provides information on the numbers and qualifications of the required personnel.

Scenarios for Marketing Planning

The scenario method is used for marketing planning in a similar way to production planning. In the mid to late seventies, when the significance of the scenario technique for strategic planning had not yet been fully recognised, the scenario method was much used as a basis for future-oriented marketing plan-

Scenario developments	Opportunities/ risks for the company	Activities to exploit opportunities/ minimise risks	Marketing requirements arising from the scenarios and the company activities	Concepts for strategic marketing (including all marketing instruments)

Figure 28: Consequence analysis for marketing planning

ning. Most companies now work out their marketing planning as part of the strategic planning based on the scenarios. This is the recommended approach, because marketing planning is essentially based on the long-term goals and strategies adopted in strategic planning.

However, if a company wants to use the scenarios specifically for future-oriented strategic marketing planning, it is advisable to use the same methodical approach (step 1: task analysis, and step 6: consequence analysis) as for production planning (see also Figure 28).

Scenarios for Personnel Planning

In the past, personnel planning was often not really regarded and treated from a strategic point of view. Usually strategic plans were worked out, projects adopted, the tasks and organisation of divisions changed, and planners were then confronted with the fact that these activities could not be implemented without involving the personnel. It was also often realised that the right staff and management were not available to carry out these tasks, or staff and management with new qualifications were needed.

Today corporate awareness has developed to the extent that personnel planning is regarded as an important component of overall strategic planning, and is taken into account within the framework of a strategic planning concept in the same way as all other areas. If personnel planning is carried out in isolation there is a risk that it will start from different assumptions without an awareness of what future strategies are planned by the company, which strategies may

Scenario developments	Oppor-tunities/ risks for the com-pany	Activities to exploit op-portunities/ minimise risks	New staff and man-agement require-ments arising from the scenarios and the company activities	Concepts for quan-titative and quali-tative personnel planning, e.g. − how many staff with what qualifications − necessary training and retraining

Figure 29: Consequence analysis for personnel planning

have far-reaching implications for staff requirements both from the point of view of quantity and quality. It is therefore advisable to include a member of the personnel department in scenario teams concerned with a company's strategic direction. In certain cases it is useful to work out scenarios for personnel planning, for example, if a company is diversifying into new markets, building up a new line of products and services that differ considerably from the existing products and services, or if the company is converting to completely new technologies that require staff with new skills.

In this case one should proceed methodically as already described for production planning and marketing planning; this applies to step 1 (task analysis) and step 6 (consequence analysis); see also Figure 29.

Scenarios for Personal Career Planning

> *He who understands others is learned, he who understands himself is wise, he who conquers others has physical strength, he who conquers himself is strong, he who is content is rich, he who does not lose his centre endures.*
>
> (Lao Tse)

There exist a number of different methods and approaches to life and career planning. This is not the place to assess or evaluate all relevant methods in this field, but to describe how such planning can be done with the scenario technique.

In contrast to the usual scenario projects, which in most cases have a specific company background and are therefore processed by a team, it is quite possible for a personal scenario project to be carried out by an individual working alone. Moreover this provides initial training in the technique so that confidence can be gained about its application. The recommendation for scenario users is first to work out a personal scenario of this nature before risking the method in the company where a number of people will be involved. A personal scenario can be regarded as a test run.

The advantage of the scenario method for personal life and career planning is that one is hardly likely to overlook or neglect important questions or areas.

The scenario process for a personal scenario is described below.

Step 1 – Task Analysis

Question 1.1:

What aspect of my personal future do I want to deal with for what reasons?

Unlike any scenarios used in the economy, the picture of one's personal future is a relatively clear, less complex reality. It is therefore possible to work relatively rapidly and to manage with less information. But the degree of astonishment and the risk of subjective misjudgements is greater when working on one's own than when working in a team with a subject not related to oneself. To avoid possible misjudgements, one can work on the picture of the future on one's own and then discuss it with a partner who knows one well. Such people could be spouses and good friends or colleagues with whom one has a relationship of trust.

Examples of answers to question 1.1 are:

- my professional future
- my future in this company
- my future in a new company in a different industry
- my existence in retirement
- my personal future not limited to my private or professional life

Question 1.2:

What is the list of strengths and weaknesses related to the chosen topic?

It is important here to be very honest about oneself and to make the most comprehensive possible list of strengths and weaknesses. This personally created list can be made more objective through discussion with trusted people, so that one's self-image can be supplemented and corrected by the image others have of oneself.

Question 1.3:

What problems can I see today that must be solved in the short, medium or long term with reference to my personal future?

This list of problems should not boil down to an attempt to eliminate all the weaknesses, since this is illusory (there are no people without faults) and this

approach is very costly in terms of energy. It might be better to formulate the question as follows:

How can I achieve professional goals despite certain weaknesses, or how can I use certain strengths even more towards achieving personal goals?

Having tackled oneself and one's strengths and weaknesses in this intensive way it is advisable to set aside a period for reflection to note what new insights one has gained into oneself and what one sees differently from hitherto.

This period of reflection should follow each step.

Step 2 – Influence Analysis

Question 2.1:
What areas of influence am I affected by?

Question 2.2:
What influencing factors within these areas of influence are relevant to me?

In the case of a personal scenario the definition of areas of influence and influencing factors is not entirely simple. The main thing is to recognise which areas are relevant to oneself. These may be for example:

– Family
– Employer
– Friends and acquaintances
– Upbringing and educational background
– Social environment

Naturally each individual must decide for himself which of the named areas of influence have an effect on the personal scenario. Within these areas those factors should be listed that according to one's personal estimation have a strong influence on oneself. These may vary considerably according to objective assessment, but the important thing is to ascertain those factors which are specially relevant to working out one's personal picture of the future.

Question 2.3
How are the factors within each area of influence to be placed in order of importance?

This assessment too should be made according to one's personal judgement and not from an objective judgement or one made externally.

Question 2.4:
How do the areas of influence and the subject of investigation, in other words, the creator of the future scenario, mutually influence each other?

In the case of personal future scenarios it is important to include oneself as an influencing factor in the network matrix

Question 2.5:
In what order of rank are the areas of influence and oneself to be placed?

This can be answered very easily with the aid of the network matrix and the system grid (see also step 2: influence analysis).

Step 3 – Projections

Question 3.1:
What period of time is to be taken as the basis?

Only in step 3 does one start to deal with the future. Now at the latest the creator of a personal scenario must define the period he wishes to deal with so as to work out sensible statements for his future decisions.

Question 3.2:
How are the individual influencing factors going to develop into the future?

At this point one will realise that one has regarded certain things in one's personal environment as certain or probable, which now that their development in the future is regarded neutrally, may develop along very different lines. One should regard the development of one's areas of influence as being without influence from oneself, so as to arrive at scenarios that indicate different developments and in some instances take on a different course from that expected. The only area not included in the projections is oneself, because the intention is to decide on the basis of the scenarios how one is going to develop. So only the external areas of influence are projected, as is also the case for company scenarios. It is also important at this point to work out plausible reasons for all developments that have alternative or definite courses.

Step 4 – Grouping Alternatives

Question 4.1:
What alternatives fit together consistently to provide a basis for different future scenarios?

To develop alternative future scenarios one can assume that the definite projections will be included in each of the futures. However, the alternative developments must be investigated to find which ones fit well together and which less well or not at all. For this purpose one can list all alternative developments in the ranking order of their areas of influence and attempt to assign them as appropriately as possible to a future scenario A and a future scenario B.

In a personal scenario one can assume with a reasonable degree of certainty that the result will be one scenario that is mainly positive and optimistic – the target scenario and one that is more pessimistic – the unwanted scenario. In this case the grouping is relatively clear and simple in contrast to company scenarios, where extensive computer-aided consistency analyses must be made.

Step 5 – Scenario Interpretation

Question 5.1:
How could the future look in the two alternative future scenarios?

Here too it is advisable, just as in company scenarios, to work out the development of the external areas of influence without reference to one's own desires and objectives. In this case it is helpful to bring a bit of fantasy and creativity into the systematic framework. Experience has shown that this arrangement of one's own environment is great fun for the participants, because they think themselves into future developments by which they are personally greatly affected and are able to interpret these. Care should be taken, however, not to mix desires and goals for one's own future into these personal scenarios.

Step 6 – Consequence Analysis

Question 6.1:
What opportunities and risks can be seen in the personal future scenarios and what should the scenario developer do if possible to exploit opportunities and minimise risks?

Especially in personal scenarios it is often apparent that the same scenario statement contains both opportunities and risks. For greater clarity on this it is essential to evaluate the opportunities and risks in terms of their importance for one's personal development.

Question 6.2:
What activities can one carry out oneself in various scenario frameworks (various opportunities and risks)?

This is the first basis for a personal master strategy which one will pursue irrespective of which personal environment scenario actually occurs.

Step 7 – Disruptive Event Analysis

Question 7.1:
What important, sudden, unique events not included in the future scenarios could occur?

These events can be negative ones, such as accident, unemployment, but also positive ones, such as undreamed-of career openings, or an inheritance.

Question 7.2:
How important are these events for me?

In this step the events compiled in 7.1 are placed in order of importance for the person concerned. In this connection it is important not only to analyse the effects on oneself but at the same time to consider how disruptive events can be avoided (preventive measures) and what response measures are necessary.
This step makes one very aware of certain events that normally are regarded as events that happen to others and not to oneself. The analysis of the risks to oneself also shows up weak points to which special attention can be paid or in respect of which one can consider how these crisis points can be avoided.

Step 8 – Scenario Transfer

Question 8.1:
How can the same activities for different opportunities and risks in the scenarios be combined into a personal master strategy, and how can preventive measures for disruptive events be integrated into this master strategy?

It is often interesting to note here that, despite various favourable or less favourable external developments, one can implement and carry through specific strategies for oneself. Precise consideration must also be given to the detailed measures with which these strategies can be implemented. From this point, therefore, one comes back to the present and considers the ways in which specific short-, medium- and long-term goals of a personal nature can be achieved. It is always helpful to connect back with the system dynamics of the scenarios and to consider where the leverage can be applied and where the greatest synergy effects take place. In other words the external developments should be used as a driving force for personal goals and strategies.

Personal scenarios of this nature are also very suitable for evaluating decisions in one's own life and aligning them with the scenarios.

Such personal scenarios are likely to change more quickly than company scenarios. It is therefore necessary to check them from time to time (every year to two years), correct them and adjust them so as to take possible changes into account. You should examine your personal scenario during a period of contemplation and rest (on a holiday or at the end of the year) in order to reflect on what has so far occurred of the envisaged developments, what changes there have been, and how can one better adjust to the future.

Concluding Remarks on Personal Scenarios

This journey into the future is not only exciting for the person concerned but generally also full of discovery and it helps one better to recognise interconnected environmental factors, to adjust to them and be able to use them.

Experience of personal scenarios also shows that in situations where the scenario developer is or believes himself to be at a dead end, systematic work opens up a number of alternatives or ways out. This enables a better insight into one's own potential and external developments and in most cases leads to a more positive, more self-starting attitude.

Instead of asking, "Am I doing this job right?", we should wonder more often, "Am I doing the right kind of job?"

(Proverb)

7

Setting up Scenarios

Selecting the Area to be Analysed

In most cases, companies are faced with the decision whether to set up scenarios for the entire company, e. g. for strategically planning the business as a whole, or rather just for one strategic business unit or a single division. Setting up scenarios for the business as a whole is an obvious solution for the smaller type of company that features a uniform product structure, or for major corporations also featuring a relatively uniform product structure. Setting up individual scenarios for single strategic business units is recommended, however, if a company is engaged in widely diversified business, which would cause its various divisions to have relatively few points of contact in common and would also make for very different external areas of influence.

Scenarios for a Strategic Business Unit (SBU)

Scenarios for a strategic business unit represent, as it were, the ideal kind of scenario, as here we have a single determined structure of product market combinations, set up in advance according to strategic criteria. However, when considering scenarios for strategic business units, there are further points to be taken into account, namely, the overall strategic goal of the company concerned and its corporate identity; for these, as internal setting factors, will form part of any task analysis. In the case of scenarios for strategic business units or for individual divisions, there is an excellent chance to get the decision-makers in any particular strategic business unit or division to participate in the scenario project. This also is one of the best prerequisites for jointly translating the strategy which will be developed on the basis of these scenarios into actual practice and taking up responsibility for the outcome.

Scenarios for strategic business units are also frequently employed when a company is considering whether to base its planning system on the scenario

approach. In these cases a strategic business unit will be selected which, as a rule, shows the greatest need for strategic planning and whose decision-makers already show a certain awareness of problems and the need for re-orientation. As a rule, this is the case whenever some outside problem pressure is being experienced and decision-makers feel forced to solve these problems – which in most cases are full of uncertainties – in the short, medium and long terms. Moreover, when applying scenarios for strategic business units, it should always be remembered that the strategy finally agreed upon and carried out must not contradict any goals and strategies of the company as a whole. This may be checked by a feedback procedure in step 8 (Scenario Transfer).

Scenarios for an Entire Enterprise

Scenarios for an entire enterprise are set up when a company feels the need to reorientate itself in relation to its strategic direction. Frequently this happens when there is unease about existing plans which are, in most cases, quantitatively orientated and have been extrapolated on the basis of past experience; there may also be uncertainty about the turn external developments are going to take. Scenarios for an entire enterprise are an obvious solution, even if the company concerned features relatively uniform product and market structures resulting in the company's various business units all being quite similar. Likewise, even if the company concerned is relatively small, a scenario for the enterprise as a whole is set up. It will also be necessary to set up scenarios for the entire enterprise, if existing goals and strategies are to be checked and strategic decisions evaluated.

The advantage of scenarios for an entire enterprise lies in the fact that a common basis is created for *all* goals and strategies as well as decisions. Following the general orientation of the enterprise as a whole, detailed planning (two-level consequence analysis) is able to show how this orientation will work through to individual company divisions and how these divisions should handle these consequences. A consequence analysis is then carried out in much the same way as this is done for individual subjects (see production, marketing and recruitment planning).

Scenarios for Subjects External to an Enterprise

Scenarios for subjects *external* to an enterprise are set up –

1. As pilot projects to study and test the scenario approach, and to decide whether to use this method for the company concerned or any of its strategic business units.

2. If a company intends to diversify into a completely new sector which it was not active in previously; here, scenarios are to aid in obtaining knowledge and information on this new sector. This requires relevant information in the new field to be readily available or to be gained by turning to expert knowledge as such and / or questioning experts, since a company that has not previously done work in this field will of course have had very little experience in this new sector. On the other hand, it is just in this kind of situation that there is the greatest need for the application of scenario techniques; for one does not really have nearly enough clues as to how the new area of diversification will develop in future, yet forward-looking information is needed to have a sound basis on which to come to well-founded decisions.

Scenarios for Global Subjects

Scenarios for global subjects are set up mostly by research institutes; these scenarios usually relate to certain subjects that are relevant to several companies or an entire sector. Subjects might conceivably be:

– developments in microelectronics
– developments in biotechnology
– developments in genetic engineering

As a rule, global subjects of this kind are dealt with on a very abstract level, in most cases taking into account worldwide influence factors as well. Because of this, scenarios and any consequences derived from them show an extremely global approach. A company interested in this kind of global subject cannot directly translate these scenarios into its own planning. First, these global scenarios need to be augmented by influence fields and influence factors of special relevance to the company concerned. Only then will it be possible to set up a meaningful consequence analysis in relation to opportunities and risks for the company concerned.

This type of scenario for general interest subjects is frequently used as basic

information for company-specific scenarios. This is highly recommended, particularly if the information is linked with company-specific influence factors. In this connection, however, there is always a need to check whether the influence factors referred to in global scenarios are really relevant to the company concerned, or if other factors exist that are particularly important to the company but were not included in those global scenarios.

General experience shows that, in most cases, global scenarios are used to provide an information base for setting up strategic business unit scenarios or scenarios for an entire enterprise. And this really represents their special usefulness and value for any company. However, no one should imagine that dealing with a global subject replaces company-specific scenarios.

Time Required to set up a Scenario

> *It is not that we do not have the time, but that we waste too much of it.*
>
> (Seneca)

The scenario approach is extremely flexible with regard to the scale on which scenario projects for companies or strategic business units may possibly be, or indeed are to be, set up. The question of scale basically depends on what task scenarios are to be set up for. If, for instance, it is intended to set up scenarios for an entire enterprise, this will only be feasible within the general framework of a scenario project; for smaller companies, however, or when dealing with well-defined subjects within a larger theme, it may be quite possible to use an abbreviated form of scenarios.

Company-Specific Scenario Seminars

This smallest-scale method of setting up scenarios is appropriate whenever the company concerned is itself rather small, or when a scenario application is to be tested using a small isolated sample case. As a rule, company-specific scenario seminars require three days, during which participants will progress through the eight steps of the scenario process. In addition, it is generally helpful to schedule a half-day meeting for a planning discussion in order to do appropriate advance work on what is to be the scenario subject, setting up the scenario team and determining who is going to prepare what information. At the end of the three-day seminar, there will be a report on scenario results, and it is recommended to follow this by a half-day, or indeed a full day, of scenario

transfer consultations. During these consultations a tentative master strategy set up on the basis of the results report is discussed and passed; at the same time possible approaches to an environment monitoring system are established, and agreement is reached on what further action to take.

Scenario Mini-Projects

Scenario mini-projects are appropriate for well-defined subjects within a larger theme, strategic business units, or particular sectors in medium-size to small companies. A scenario mini-project comprises two scenario workshops of three days each. Additionally, there is one half-day planning meeting, during which there are pre-discussions on scenario goals on who is going to take part and on how information is to be provided and prepared. At the end of both workshops there is approximately one day of final discussions during which a master strategy is passed, definite activities derived from the latter, and an environment monitoring system established.

The first workshop concerns itself with steps 1 to 4 (task analysis, influence analysis, trend projections, and grouping of alternatives). With regard to step 1, scenario team members will be given some questions at their planning meeting; until they meet for their first workshop, members are to consider how to find possible answers. These answers will then be collected, weighted and evaluated during the first workshop. Questions usually refer to, e. g.:

– Company policy
– Present goals and strategies (short-, medium- and long-term)
– Strengths and weaknesses of company or division
– General internal conditions

In this connection it is important that only policies, goals and strategies are listed which *actually* exist in the company concerned. If, for instance, the workshop brings to light any gaps or shortcomings, there is no need for participants to correct these at this stage. At this moment they are merely concerned with an analysis of the situation 'as is'. Any goal or strategy shortcomings brought to light are then corrected on the basis of consequence analysis and master strategy.

In the first scenario workshop, step 4 (grouping of alternatives), too, is taken only as far as consistency evaluation by participants. Data input and processing by computer program takes place during a break between the first and second scenario workshops. This break usually lasts four to six weeks. When consistency calculation results become available during this same break be-

tween the first and second scenario workshops, scenarios are elaborated and interpreted in networking terms. Scenarios are elaborated on the basis of computed results, definite trend projections and networking analyses from step 2. Interpretations of scenarios should be carried out not by a team, but by an individual, preferably by the process manager responsible for methods.

The second scenario workshop starts by presenting the scenarios arrived at; these are then edited by scenario team members. Any alterations done at this step should not question the validity of computed results. The term "editing" itself implies that scenario team members effect minor alterations on scenarios, whilst leaving their core intact. There are several advantages in this approach:

1. Scenario team members are able to work intensively with their scenarios, leading to an identification with results.

2. Pre-formulating work going into scenarios as described above considerably shortens the scenario interpretation process, allowing team members to be principally employed on tasks where, by results, they yield substantially more output as a team.

The second scenario workshop also comprises steps 6 (consequence analysis), 7 (disruptive event analysis), and 8 (scenario transfer). However, in most cases it will not be possible to formulate any master strategy during the course of this second scenario workshop; at the end of the scenario workshop, this is worked on by an individual, preferably the process manager, once results are in from consequence analysis and preventive action against disruptive events. The time scale for a scenario mini-project of this kind, from planning discussion to final meeting, may be calculated at approximately three months. All costs that the company concerned must calculate are worked out on the basis of number of project days times number of participants plus working hours required by the process manager for project days and interim tasks (reports, computer-aided analyses, scenario interpretation, and the development of a master strategy).

Scenario Projects

Scenario projects are appropriate for setting up fully comprehensive scenarios for medium-sized and large corporations. However, in this instance care must be taken to ensure that the company's strategic business units or divisions are not active in too disparate a range of markets; there should be a relatively

homogenous company structure. Fully comprehensive scenarios, encompassing an entire business, may then be set up by large and medium-sized corporations. Additionally scenario projects are suitable for strategic business units within large corporations, which means that any such strategic business unit is to all extent and purposes regarded as an independently operating company.

Scenario projects comprise half a day of planning discussions, four scenario workshops of two to three days each, and approximately one day of final discussions. Planning discussion and final discussion contain the same elements as for scenario mini-projects.

Scenario workshops are structured as follows:

1. First scenario workshop
 Working out step 1 (task analysis) and step 2 (influence analysis).

2. Interim phase
 A break of some four weeks to evaluate in report form the results of this first scenario workshop and, if necessary, to collect or obtain further information which may serve to support the first scenario workshop results and which is in any case essential to the next workshop for the drawing up of projections.

3. Second scenario workshop
 Working out step 3 (trend projections), and step 4 (grouping alternatives).

4. Interim phase
 In this phase, the team's consistency evaluations are processed using scenario software (consistency, stability, and sensitivity analyses). In a fashion similar to that employed for scenario mini-projects, computed scenarios are then filled in and interpreted by the process manager.

5. Third scenario workshop
 Just as the mini-projects' second workshop, this third scenario workshop starts by presenting the scenarios, which are then edited by team members. However, the real core activity of this third workshop is consequence analysis, which takes approximately two days.

6. Interim phase
 Preparing results in report form and developing a tentative master strategy, based on step 6 results (consequence analysis).

7. Fourth scenario workshop
 Working out step 7 (disruptive event analysis) and step 8 (scenario trans-
 fer).

8. Follow-up phase
 In addition to writing up results, the tentative master strategy is comple-
 mented by measures preventing disruptive events.

9. Final discussion
 This meeting agrees and passes the master strategy in its final form, defines
 projects within this master strategy and assigns relevant responsibilities,
 sets up a project plan for individual activities, and establishes the environ-
 ment monitoring system by setting up the organisational structure and
 assigning responsibilities and tasks.

For certain applications, it may be appropriate for companies to implement
a two-level consequence analysis. This applies if a major corporation sets up its
forward planning for the entire business and wants to gear planning in even
greater detail towards its various strategic business units. The first phase of
consequence analysis determines opportunities, risks and activities for the cor-
poration as a whole. The second phase consistently gears such opportunities,
risks and activities towards strategic business units. A two-level consequence
analysis may also be required when categorising according to regional aspects,
e. g. deriving particular strategies for industrialised countries, threshold coun-
tries and developing countries. Applying a two-level consequence analysis is
appropriate, too, in cases where consequences are to be worked out for special
subject areas in addition to the strategic orientation of the company as a whole
(see p. 173). When implementing a two-level consequence analysis of this
kind, an additional scenario workshop may, but need not necessarily, be intro-
duced. In most cases this works out such that the third scenario workshop
derives consequences for the corporation as a whole, the fourth scenario
workshop develops second phase consequences for a strategic business unit or
some special subject area, and the fifth scenario workshop finally deals with
the same tasks which, in an ordinary project, a fourth scenario workshop
would comprise.

The time-scale for implementing a scenario project, starting with a planning
discussion and ending with a final meeting, is six to eight months. Costs to the
company, in terms of time required, may be calculated on the basis of number
of project days times number of scenario team members plus the relevant time
periods required by the process manager, and taking into account working
days between individual scenario workshops as well.

A further advantage inherent in scenario projects is the fact that there is more time set aside at the start to carry out detailed and intensive work on all the individual steps of any scenario process; each scenario step will require a full working day, with step 6 (consequence analysis) having to be calculated at two working days in most cases.

With regard to the question of how a given company can decide what kind of scenario processing and what scale to select, see Figure 30.

Company goal	Learning the method, and applying it in case not specific to company	Scenario results as basis for SBU planning	Scenario results as basis for planning of entire company
Company size	small, medium, large	small	small
Complexity of subject	low	low to medium	medium
What type of scenario to set up			
1. A three-day company internal seminar + ½ day planning + 1 day final discussion	X	XX	X
2. Scenario mini-project (2 scenario workshops of 3 days each + ½ day planning + 1 day final discussion)		X	XX
3. Scenario project (4 scenario workshops of 2–3 days each + ½ day planning + 1 day final discussion)			
4. Scenario Project (5 scenario workshops of 2–3 days each + ½ day planning + 1 day final discussion) *			

Note: * This additional workshop may be required when doing a two-level consequence analysis. Preference is to be given to versions marked by crosses.

Fig. 30: Scenario scale in relation to company size, company goal, and complexity of subject.

Scenario results as basis for SBU planning	Scenario results as basis for planning of entire company	Scenario results as basis for SBU planning	Scenario results as basis for planning of entire company
small to medium	medium	large	large
low to medium	medium to high	medium to high	high
X			
XX	X	X	
	XX	XX	X
			XX

Organization

> *Man is given dominion over an infinitude of abilities, once he throws off lethargy and trusts that he must succeed when doing what he seriously puts his mind to.*
>
> (Ernst Moritz Arndt)

Selecting a Team

The quality of scenario results will be influenced decisively by the composition of the scenario team. For a company-specific scenario project, team members must be selected using the following criteria:

1. Decision-making and scenario transfer competence
2. Knowledge, experience, and know-how in the subject as well as some individual subject areas of influence
3. Diversity of specialisations and / or qualifications
4. Diversity of age groups
5. Social homogeneity

Decision-making and Scenario Transfer Competence

Scenarios serve to work out a basis for strategic and other company planning projects; right from the start, therefore, it is most important to involve a company's decision-makers in the scenario process. What this means is that first, second and third line management personnel (in the case of major corporations) should be won as scenario team members. Naturally, one of the objections always raised at this point is that management personnel operate under heavy time constraints; i. e. their appointments list is usually very long indeed, so that they simply do not have the time needed for engaging in a scenario project. The answer lies in realising that one of the most important tasks facing the management of any company is that of securing their company's future; and this means engaging in strategic planning and scenario development. Management should be fully aware that securing the future of their company is one of their most important tasks; in consequence, this task should not be delegated to lower levels.

If an attempt is made to delegate to middle management the task of setting up scenarios and developing strategies, it will be found in most cases that the

results do not lend themselves to being transferred easily; the reason for this is that a middle management scenario team faces the additional task of having "to sell" and communicate its results to higher-level decision-makers as well as to colleagues on the same and lower levels. Right from the beginning, any project employing a team of this type faces a much lower chance of success. The best experiences with actually transferring scenario results have been made when it is *first line management that takes time out for a scenario project*. In response to the often quoted and generally known lack of time, those at the helm of their company should not ask themselves, "Am I doing this job right?" but rather "Am I doing the right kind of job?".

Knowledge, Experience, and Know-how in the Subject as well as some individual Subject Areas of Influence

The second objection which is frequently raised with regard to highest-level management is: Do first-line managers have the necessary know-how for implementing a scenario project? In most cases, the know-how of scenario team members is quite sufficient. In the event of any special information – beyond the scope of team members' know-how – being required, these tasks may be delegated to staff members who will then collect, analyse and prepare that information in between scenario workshops; it will then be available, as and when required, during scenario workshops.

As scenario projects concern themselves, by definition, with the external influence factors for any given subject, it is most important to be able to draw on a correspondingly wide and heterogenous spectrum of know-how. At this point, it is often suggested that external experts might be included in scenario teams; such experts would then be able to deal with certain well-defined topics within the overall subject. Actual experience of results gained by employing such external experts has proved to be quite diverse; reactions range from favouring their employment to unconditional rejection. The problem is that these experts do not know the company situation well enough to "home in" on it when presenting their topics. Furthermore, there is a real danger of experts trying to dominate the group (i. e. the scenario team) with their point of view, as they are convinced that they are the only people on earth who "really know" the subject under discussion. Frequently experts are not willing or not able to admit the possibility of alternative developments in their specialist subject. A further problem is posed by the very confidentiality of information, data and evaluations worked out and discussed in company scenarios. Thus, if the presence of external experts leads to a scenario team not discussing certain company internal topics with a sufficient degree of honesty and openness, the sce-

nario project loses depth and credibility, and may allow incorrect accentuations and directions to enter.

How is one to solve then this question of urgently required expert know-how not available from within the company itself? Several solutions are possible:

– Certain analyses on specialist topics may be obtained from various market research institutions and research establishments

– Furthermore, data bank searches and analyses on certain topics are available and may be retrieved on a world-wide basis

– Additionally, certain topics may be dealt with by conducting a survey of external experts, taking the form of delphi-questioning or interviews; the results may then be used as input into the scenario project. It must be ensured, however, that not only *one* external expert's opinion or just *one* survey or analysis is being used but that *a variety* of sources will be employed. Using a variety of sources provides from the first a basis for alternative developments

Diversity of Specialisations and Qualifications

To cover the various internal functional groupings and company divisions as well as quite a diverse range of external areas of influence in respect of knowledge, experience and information, scenario team members should always represent a diversity of specialisations and qualifications. In this context, it is wise to consider before the actual start of the project (usually during the planning discussion) what internal functions and divisions are relevant to the task in hand and will be affected by any results obtained. It is also recommended that a brief advance analysis of external areas of influence be carried out in order to determine what areas of influence are relevant to the scenario subject selected and what level of know-how will be required to deal with them. The level of know-how required should not be set too low; the expert with a "single-track mind" who knows all there is to know on a very narrowly defined subject is therefore less suited to the task in hand than the expert with a "multi-track" mind who is fairly well informed on at least two specialist subjects and at the same time able to evaluate their (immediate) environments. In this regard, it is also quite important to feed in, via scenario team members, any information on competitors, their environments and technologies which may still be somewhat further afield from one's own company but which might pose a threat of substitution for the future.

A correct diversity of scenario team members' specialisations raises the chances for qualitatively good and useful alternative developments (step 3) and improves the chances for new ideas and strategy approaches that go beyond present company activities. A scenario team, working on a company scenario and featuring a diverse mix of specialisms, might for instance consist of management personnel from the following departments:

- Top-level management
- Strategic planning
- Development
- Production
- Quality control
- Application technology
- Marketing
- Distribution
- Personnel
- Controlling

Diversity of Age Groups

Considering the first criterion for scenario team member selection, the decision-making and scenario transfer level, this subsequent demand for a diversity of age groups represented in the team would appear to be a slight contradiction in terms, as in most cases there are no young employees to be found in first-line company management. Imagining, however, that any first-line company management will consist to a large extent of personnel belonging to approximately the same age group (in an extreme case, the team might consist of people in their mid-fifties), it becomes quite clear that experience and age will lead to a certain uniformity of outlook and statement. But as the aim is to develop and process a wide range of *different* alternatives for the future, it is recommended that younger staff be included in the scenario team, for example, young executive assistants, strategic planning staff, marketing staff, or staff from other company departments. The advantage of this approach is that young staff members view any inclusion in the scenario team (in any capacity) as something of a distinction and will show a very strong commitment to the task in hand in order to come up with particularly good contributions. On the other hand, younger scenario team members very often question aspects, or simply view them differently, which within a group of uniform age structure might tend to be seen and determined in just one way, and one way only. Ensuring in this way that there is a diversity of age groups represented in scenario teams

works particularly well in companies already practising an open and participatory style of management. In the case of companies where a hierarchic and authoritarian style of management is prevalent, this type of team work might be their first chance to change their management behaviour positively and give it a new direction.

Social Homogeneity

To ensure that scenario team members speak approximately the same language and will be able to communicate on the same intellectual level, the scenario team should be determined by a certain social homogeneity. Therefore it is not to be recommended to select scenario team members all the way down from board of directors level to specialist staff level. The more open and participatory a company's style of management is, the easier it will be to include team members from different hierarchical levels. Also, team members should show commitment to their position; they should be interested in the future of their company and be prepared to follow new paths for managing their company's future. People who show some scepticism when faced with a project of this type may still be included in the team; however, someone who rejects the scenario approach is not suitable as a scenario team member, even if they are well qualified to contribute to a given project.

Finally, a note on the size of scenario teams: As all work in the various individual steps of the scenario method will be carried out by division of labour (e.g. projections will be worked out by all members of the team, but in different working groups that concern themselves with different areas of influence), it is recommended that the team consist of approximately ten to twelve persons. This number of twelve scenario team members has frequently proved to be quite ideal. It is then possible to work in three working groups of four persons each, or in four working groups of three persons each. More than twelve team members should not become involved, otherwise agreement and presentation, as well as discussion, of working group results in the plenum will take up too much time. For larger teams, the ability to communicate and come to decisions decreases with the increase in the number of scenario team members exceeding the optimum team size. A team of three persons will be able to cope very well indeed with all systematic scenario method steps. If, for instance, a three-person team is to be tasked to work on future developments of technologies, it is to be recommended that two technology experts with differing know-how and differing information backgrounds as well as one team member from a more application- or marketing-oriented background be selected for the job. In the same way, when a team is to be tasked with develop-

ing sales markets, it should also include someone with technical know-how. This mix of specialisations within a small team helps to avoid one-sidedness either in outlook or evaluation. It is also one of the best provisions for high quality alternative developments.

Scenario Project Planning

Naturally, planning a project of this kind also encompasses aspects such as project location, premises, and materials required.

The project as such should be held in some location outside the company concerned, enabling participants to detach themselves and their feelings mentally and physically from day-to-day company business. In this regard, conference centres and company training centres are a good solution. Another prerequisite for scenario project success is that there should be absolutely no intrusion of day-to-day company business into project work. That is, participants should not be called out of their scenario project meetings to deal with telephone queries from their company. The physical distance to their company enables participants to take a detached look at it and to concentrate on securing its future, free from the pressures of day-to-day business.

With regard to premises and materials required, the following set-up is to be recommended: one large meeting room featuring a plenary seating arrangement (tables arranged like a horseshoe), one overhead projector and two flip-charts. If the meeting room is large enough, there is the possibility of accommodating working groups in its four corners; if not, then group meeting rooms must be made available in sufficient numbers (three to four). Furthermore, eight to twelve pin walls and adequate metaplan equipment. If possible, a personal computer may be provided; this enables scenario software to be demonstrated and explained to participants, using a practical example. In doing so, the so-called black box effect on participants can be avoided: they learn what happens with this software, how their data will be processed, and will understand in principle how computer-aided scenario operations work.

Implementing a Scenario Project

As participants need to travel to some location outside their company anyway, it is recommended to start scenario workshops directly on the night of arrival. These first sessions may be used for warming up and, in subsequent scenario workshops, for recalling any results obtained so far. This is done by briefly

…sults arrived at during any previous scenario workshops; analy-
… will be discussed and any queries dealt with. This clears the
…nediately with project work proper on the morning of the first
…op day. Scenario workshops are extremely labour-intensive
and, in most cases, include some evening work as well. When a scenario
workshop has been completed, the process manager collects whatever results
have been worked out (in most cases, these take the form of pin-wall papers,
flip-charts and evaluation sheets), writes up those results, notes where addi-
tional information needs to be obtained, and returns the scenario workshop
minutes to the team as soon as he or she possibly can. Between this and the
next scenario workshops, all scenario team members should have ample op-
portunity to consider those results, whilst obtaining and inserting any infor-
mation still missing.

Tracking and Organisationally Establishing a Scenario Project

When a scenario project has been completed, the final discussion – in most
cases, results will then be presented and introduced to a larger audience as well
as scenario workshop participants – must be followed by a brief session of *all*
scenario team members; this session will determine precisely *who* is going to
deal with *what task* by *which date* now that the project has been completed. In
this context, it is important to guard against the illusion that all the work has been
done once a scenario project has been completed. The real work, namely trans-
ferring scenario project results, is only just starting. Against the background of
the master strategy, it is recommended to define certain projects for further
tracking, to appoint a project leader, and to determine dates and expected
results right from the start. Also someone should be given responsibility for
transferring project results to company reality; staff from strategic planning
departments are best suited to this task; they will function as scenario transfer
coordinators. That is, it will be their job to call in monitoring results from the
environment monitoring system, and to organise a meeting of the scenario team
from time to time at which results and project progress will be discussed. Organi-
sational establishment of a scenario project should be handled similarly to
innovation management procedures and in line with the promoter model. That
is to say, someone from the board of directors or first line management will be
responsible, as power promoter, for the project and its further tracking. They
will secure budgets and sufficient freedom for project staff and, from time to
time, will be informed on the progress of individual projects. Additionally, a
so-called specialist promoter will be needed; as a rule, this should be a member
of the strategic planning staff, who will take on all remaining tasks such as
schedule control, calling in project and environment monitoring results, and

approving suggestions and formulating applications to first line management. In all cases, a final discussion should end by setting up a project plan, which might look something like this:

What?	Who	In coopera-tion with	By when?	Checked by
e.g.: Market analysis for search fields A + B R & D-Project Product Y, Z, ... Deciding on new business activities, using: – environment monitoring system – results of market analysis – development progress of R & D-projects for products Y, Z				

Figure 31: Project plan for transfering scenario results

How an Enterprise Benefits by Scenario Planning

Benefits for Planning as such

The scenario approach can be used to secure and improve, in various directions, existing company planning as well as any planning that will have to be newly developed. Alternative future developments will be recognised, whilst learning at the same time how to adjust to and anticipate these developments. Instead of just *reacting*, as usual, it will be possible to recognise early how to influence and utilise such developments *actively*.

With a scenario project, a company also gains a certain time advantage as future developments are being thought out in advance and the decisions of tomorrow and for tomorrow are being prepared today. To this end, however, scenarios, strategies and the environment monitoring system must be rigorously linked.

Using scenarios, a company will be able to recognise future opportunities which planning based on past and present events has not brought out clearly yet in good time for early action. Another important point is that potential risks will be recognised early. It is quite possible for a company to recognise during a scenario process that there are no longer any long-term chances for certain products or strategic business units due to these products being either substituted or subject to the disappearance of their industrial market or to market changes or shifts in direction. In this context, one of the benefits of using a scenario approach is that, due to the wide environmental scope of scenarios, a company not only recognises which products it will no longer be able to sell in the future but also its various options for solving this problem, that is, what new markets or product fields are shown by scenarios to promise future success. If, for instance, a company with relatively long lead times for developing new products and production methods recognises today that its most important strategic business units will be in serious jeopardy within the next ten years or so, this means that it must start right now to look for substitution products and services.

Disruptive events can be handled using scenarios, if their effect analysis is simulated consistently and if there are early plans on how to deal with them. Handling disruptive events should be seen as some kind of crisis training for management. Frequently, this will dispel a fear of such events; disruptive events will be seen as a challenge to management rather than a crisis.

Scenario planning enables a company to develop a common basis for its strategic planning and all other plans derived therefrom. Using this procedure and involving decision-makers on staff and line management level, awkward and tedious agreement procedures within the company will be avoided; often, such procedures will be necessitated only due to company departments planning in isolation and independently from one another. In most cases, when plans of this kind have been submitted, there follows a labour-intensive discussion and agreement process; this process will take a long time; and, finally, a decision will be reached that was not arrived at by recourse to some firm basis for planning.

A further way in which scenarios benefit companies is that their planners will be given better arguments for explaining why a certain direction should be taken and why what activities will be necessary and should be engaged in.

Benefits for Communication within an Enterprise

Because the scenario method observes and analyses developments holistically, as a network, company decision-makers are able to learn how to move away from a one-dimensional, monocausal perspective to a more holistic, future-

orientated way of thinking and seeing things. And since the environment in which the company of today finds itself is a complex, network-like system itself evolving in the context of a web of interconnections, companies must, in order to ensure their future success, transfer and carry this external networking into their internal structures.

Another advantage inherent in the scenario process is that participants become more aware of external developments. Once a team, working on a scenario project, has consistently thought out and translated all the alternatives and linkages involved in such external developments, it is much better equipped to recognise the connections between the various external developments, and the individual members of the team are then much more attuned to recognising changes in their company's environment.

A project of this kind also leads to improved communication between the various specialist departments, company divisions and all kinds of management personnel. A scenario process makes it clear that individual departments cannot function in isolation and independently of each other; rather, each department requires the know-how, information and experience of the others, and it is only together that they are able to achieve the best results. There also emerges an appreciation of the fact that the diversity of specialist knowledge available within a company can be much better utilised and integrated into the work process. A project of this kind often reveals a greater wealth of know-how in the company than had ever been tapped by previous company policies and planning procedures.

Goals and strategies become transparent to all scenario project participants, thanks to their having developed them jointly and thereby gained an insight into the reasons why some goals and strategies are being pursued while others are bracketed out.

A scenario project increases the acceptance of the results on the part of all those involved and motivates members of the scenario team, who of course are themselves affected by the implementation of strategy, to put decisions into practice effectively and promptly. In other words, those affected thus become participants bearing responsibility for the quality of scenario results.

8
Working Techniques within the Scenario Method

Teamwork Techniques

One working method, which is used during the entire scenario process, is known as the metaplan method. This procedure enables all individual development and evaluation stages to be made transparent and visual to the scenario team as a whole. The path to the various scenario results is recognised clearly and thereby more easily justifiable, which in turn leads to increased acceptance and better understanding by participants.

In addition to the metaplan method, certain stages make use of creativity techniques (particularly in step 7, where disruptive events are generated). Here brainstorming and brainwriting methods appear most suitable. Brainwriting methods may loosely be defined as brainstorming variants using the written form.

Various evaluation procedures form another group of techniques; these are of particular relevance within the scenario process. In order to determine hierarchical orders, taking, for example, strengths of influence for the various external influence factors as a criterion, the concept of relative hierarchical order may be used. A relative hierarchical order is set up as follows: All influence factors are written down on cards (one influence factor per card) and then stuck on the pinwall in a horizontal row. Next the first two factors are compared with reference to their strength of influence on the subject under consideration. Here it is quite important that the first card always stays at the same level. All other cards are re-arranged either above this reference card, if their influence is stronger than that of the reference card, or below the card, if their influence is weaker. This method very quickly yields a relative hierarchical order; this relative hierarchical order, however, requires less work and effort, for it is no longer a case of comparing every card with every other card, as when comparing pairs, but a case of reduced effort due to using the reference card

for orientation. Another advantage, when setting up relative hierarchical orders, is that by comparing cards participants will start re-wording or re-phrasing factors, if it is found, for example, that certain levels of abstraction cannot be compared with one another, or that one particular factor is a partial set or subset of some other factor.

With this method, it is not necessary to try and determine precise hierarchical distances between positions 1 and 2, positions 2 and 3, etc. Any attempt of this kind would be very difficult to carry out in practice, as one is dealing with a mixture of quantitative and qualitative aspects; the work and effort involved in measuring these differences would be out of all proportion to the results, which would not be improved in their meaningfulness (see Figure 31).

Relative hierarchical orders are set up in step 2 (hierarchical order of influence factors relative to their influence strength on subject considered), in step 3 (evaluation of future projections, per influence area, with regard to their relevance for the company), and in step 7 (for setting up, per influence area, relative hierarchical orders of disruptive events).

Network analysis, fully discussed in step 2, represents another evaluation method. Here it is determined in what way each influence area influences every other influence area, concentrating not on the rather generally worded headlines but on questions like: How strong is the influence of area A, characterised by its factors, on area B, characterised by its factors. Proceeding in this way, individual influence area structures and their real system dynamics are more fully taken into account. All other details on network analysis and system grids have already been dealt with in step 2 (influence analysis).

The scenario method also uses consistency analysis, which in turn has been fully discussed in step 4 (grouping alternatives). Completing a consistency matrix represents, in terms of method, the most demanding evaluation step within the scenario process; for it is at this juncture that an attempt is made to evaluate how certain alternative future developments will or will not match logically. It is quite important not to base this step on probability evaluations. In all cases, it is recommended to carry out this step under instruction and guidance by a process manager experienced in the method. One typical error, made again and again by those who are using consistency analysis for the first time, is that two alternative developments are linked "by force"; i. e. these two developments are linked by including a number of other factors in the same relation. Here it is vital that individual alternative developments are linked without using the aid of third, fourth and fifth factors "to force the issue".

Very often, the scenario method uses matrices; either these serve to determine relative influence strengths of parameters on one axis to parameters on the other axis, or to carry out evaluations of strategies and strategy elements in respect of the various scenarios under consideration (see pp. 161 and 168).

1. Arrangement of Factors

2. Evaluation of all factors relative to A

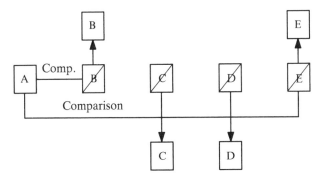

3. Evaluation between B + E (on the same level) and between C + D (on the same level).

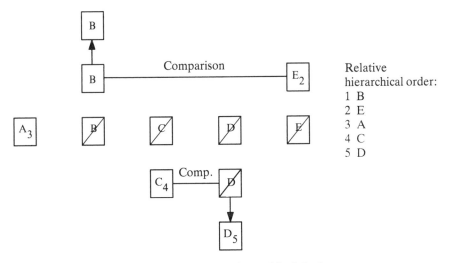

Figure 32: Relative Hierarchical Order

Computer-Aided Methods within the Scenario Procedure

In order to improve speed and quality of results when carrying out some of the more complex tasks within the scenario method, tasks which require a large number of calculations, for example, stability and sensitivity analyses and dis-

ruptive event simulations, a software has been developed that encompasses all calculations within the scenario method. CAS (Computer-Aided Scenarios) is a software package for IBM PC, XT, AT or compatible computers, which supports planning by implementing scenario techniques.

The first CAS element was consistency analysis, which usually becomes almost impossible to handle manually once a certain data quantity level has been reached (more than 15 alternative descriptors). On the basis of the data and linkages between all of the alternative descriptors which had been arrived at in the consistency evaluation, it was then possible to add further analyses such as the stability of computed scenarios and the sensitivity of all descriptors and scenarios. Network analysis was the next element to be added, followed by its linking with consistency analysis, and disruptive event simulation possibilities. And lastly, to round off this scenario software package, the final module added routines for linking scenarios with internal parameters/descriptors as well as procedures for checking master and alternative strategies selected against actual scenarios. Thus a software package is available today which provides a fast and uncomplicated means of calculating, in dialogue with the computer, what effects intended changes of data will have. Even at a later stage, it is possible to enter further descriptors or disruptive events and then analyse their effects. On completion of a scenario project, therefore, strategies may easily be kept under continuous review in this way, with scenario projections being continuously updated and extended.

CAS evaluations, being more precise and meaningful than manual evaluations, all those data that were determined in the individual steps of the scenario process, some of them involving a great deal of effort, may be utilised more adequately than would otherwise be possible. CAS uses optimising procedures instead of the more usual heuristic procedures. Not only does this yield more accurate results, but it also ensures that the quality of those results depends only on the data input and not on some evaluation procedure accidents.

Network Analysis

Once influence areas – and possibly subdivisions within the influence areas – have been defined, the way these influences relate to one another is established and evaluated, using a network matrix. This yields a classification of influence areas into active, passive, buffering, and ambivalent. Active influence areas, with ambivalent influence areas being immediately next in line, structure scenarios particularly strongly. Appropriate weighting in subse-

quent CAS evaluations can further enhance this effect. This weighting is automatically determined by the computer; it is possible, however, to enter or change weighting values manually.

Dependency Analysis

In cases where there are a great many alternative descriptors - the program can process up to 35 alternative descriptors – the consistency matrix will be almost too complex to handle. The dependency analysis shows among which consistency matrix areas there are no connections. For consistency analysis purposes, pairs of descriptors belonging to two different and unrelated areas will then be excluded from consideration. In this way, data entry effort and thus evaluation effort by users can be reduced by up to 50 per cent. CAS takes this into account when printing out data entry forms for consistency values. Moreover, this reduces computing time too.

Consistency Analysis

The scenario method centres on consistency analysis, i. e. determining highly consistent scenarios which are as different as possible from one another. Manual implementation of consistency analysis is possible only if there are just a few descriptors; and even then an auxiliary procedure will need to be used, which in many cases will yield poor results. Quite frequently, actual values achieved will remain far below possible maximum values regarding consistency and diversity.

The manual method does not afford any control of how good a particular solution is. Thus it is quite possible to invest a great deal of careful work and time in determining consistency values for individual descriptors and then, due to poor evaluation of these data, to work with unsuitable scenarios without realising the error.

In CAS, up to 35 alternative and 50 definite descriptors can be used; for these descriptors, optimum scenarios regarding a high level of consistency are computed. All this has become possible only due to a new and very efficient combinatory optimisation algorithm, which was specially developed for CAS. PC AT computing times, even with a maximum number of descriptors, are usually less than one hour – quite astonishing, if you consider that with 35 alternative descriptors, 2^{34}, i. e. more than 30 billion, different scenarios exist. The number of theoretically possible scenarios is 2^{n-1}.

From the best scenarios determined in this way (up to 1024 scenarios can be

computed), CAS then selects two scenarios which will be as different from one another as possible. In dialogue with the computer, the user determines how the two aims – a high level of consistency on the one hand, and a high degree of diversity on the other – are to be weighted. The result will again be an optimum in relation to the combined selection aims (a high degree of diversity and a high level of consistency). Using CAS, the best possible results can be obtained from consistency data. In this way, a sound basis for all further planning steps can be created.

Stability Analysis

The other CAS building blocks will help to increase understanding of the complex structure of networked systems which are the subject of the planning process. These CAS elements build on the two scenarios already determined.

The stability analysis shows how sensitively a scenario will react to minor disruptions: If it asserts itself, i. e. if minor disruptions cannot fundamentally change its structure, then it may be said to be *stable*. But if some minor disruption can upset the entire scenario structure, then it is *unstable*.

On the theory that scenarios will always tend towards the highest possible level of equilibrium and synergy, this means for stability analyses that whenever a scenario achieves a higher level of consistency after minor disruptions have been introduced, the scenario is unstable. If there is no change in its behaviour, or if it tends towards a lower consistency after minor disruptions have been introduced, then it may be considered stable. That is to say, this particular scenario has achieved the highest synergetic effect as well as the highest level of internal cohesion.

Sensitivity Analysis

Sensitivity analyses introduce structure into the mass of alternative descriptors: in most cases, the structure of a scenario will be moulded by the characteristics of just a few descriptors. If one of those "key descriptors" changes in its characteristics, the present scenario trend line will be left, and the scenario will start to develop in a new direction. With a knowledge of the key descriptors, an environment monitoring system can be set up which will enable users to recognise early any impending trend line upsets, including their effects on the scenario.

Other descriptors adapt to key descriptors, in other words, they are "passive". If, over a period of time, there are any changes here, this is usually due

to some minor disruption that will not influence the scenario structure in any way. Quite frequently, the descriptor will revert to its former state as soon as the disruption clears.

For a third group of descriptors the analysis shows that, given reasonable consistency values, they will never change their characteristics. Thus they can be treated in the same way as definite descriptors. This reduces the variables to be considered in planning.

Simulating Disruptive Events

Procedures for simulating scenario development, when influenced by one or several disruptive events, will first show whether a scenario is relatively stable in a certain disruptive event situation. If it is, then the disruptive event is non-critical for any planning based on this scenario.

If not, then the simulation will determine a number of logical developments which may be triggered by this disruptive event. These developments will finally lead to scenarios which will be stable in a continued disruptive event environment. They indicate in which direction some disruptive event will push a given scenario. Also it will become clear which descriptors remain unaffected by the disruptive event.

Time and again users find that by introducing disruptive events certain new scenario structures arising from the simulation will occur in some distribution. Thus a company will be able to concentrate on those scenarios which occur again and again in some maximum distribution (70 to 80 per cent). For planners this means that, in disruptive event situations, scenarios do not drift off into an infinitely diverse number of directions; rather, certain new constellations tend to assert themselves again and again, which may then be taken seriously as real disruptive event effects. This also facilitates planning in respect of the sheer diversity of scenarios occuring as a result of simulated disruptive events.

Strategy Proposals in Comparison to Scenarios

Strategy planning is supported by the analysis of internal descriptors. The program maps decision parameters for planning as a selection from some few distinctly diverse possibilities. Considering their relationship to external descriptors, these possibilities are termed *internal descriptors*. For them, the computer will determine three strategies:

– optimum strategy (master strategy), well adapted to both scenarios

– alternative strategy 1, optimally adapted to scenario A

– alternative strategy 2, optimally adapted to scenario B

Information on the relative importance of individual decision parameters will be obtained by a sensitivity analysis determining the degree to which a certain decision parameter depends on the environment scenario, as well as its influence on the strategy. The result will also be represented graphically, using the portfolio format.

Mask and Menu Manager (MMM)

CAS software features a comprehensive user interface and thus is character-ised by a specially high degree of user-friendliness. This user-friendliness is based on a package of software routines for screen handling and, in particular, for handling selection menus and input masks. Hence its name, MMM, or Mask and Menu Manager. All input and output actions are routed through this package of software routines; this ensures standardised operation procedures for all CAS software elements. MMM also comprises a text editor featuring everything one would expect from a professional word processing system.

Using the text editor, all CAS outputs can be edited manually before print-ing them out; also, texts can be stored on floppy or hard disk.

Via a so-called ASCII data facility, texts can be accessed by most word pro-cessing systems on the market today. It is also possible to edit or process CAS protocols using, instead of the CAS text editor, one of these word processing systems.

CAS Hardware Requirements

CAS runs under MS-DOS or PC-DOS, version 2 or higher, on all IBM PCs or compatible systems. CAS needs at least 256 KB random access memory. The program works with two floppy disk drives; alternatively, it can be installed on a hard disk. It is recommended to use a fast processor (8086 or 80286 with 8 MHz or faster), as some parts of the program are highly computer-bound. However, using an arithmetic co-processor does not significantly increase computing speed.

CAS supports both the monochrome as well as the colour graphics adapters

for screen connection and handling. As all screen adapters on the market simulate at least one of the above, there are no problems with connecting a screen.

The program can be installed for any printer. Completed installations for the IBM Graphics Printer, the EPSON FX series, and the EPSON LQ series are included in the package.

Bibliography

Scenario Techniques

Beck, P. W., Strategic Planning in the Royal Dutch/Shell Group, a paper presented on March 1, 1977, on the conference of Corporate Strategic Planning, Shell International Petroleum Co. Ltd.

Biberstein, V. R., Bormann, W., Die Szenario-Methode als Verfahren zur zukunftsorientierten Untersuchung komplexer sozialer Probleme, in: Analysen und Prognosen, January 1985, pp. 21–23.

Brauers. J., Weber, M., Szenario-Analyse als Hilfsmittel der Strategischen Planung: Methodenvergleich und Darstellung einer neuen Methode, in: ZfB, 1986, pp. 631–652.

Ducot, L., Lubben, G. J., A Typology for Scenarios, in: Futures, 1980, pp. 51–57.

Geschka, H., Reibnitz, U. von, Zukunftsanalysen mit Hilfe von Szenarien – erläutert an einem Fallbeispiel "Freizeit im Jahr 2000", in: Politische Didaktik (1979), *4*, pp. 71–101.

Geschka, H., Reibnitz, U. von, Die Szenario-Technik als Grundlage der strategischen Planung, in: Töpfer/Afheldt (ed.): Praxis der strategischen Unternehmensplanung, Frankfurt a. M. 1982.

Gomez, P., So verwenden wir Szenarien für Strategieplanung und Frühwarnsystem, in: Management-Zeitschrift – Industrielle Organisation, pp. 9–12.

Gomez, P., Escher, F., Szenarien als Planungshilfen, in: Management-Zeitschrift – Industrielle Organisation, vol. 49 (1980), *2*, pp. 141–150.

Grimm, W., Reibnitz, U. von, Persönliche Zukunftsbilder: Die Nutzung der Szenario-Methode für die Lebens- und Karriere-Planung, Abdruck aus: Personalwirtschaft 3/85.

Hammer, R., Reibnitz, U. von, Strategische Unternehmensführung mit Szenario-Technik, in: Der Innovations-Berater, Freiburg i. B. 1984.

Hankinson, G. A., Energy scenarios – the sizewell experience, in: LRP, 1986, *5*, pp. 94–101.

Ilsemann, W. von, Die geteilte Zukunft – Szenario-Planung bei Shell, in: Manager-Magazin (1980), *5*, pp. 115–123.

Klein, H. E., Newman, W. H., How to Use SPIRE: A Systematic Procedure for Identifying Relevant Environments for Strategic Planning, in: Journal for Business Strategy, 1980, pp. 32–45.

Leemhuis, J. P., Using Scenarios to Develop Strategies, in: LRP, 1985, *2*, pp. 30–37.

Linnemann, R. E., Klein, H. E., The Use of Multiple Scenarios by U.S. Industrial Companies, in: Long-Range-Planning, vol. 12 (1979), *2*, pp. 83–90.

Material-Manager-Seminar, ZP-lecture: Szenarien und langfristige Prognosen, 20. 6. 1984, Deutsche Shell AG, Hamburg 1984.

Meadows, D., Die Grenzen des Wachstums, Stuttgart 1972.

Mesarovic, M., Pestel, E., Menschheit am Wendepunkt, Stuttgart 1974.

Nair, K., Sarin, R. K., Generating Future Scenarios – Their Use in Strategic Planning, in: LRP, June 1979, pp. 57–66.

Reibnitz, U. von, Geschka, H., Seibert, S., Szenario-Technik als Grundlage von Planungen, Frankfurt a. M. (Battelle) 1982.

Reibnitz, U. von, So können auch Sie die Szenario-Technik nutzen – für mehr Handlungs-spielraum in Ihren Marketingplanungen, in: Marketing-Journal, vol. 14 (1981), *1*.

Reibnitz, U. von, Mit der Szenario-Technik die Zukunft bewältigen, in: Aigner, G. (ed.): 90 Überlebenskonzepte für deutsche Manager, München 1982.

Reibnitz, U. von, Szenarien als Grundlage strategischer Planung, in: Harvard-Manager, 1/83.

Reibnitz, U. von, Lecture on "Methoden der Unternehmensführung aus der Sicht der zu-künftigen wirtschaftlichen und sozialen Entwicklung", Subtitle: Führung in der Zu-kunft; conference of innovation and management of Wirtschaftsförderungsinstitut der Bundeskammer der gewerblichen Wirtschaft in Wien, April 1986.

Reibnitz, U. von, Szenario-Technik – Optionen für die Zukunft, in: Der Controlling-Bera-ter, Freiburg i. B., vol. 4, September 1986, *5*, pp. 167–347.

Stümke, W., Strategische Planung bei der Shell AG, in: Steinmann, 1981, pp. 331–347.

Wack, P., Scenarios: Uncharted Waters Ahead, in: Harvard Business Review, 1985, a, pp. 72–89.

Wack, P., Scenarios: Shooting the Rapids, in: Harvard Business Review, 1985, b, pp. 139–150.

Wack, P., Learning to Design Planning Scenarios: The Experience of Royal Dutch Shell, Working Paper, Harvard Business School, June 1984.

Zentner, R. D., Scenarios: A New Tool for Corporate Planners, in: Chemical and Engineer-ing News, International Edition, vol. 53 (1975), October, pp. 22–34.

Strategic Planning

Albach, H., Beiträge zur Unternehmensplanung, 3/e, Wiesbaden 1979.

Ansoff, H. I., The State of Practice in Planning Systems, Sloan Management Review, vol. 18, 1977.

Ansoff, H. I., Declerck, R. P., Hayes, R. L., (ed.), From Strategic Planning for Strategic Management, London 1976.

Ansoff, H. I., Leontiades, J. C., Strategic Portfolio Management, in: European Institute for Advanced Studies in Management, Working Paper 76–16, May 1976.

Beck, P. W., Corporate Planning for an Uncertain Future, Report of Shell UK Ltd., London (1981).

Bratschitsch, R., Schnellinger, W., (ed.), Unternehmerkrisen – Ursachen, Frühwarnung, Bewältigung, Stuttgart (1981).

Clauswitz, C. von, Vom Kriege, Frankfurt a. M., Berlin, Wien 1980.

Gälweiler, A., Strategische Unternehmensplanung, in: Steinmann, H. (ed.): Planung und Kontrolle, München 1978.

Hahn, D., Taylor, B., Strategische Unternehmensplanung, 2/e, Würzburg, Wien 1982.

Hammer, R. M., Unternehmensplanung, München 1982.

Hinterhuber, H. H., Strategische Unternehmensführung, 2/e, Berlin, New York 1980.

Kirsch et al., Unternehmenspolitik: Von der Zielsetzung zum Strategischen Management, München 1981.

Kreikebaum, H., Strategische Unternehmensplanung, Stuttgart, Berlin 1981.

Leontief, W. W., Die Zukunft der Weltwirtschaft, Stuttgart 1977.

Linnemann, R. E., Shirt-Sleeve Approach to Long-Range-Planning, Englewood Cliffs 1980.

Porter, Michael E., Competitive Strategy, Techniques for Analyzing Industries and Competitors, London 1980.

Pümpin, C., Strategische Unternehmensführung, Die Orientierung, no. 76, 1980.

Roventa, P., Portfolio-Analyse und Strategisches Management, München 1979.

The New Breed of Strategic Planner, Cover Story in: Business Week, September 1984.

Trux, W., Kirsch, W., Strategisches Management oder die Möglichkeit einer "wissenschaftlichen" Unternehmensführung, in: DBW 39 (1979), pp. 215–235.

Ulrich, H., Unternehmenspolitik, Bern, Stuttgart 1978.

Trends of the Future

Alfeldt (ed.), Bilder einer Welt von morgen – Modelle bis 2009, Stuttgart 1985.

de Bono, E., Technology Today, London 1971.

de Bono, E., (ed.), Lateral Thinking for Management, London 1971.

Buchinger, G., (ed.), Umfeldanalysen für das strategische Management: Konzeptionen – Praxis – Entwicklungstendenzen, Wien 1983.

Capra, F., Wendezeit – Bausteine für ein neues Weltbild, München 1983.

Die Bundesrepublik Deutschland 1990, 2000, 2010, Prognos Report, no. 12, Basel 1986.

Dörner, D., Denkpsychologie und der Umgang mit Unbestimmtheit und Komplexität, 1983 (a), in: Dörner et al., 1983, pp. 100–104.

Dörner. D., Kreuzig, H. W., Reither, F., Stäudel, T. (ed.), Lohhausen, Vom Umgang mit Unbestimmtheit und Komplexität, Bern, Stuttgart, Wien 1983.

Dörner, D., Reither, F., Über das Problemlösen in sehr komplexen Realitätsbereichen, in: Zeitschrift für experimentelle und angewandte Psychologie, 1978, pp. 527–551.

Drucker, P. F., Towards The Next Economics And Other Essays, London 1981.

Global 2000, Report to the President, 1980.

Hawken, P., Ogilvy, J., Schwartz, P., Seven Tomorrows, New York 1982.

Kahn, H., Vor uns die guten Jahre, Wien, München, Zürich, Innsbruck 1977.

Kahn, H., Redepennning, M., Die Zukunft Deutschlands, Wien, München, Zürich, New York 1982.

Kahn, H., Wiener, A., Ihr werdet es noch erleben, Wien, München, Zürich 1968.

Lutz, C., Westeuropa auf dem Weg in die Informationsgesellschaft, Gottlieb Duttweiler Institut, Rüschlikon 1984.

Naisbitt, J., Megatrends, 6/e, 1983.

Tietz, B., Optionen bis 2030, Stuttgart 1986.

Toffler, A., Die dritte Welle – Zukunftschance, München 1980.

Vester, F., Neuland des Denkens, Stuttgart 1980.

Vester, F., Ballungsgebiete in der Krise, Stuttgart 1976.

Ziegler, A., Annahmen über zukünftige Entwicklungen, 1987.

SUMMARY

1. Scenario Techniques – Origins

Learning what the future may hold is one of mankind's most ancient desires. Its origins can be found in Seneca's writings and were later further refined by planners of military strategy, like Clausewitz and Moltke.

The business world needed serious economic crises, such as occurred during the seventies, to start looking away from conventional forecasting and into planning methods which focus more strongly on future developments. 11

2. How the Scenario Approach Compares to other Planning and Forecasting Methods

The scenario method describes future environment situations (scenarios) and develops paths leading from present situations into various future situations, all distinctly different from one another. In doing so, the scenario approach – in contrast to other planning and forecasting methods – focuses planning more strongly on future environment situations, thus enabling forward-looking strategies to be developed. 15

3. Reorientation in Planning Approaches

Changes in business environment and the uncertainties thus arising cause more and more companies to turn away from simple extrapolations and projections of past events and performance into the future; they start to use methods which specifically look into future environment situations and, moreover, include qualitative aspects in planning. 21

4. The Scenario Approach: A Description

The Scenario Model

The scenario model illustrates the uncertainties of the future, the complexity of many diverse developments and their interrelationships in so-called networks, and assists planners by enabling them to see how to handle the uncertainties and complexities of the future. 27

The Eight Steps of the Scenario Process

Step 1: Task Analysis

Using task analysis procedures, the internal company situation will be ana-
lysed as it exists at present. This first step of the scenario process will review
present company policies, current goals and strategies, and then analyse com-
pany strengths and weaknesses in order to filter out those problems that must
31 be solved for successful future development.

Step 2: Influence Analysis

Influence analysis procedures are used to analyse the external company situa-
tion (analysis of business environment) as it exists at present; this is done by
defining influence areas and determining those influence factors within those
areas that will be relevant to the company. On this basis, network relationships
among influence areas will be determined in order to learn system behaviour
36 and how to handle its actions.

Step 3: Projections

Using the influence factors determined in step 2, step 3 sets up projections into
the future. Here it is particularly important to work out and justify diverse
alternative paths into the future for all those areas where there are significant
43 uncertainties over future developments.

Step 4: Grouping Alternatives

Here there is a comparison of the majority of alternatives worked out in step 3.
This is to determine which alternatives will prove to be a particularly good
match for the future and which alternatives will be mutually exclusive; this
evaluation will then lead to a selection of logically consistent and credible sce-
44 nario base structures.

Step 5: Scenario Interpretation

Using the information data worked out and calculated in steps 1 to 4, visions of
the future are developed from a given present situation to logically consistent,
48 credible, and stable but widely differing scenarios.

Step 6: Consequence Analysis

Using the two different scenarios, opportunities and risks for a given company will be derived. On this basis, appropriate activities will be developed to utilise opportunities as early as possible and minimise risks as much as possible or turn them into opportunities.

Step 7: Disruptive Event Analysis

This step analyses what disruptive factors might occur internally as well as externally, what effects they might have on the company, and how they could be handled. Handling disruptive events means: How could they be prevented; or how could a company "immunise" itself, so that it will be well able to cope with the effects of disruptive events; and what reaction or crisis plans could be drawn up?

Step 8: Scenario Transfer

Using scenario transfer techniques, a synthesis of these various activities is set up; from this a master strategy is developed that is likely to be successful under various different external settings. This master strategy is further consolidated by integrating the preventive measures worked out in step 7, and setting up an environment monitoring system. The latter functions as a controlling or feedback device for the master strategy.

5. Practical Application of Scenario Techniques – Some Examples

6. Translating Scenario Techniques into Actual Planning

Chapter 6 introduces some applications of scenario techniques for solving various planning problems.

The Scenario Method in Strategic Planning

Developing and Testing Corporate Identity

Corporate identities should be developed and tested in tandem with the development of strategies on the basis of worked out scenarios. In doing so, more dynamism and future developments can be introduced into the development of operating principles. And it is also possible to ascertain that the new corporate identities are not in conflict with future developments.

Development Goals and Strategies (Master and Alternative Strategies)

A master stratey should be robust and flexible under a variety of external settings (scenarios). This means that a master strategy will concentrate on such elements as will function under both scenario settings. Alternative strategies are master strategy branches, suitable for only one scenario respectively; they will only be activated if it is observed that external developments appear to 150 tend towards a certain scenario.

Re-examining Existing Goals and Strategies

In order to review presently existing company goals and strategies, checking whether they are likely to prove successful under various different external settings, strategies can be tested against scenarios. Using a matrix, the respective strategies are compared to scenario descriptors; this results in a comprehensive evaluation per strategy and per scenario. Then a strategy will be selected which comes out top in both scenarios; if possible, this strategy will be 152 further complemented by activities from consequence analysis.

Scenarios for Assessing Strategic Decisions

Company decisions of strategic importance for the future involve great risks as well as major opportunities; therefore, they ought to be reviewed and checked with the aid of scenarios. The various alternative decisions possible are evaluated in respect of their matching or not matching individual scenario settings; in this way, an evaluation of how well what decision matches which scenario is obtained first. As a second criterion for evaluation, a check is made on how prone to disruptive events the various alternative decisions are. Both criteria are then used to arrive at a certain value. In this manner it will be possible to come to a decision for a strategy orientated towards the future and likely to be successful under various different external settings; moreover, this will be a 155 strategy able to stand up robustly against disruptive events.

Use of Scenarios in testing Short- to Medium-Term Operative Planning

Scenarios may also be used to review short- to medium-term operative planning. Here last year of the extrapolated planning system is compared with scenario time horizons; in this way, it then becomes clear whether or not there 159 is already a need for changes in short- to medium-term planning.

The Scenario Method as a Basis for Environment Monitoring

Environment monitoring is the link between external future possibilities (scenarios) and strategies orientated towards this future. Environment monitoring functions as a control and feedback device for the master strategy.

Structure and Organisation of an Environment Monitoring System

To set up an environment monitoring system, two analyses are needed:

– A matrix for determining how scenario descriptors influence directly the various internal parameters, functions, or products of the subject company.

– An analysis of the environment system dynamics of the various scenario descriptors (Can be determined by computer-aided sensitivity analysis).

From both analyses, it becomes clear which external parameters will be decisive for the company, and must therefore be consistently monitored and analysed.　　161

Environment Monitoring to check and bring into line the master strategy

The environment monitoring system is used to achieve some fine-tuning of the master strategy over time. To this end, the results of external developments and internal project progress are compared with the master strategy at certain decision points on a time axis; depending on external developments, the master strategy is then carefully adjusted. Starting at the beginning with a wide framework of two scenarios, the master strategy is refined into a customised strategy for the future situation as it actually occurs. This allows most risks and uncertainties to be removed, whilst the method enables planners to decide freely how best to adjust to the future – by carefully weighing up the situation or by being enterprising.　　166

Using the Environment Monitoring System to detect new Developments

Another advantage of the environment monitoring system is that it will not only monitor scenario descriptors but also take in and process new developments not yet anticipated in scenarios.　　168

Revising Scenarios with the aid of the Environment Monitoring System

As it is necessary to revise scenarios from time to time (approx. every four to six years), the environment monitoring system can be used extremely well to carry out such revisions. By monitoring external developments new trends and parameters are taken in, which will then have to be included in scenario revisions. Existing scenario descriptors are reviewed as to their relevance for the long-term future and as to how they have been complemented by new factors; also, all projections and calculations are redone and there is a new consequence
169 analysis on the basis of the new scenarios reaching further into the future.

The Scenario Method as a Basis for Separate Topics

In addition to using scenarios for various aspects of strategic planning, it is also possible to employ scenarios as a basis for future strategies in relation to some specific separate topics.

Scenarios for Innovation Planning

Scenarios for innovation planning are used if either some new product is being developed or new approaches are being sought that will generate new product
173 ideas as well as products for the future.

Scenarios for Diversification Planning

As in innvoation planning, scenarios for diversification planning serve two purposes:

1. Consolidating a selected direction of diversification
2. Recognising search fields relevant to the future, and developing solutions for these search fields

In addition, any planning of diversifications can be improved by using scena-
174 rios to plan, control, and realise their implementation in time.

176 Scenarios for Production Planning

178 Scenarios for Marketing Planning

Scenarios for Personnel Planning

Scenarios for individual planning tasks within a company, such as production, marketing and personnel, will usually be carried out in two stages. First, consequence analysis procedures will be employed to analyse opportunities and risks for the company and to develop appropriate activities; from these the requirements for respective individual topics (planning tasks) are derived, which will then be subject to further scenario conceptions. 179

Scenarios for Personal Career Planning

In addition to the more usual business applications of the scenario method, scenarios can also be used for planning one's personal future. This form of scenario development can be carried out by an individual. No team is necessary, apart from a discussion partner in some steps. The advantage of proceeding in this way is that it enables one to recognise opportunities for one's own personal and career planning, based on holistic and interrelated alternative future developments, i. e. opportunities which would not come out in linear projections. Even those who appear to be at a dead end in their present jobs should be able to find new paths for actively shaping and enhancing their personal careers. 180

7. Setting up Scenarios

Selecting the Area to be Analysed

Before a scenario project is started within a company, there should be careful consideration of the goals aimed for, results expected, and what the project is to achieve. Depending on the outcome, the appropriate area for analysis will be selected. This may be some strategic business unit, the enterprise as a whole, or some company external topic. 189

Time Required to Set up a Scenario

The scenario method is very flexible in its applications, and the time and effort the latter take to implement. Implementations range from three-day company-specific scenario seminars to scenario projects comprising four to five scenario workshops. The actual form of scenario application to be selected for a given company project can be derived from project goals, the size of the company, and the complexity of the subject under consideration. 192

Organization

For successful implementation of a scenario project, there is an important role to be played by organizational aspects such as correct team selection, project planning, aspects such as correct team selectioneffeoject planning, project implementation as well as project tracking. The quality of scenario results worked out depends in particular on the quality of the scenario team selected.

200

How an Enterprise Benefits by Scenario Planning

Scenario planning aids companies in putting their planning on a well-founded and future-oriented basis, in recognising opportunities and risks early, and in adjusting to the new situation in good time; simultaneously, scenario planning also improves communication among participants as well as the way in which they are "sensitised" to possible future developments.

207

8. Working Techniques within the Scenario Method

Various working techniques must be used within the scenario procedure. Their range includes presentation techniques, creativity and evaluation techniques, as well as computer-aided analyses.

211

Index